ISBN 978-1-330-55097-7
PIBN 10077412

This book is a reproduction of an important historical work. Forgotten Books uses
state-of-the-art technology to digitally reconstruct the work, preserving the original format
whilst repairing imperfections present in the aged copy. In rare cases, an imperfection in
the original, such as a blemish or missing page, may be replicated in our edition. We do,
however, repair the vast majority of imperfections successfully; any imperfections that
remain are intentionally left to preserve the state of such historical works.

1 MONTH OF
FREE
READING

at

www.ForgottenBooks.com

By purchasing this book you are eligible for one month membership to ForgottenBooks.com, giving you unlimited access to our entire collection of over 700,000 titles via our web site and mobile apps.

To claim your free month visit:

www.forgottenbooks.com/free77412

English
Français
Deutsche
Italiano
Español
Português

www.forgottenbooks.com

Mythology Photography **Fiction** Fishing Christianity **Art** Cooking Essays Buddhism Freemasonry Medicine **Biology** Music **Ancient Egypt** Evolution Carpentry Physics Dance Geology **Mathematics** Fitness Shakespeare **Folklore** Yoga Marketing **Confidence** Immortality Biographies Poetry **Psychology** Witchcraft Electronics Chemistry History **Law** Accounting **Philosophy** Anthropology Alchemy Drama Quantum Mechanics Atheism Sexual Health **Ancient History** **Entrepreneurship** Languages Sport Paleontology Needlework Islam **Metaphysics** Investment Archaeology Parenting Statistics Criminology **Motivational**

The authorities for the letterpress are in many cases, and where important, acknowledged throughout the volume; but, in numerous instances, having obtained the same information from different channels, it has not been possible precisely to define the original source of what has become common property. The following are the chief works consulted and quoted from :—
" Corot, Souvenirs Intimes," H. Dumesnil, 1875; "Corot," J. Rousseau et A. Robaut, 1884 ; "Exposition de l'œuvre de Corot," Notice par P. Burty, 1875; " Douze Croquis et Dessins," par Corot, 1872 ; " Douze Lithographies d'après Corot," E. Vernier, Notice par P. Burty, 1870; " Notes et Souvenirs," Ludovic Halévy, 1889; "Souvenirs sur Théodore Rousseau," A. Sensier, 1872 ; "Etudes et Croquis de Théodore Rousseau," 1876; " La Vie et l'Œuvre de J. F. Millet," A. Sensier, 1881 ; "J. F. Millet," Charles Yriarte, 1887 ; " Jean François Millet," W. E. Henley, 1881 ; " Catalogue de l'Exposition de J. F. Millet," Notice par P. Mantz, 1887 ; " Au Pays de J. F. Millet," C. Fremine [n:d:]; "C. Daubigny et son œuvre," Fred. Henriet, 1878; "Peintres et Sculpteurs Contemporains," J. Claretie, 1882; "La Capital de l'Art," Albert Wolff, 1886; " Maitres et Petits Maitres," P. Burty, 1877 ; " Peintres Romantiques," E. Chesneau, 1880; "L'Hôtel Drouot," 1881 ; " Peintres Français Contemporains," C. Bigot, 1888; "L'Autographe au Salon, 1864," etc.: articles in the chief French newspapers such as the *Figaro*, *République Française*, *Gaulois*, *Paris Journal*, *Temps*, *Moniteur*, etc., by such writers as MM. Albert Wolff, Adrien Marx, E. Chesneau, E. Blavet, and A. Robaut.

I have further to acknowledge the assistance of Mr. Thomas Allan Croal, Edinburgh and Mr. James Thomson, in the revision of the letterpress, and to thank Mr. Henry Wallis, Mr. Douglas Freshfield, Mr. and Mrs. E. S. Calvert, Mr. Alfred East, Mr. Deschamps, Mr. E. Bale, Mr. M. H. Spielmann, and other friends, for notes or useful help. Also Mr. Walter Sickert, for his etching of " The Boatman," by Corot.

In the preparation of such a volume, occupying the leisure hours of fully three years, a great amount of laborious and sometimes irksome work has been necessary, but this will be amply compensated should the result be judged worthy, in some measure, of the great artists whose lives are set forth.

D. C. THOMSON.

LONDON, *June 6th*, 1890.

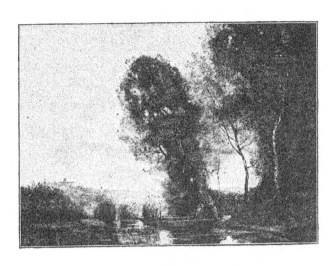

Afternoon By Corot. From the Picture in the Collection of Sir John Day.

TABLE OF CONTENTS.

TABLE OF CONTENTS.

LIST OF FULL-PAGE PLATES.

LIST OF SMALL ILLUSTRATIONS

PRINTED IN THE TEXT.

LIST OF ILLUSTRATIONS.

Landscape by Corot. From the Picture in the Collection of G N. Stevens, Esq.

GENERAL INTRODUCTION,

THE landscape art of France in the first quarter of the nineteenth century was of the most conventional and often of the most insipid kind. One painter, Georges Michel, who inherited the true love of the grandeur of nature, though but in a conventional way, was unknown and entirely neglected. The figure painters in vogue were better artists than those working in landscapes, but they too were rapidly sinking into conventionality and loss of power. Then, unexpectedly, a new revelation was given to the whole army of artists in France, and that in a haphazard way.

A French connoisseur came to England and there he purchased three works: "The Hay Wain," "An English Canal," and "A View near

the period very greatly admired, and his breezy and showery effects were often the subject of jokes amongst the Academicians and others. Fuseli, for example, was once seen to put up his umbrella as he entered the exhibition of the Academy. "What are you doing with your umbrella up?" asked a passing friend. "Oh," said Fuseli, "I am going to look at Mr. Constable's pictures." But the French dealer was fortunately unprejudiced, and he had the courage of his opinions—a very uncommon faculty in art circles—and so he bought Constable's three pictures and directed them to be forwarded to Paris.

The purchaser sent them to the Salon of 1824, and a revolution in French art was the result, while a gold medal was awarded to Constable. The principal picture, the "Hay Wain," is now fortunately in the National Gallery* in London, where all the world may see it. Looking at this picture with the knowledge of art we now have it does not appear startling or revolutionary in its method or style. It is only by an effort that the exact position in 1824 can be realised. Then the "brown tree" was always part of a landscape; there were usually ruins after the fashion of Claude, as witness the works of Wilson or the early works of Turner, and a certain conventional scheme of colour which could not be disregarded. To paint a landscape just as it could be seen was not thought of as a principle of art, although there are examples of naturalistic and realistic pictures even in landscape earlier than the time of Constable.

Somehow, artists had lost sight of nature in its true aspect, and the surprise of the French painters when they beheld "The Hay Wain" in the Salon was only equalled by their delight. All at once it seemed to flash through their minds that they had been groping in the darkness of studios or galleries, while outside, in the fields and hills, Nature was calling on them to be faithful to her and to themselves, and paint what she put before them.

The French are notoriously quick in grasping an artistic idea. Even in the few hours of the varnishing day, some artists, after having seen Constable's

* By the generosity of a true lover of art, Mr. Henry Vaughan.

paintings, changed the tone of their own works, and this one glimpse of truth set the whole art world of France in a blaze. Of course, the conventional and conservative artists and critics of Paris decried the movement, and pronounced it absurd that any other style but the traditional one could, or should, be pursued. Even now, after so many years, there exists a strong feeling in some quarters, that all the admiration accorded to Constable and to the painters of the Barbizon School is a mistake.

But the best men did not think so, and Constable had the satisfaction of knowing that his work effected the regeneration of the great landscape art of France. Thoré, who wrote under the name of G W. Burger, and who was banished from France for political reasons, was by far the most acute art critic of his day, and his writings on French, English, and Dutch pictures are still looked upon as authoritative. This writer affirms positively that Constable was the cause, in France, of the *point de départ* of the Barbizon School, although he thinks that Constable learned much from Gainsborough, to whom Thoré accords some of the honour of leading the new French school. But inasmuch as Gainsborough learned a great deal from the old Dutch School, we should only go back to the beginning of landscape art if we went farther, for, in doing so, we should have to include Claude Lorraine, as well as Hobbema, Van Goyen, Jan Both, and Cuyp, and we thus again find ourselves in France, where the art of Constable had really re-kindled, rather than created, a fire which had been smouldering after the great and sometimes overpowering art of Claude.

Taking it for granted that Constable learned the best of his art from nature, and some of it elsewhere—most probably from Gainsborough—we find that, in general, French artists and writers accept his pictures in the Salon of 1824 as the origin of that group known variously as the Barbizon School, the School of 1830, and the Romanticists.*

The first title has been adopted in this volume, even although it may not be geographically defensible in every case. We prefer it to "the Romanticists," which is confusing, besides being incorrect,* as well as to the other alternative, which is meaningless, and is still less accurate, in general, than the first.

Barbizon is a village on the western outskirts of the forest of Fontainebleau, thirty miles south-east from Paris, where Rousseau, Diaz, and Millet lived for many years, and where Corot and Daubigny sometimes visited. All these artists were of one group, and we have chosen the term in the belief that while it is not free from question, it is the best title that can be found for this school of artists.

The painters whose careers are set forth in this work followed on the lines of the study of nature suggested to them by Constable. They did this as a protest against the older and more conventional treatment of landscape in France, which had gone on repeating the traditions of painting until life and vigour had left French landscape painting. Everywhere except in England landscape had become nearly always subordinate to figure painting. It was lifeless, emotionless, dull, and uninteresting. Even in England it was neither understood nor loved as it now is. It was in fact looked upon more as an amusement for artists than as a method of serious artistic work.

As has lately been observed,† the art of landscape painting is the last of the pictorial arts to be appreciated by the multitude. Figures, animals, and ships are easily understood in a picture, not necessarily from an artistic point of view, but chiefly because of their story-telling power. The spectator is interested in what is represented before him, and may think little or nothing of the way in which it has been produced unless it be a pure imitation, where the canvas is made to look like marble or satin or some well-known material, and he is delighted, or not, just as he feels he comprehends what ought to be

* " Romanticism—the movement in art, that is to say, of which 1830 is accepted as the golden year had nothing special to do with romance."—W. E. Henley.

† See Mr. Hamerton's " Landscape."

the obvious meaning of the picture. With such works of mere literary or story-telling interest we have here very little to do. A picture whose sole attraction lies in its subject may scarcely be a work of art at all, for it is only when the picture is good in composition and harmony, and also well painted in the technical sense, that it becomes interesting and permanently enjoyable.

But with a landscape, there is, to the uncultured eye having no love of nature, nothing to look at, nothing immediately to grasp, nothing superficially to understand. It takes a certain elementary education in art or observation of nature to be interested in a landscape—one has to be a long way past the artistic equivalent of taking pleasure in popular airs before a glimmering can be possessed of the glories of the Mendelssohns and Mozarts of landscape painting.

The story of the lives of the painters, given in this volume, will doubtless lead the reader to the conclusion that the younger days of all such artists are mostly a veritable martyrdom. This is not necessarily a financial martyrdom—for that may be as much a gain as a loss—but a martyrdom of sympathetic and enthusiastic spirits who live through years of despondency, sometimes even of despair, before they are encouraged with the approval of their compeers, and admitted to be something more than mere dreamers. Such men know that their works are sincere and true and worthy of at least some attention, but they go on year after year, meeting with little sympathy or encouragement, and they may even die before their powers are generally acknowledged.

This seems inevitable with every artist who declines to submit to passing fashion, or to produce purely imitative art in a style already known. His way for years is difficult, dreary, and often monetarily unpleasant. But he goes on, resolved that his art shall conquer some day, even if it be after his death. Such men live now, in England, as well as in other parts of Europe; they wait to be welcomed, they weary to be understood, but they adhere to their standards, and perhaps it will be another generation who shall comprehend and gladly accept them.

But our present purpose is with those who have already passed through the fiery ordeal, and whose lives are now sought to be known by those who have come to admire their works.

The following pages relate the history of the painters' personal joys and sorrows, their trials and triumphs. They deal more with the inception, completion, and sale of their works, than with prolonged discussion of their merits. This is done designedly and not without a purpose. The pictures we still have with us, and every one can see and judge of their quality and power.

This volume seeks to render the admirers of Corot, Rousseau, Millet, Diaz, and Daubigny familiar with the facts of the lives of these artists, and also to help them to yet more thoroughly appreciate their pictures by possessing a knowledge of the painters' artistic career and experiences. And in thus assisting towards this judgment the writer has no apprehension as to the ultimate decision at which the world will arrive regarding the labours of the Barbizon School of Painters.

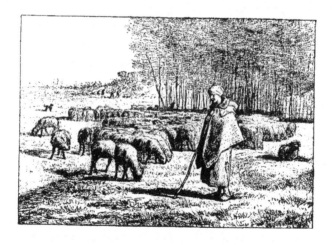

A Barbizon Shepherdess. After Millet.

JEAN BAPTISTE CAMILLE COROT.

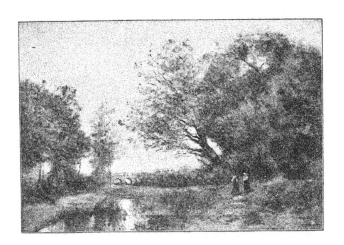

By the River. Corot From the picture in the collection of J S. Forbes, Esq

J. B. C. COROT:—INTRODUCTION.

I T is an interesting fact, and one that will bear some consideration, that three of the five great painters of the Barbizon School were born in the city of Paris—Corot, Rousseau, and Daubigny were all natives of the capital of France, and all their lives they were hovering around it. A celebrated landscape painter of England, J. M. W. Turner, was also a metropolitan child; and other similar instances could readily be found.

Although at the first thought it would seem natural and proper that a landscape painter should be born in the country, yet there can be no doubt that a person with artistic feelings is much more likely to appreciate the beauties of the country if brought up in a town, than one who, having been born amongst them, has early learned to accept these charms as a matter of course.

But when a boy is born in a city thoroughfare such as the Rue du Bac, as

B 2

Corot was, or the Rue d'Aboukir, near St. Eustache, as was Rousseau, or Maiden Lane, London, like Turner, then that child, having instincts of an artistic kind is greatly impressed and captivated when confronted with the grace and loveliness of nature. He has been so much accustomed to be satisfied with the artificial form and colour of the never too artistic city architecture, that the contrast of natural tints and lines in the country is a source of constantly increasing joy to him during his whole lifetime. For like reasons, those who are born and brought up in a city, or in a district admittedly uninteresting, have the very satisfactory consolation that they are likely to be more highly charmed with natural beauty, than are those who simply receive nature in its ever-changing scenes as a matter of ordinary fact, to be accepted without remark, and not as a gift to be admired and lovingly appreciated.

For Corot then to be born in Paris was no great loss, but, on the contrary, it was probably one of the reasons of his success. Moreover, Paris even in the Rue du Bac is never so unlovely as many English or American cities, for although one end of the Rue leads to the less attractive part of Paris, the other brings one to the River Seine, opposite the Tuileries. Moreover this is within a short distance of a sight of the great towers of Notre-Dame, the Pont Neuf, Tour St. Jacques, and other fine prospects of Paris which existed at the end of the last century. For it is to be borne in mind that Corot was a son of the eighteenth century, although he lived until the year 1875. He experienced all the usual difficulties of painters who help to inaugurate a change of artistic method, but he lived long enough to be the " Père Corot " of many young painters, and of others who acknowledged with fervour the exalted position the artist had attained during his career.

Corot has been chosen as the first in this series of the great landscape painters of France of the nineteenth century, because on the whole it is likely that his works will be more lastingly and widely appreciated than those of the others to be considered. For the time the works of Theodore Rousseau may be more commercially valuable, but this arises mainly because of their scarcity,

and also in part because they are more readily understood by the ordinary picture collector. Corot, to be properly appreciated, requires more knowledge; but as the world becomes older and wiser, this will gradually vanish as an objection to his work.

The personality of Corot is also more interesting than those of his colleagues. His aims were high, his life was pure, his achievements were great, and altogether Corot is one of the painters of the century about whom it is possible to become unusually enthusiastic. He was the artist-poet of the morning and of the evening, the delightful painter of twilight, of rosy dawn and dewy eve. He was the man of all others who could paint the atmosphere, the aqueous vapours of the rivers and lakes, and the mists of the valleys; and who could invest every landscape he produced with a romanticism and charm which are thoroughly wonderful. Corot was an artist who in all his many hundreds of pictures, has revealed beauties and disclosed exquisite poesies, which, when once understood and appreciated, never fail to charm and permanently please. He was the acknowledged leader of a great school of landscape painting, and for many years before his death he had a powerful influence over numerous painters who have become, or will yet become, famous. While for a long time Corot was known and acknowledged only by artists and a few connoisseurs, he is now one of the modern painters whose works are most popular in England, Scotland, and America, as well as in France.

At his death Corot left numerous early sketches which showed the patient training he had gone through in his youth. It is sometimes quite a revelation to those possessing little knowledge of painting, that Corot should have required any severe training to be able to produce his later works. His style is apparently so facile, there is, designedly, so little evidence of work in his pictures, that those who superficially examine them very often leap to the conclusion that they have been easy to execute. In reality, as every artist knows, nothing is farther from the truth. It is only because of the severe training a painter has gone through, that he can permit himself the liberty

to sweep his brush about the canvas without apparent effort. It will be observed that the words "apparent" and "apparently" have to be employed here, for it is certain that in the effort to produce these pictures great thought, and consideration—great "Art" in fact—must have been exercised. No tyro could produce fine landscapes, such as those by Corot—they are only to be painted after much experience has been gained and much practice gone through.

In order to work after Corot's manner the artist has to set about painting in a very different way from the realist. The realist may go to a little dell or to the edge of a forest and there paint every detail, beginning in the morning and toiling at the same picture all day. Corot on the contrary would go again and again to look at a landscape until he found the right time of day to paint it, and then he would return perhaps more than a dozen times at the hour he chose until he had imbibed the entire sentiment of the scene. Yet Corot was fully alive to the great qualities of the old Italian painters, and sometimes he used to contrast Raphael with himself;—the one who achieved so much and died at thirty-three, with the other who lingered at nearly eighty —and still felt he had accomplished comparatively so little.

Corot was, however, one of the few artists who have continued to improve as painters up to their latest years. Some of the old masters, so far as we can ascertain, were equally successful in maintaining their powers to the end. But as a rule the vast majority of painters reach a well-marked apogee, after which they as markedly and often rapidly decline. Corot's last pictures, however, were equal to those he painted in his strongest time, and are superior to all his earlier work. While his later pictures are sometimes less formal in composition, and less attentively carried out in details, they are richer and fuller of his great qualities of tone and colour as well as of noble poetic insight into the deeper and more subtle truths of nature.

Corot's pictures are not to be understood without study. If they give much to those who know how to appreciate them, so do they demand some

previous knowledge from the spectator. As has been aptly said by a French critic, "It is certain that Corot's merit will always exceed his reputation," for it requires a certain education before his pictures can be faithfully admired.

The principal lessons of Corot's life, and what it will be the endeavour of the succeeding pages to show, are his ardent and appreciative yet patient study of nature; his perseverance — amidst early disappointments, and neglect by the ordinary public which continued down to his later days—in adhering to the high standard of Art which he had set before him ; as well as the capacity shown in his work to appreciate, and express in the most power- ful poetic way, the most subtle, and beautiful, of Nature's varying effects.

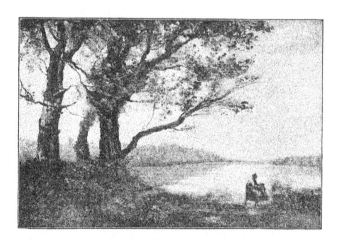

The Lake. By Corot. From the picture in the collection of J. S. Forbes, Esq.

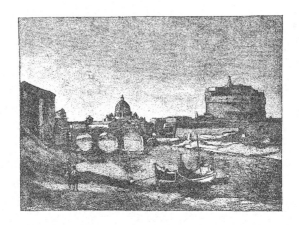

The Castle of St Angelo, Rome. By Corot. From the Louvre.

COROT :—CHAPTER I.

BIRTH; EDUCATION; BUSINESS; EARLY WORKS.

JEAN-BAPTISTE-CAMILLE COROT was born on the 26th July, 1796, in his father's house in the Rue du Bac, at the corner of the Quai d'Orsay, Paris. Corot's mother—for to a Frenchman this is the more important parent, and one whom he never fails to honour and believe in—was a native of Switzerland, who had in the Rue du Bac a milliner's and draper's business, " *une maison de commerce, de nouveautés, modes et rubans*," which for many years was in a flourishing condition. Corot's father was employed in Paris, being vaguely described as a clerk, and he was of the staid and strict order associated with the older bourgeois of France. He came from a family of vineyard cultivators of the Côte d'Or in the east of France. He followed the fashion of wearing a white cravat continually, and is described as inclined to be too austere. Corot always had the highest love and esteem for both

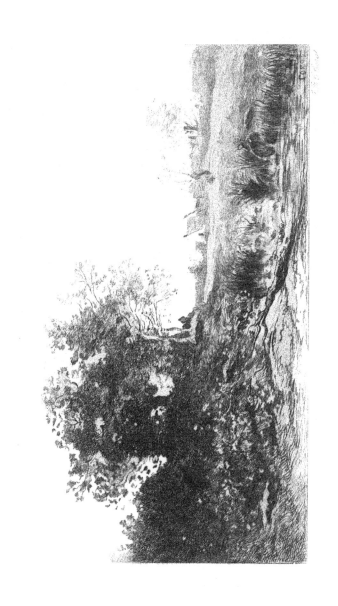

his parents, and in after life he repeatedly put himself to great personal sacrifice to follow the commands or wishes of his father.

Besides Camille Corot, as he was then always called, there were two daughters, one of whom died before reaching middle life, and the other lived to become Madame Sennegon. The latter sister, born in 1794, was devoted to her brother, and between them there always existed the most cherished affection. Although delicate in health she lived nearly as long as her brother, and their attachment during their lengthy lifetime was always delightful to behold.

Altogether Corot's family relations were of an affectionate and thoroughly happy character, and doubtless the amiable disposition he displayed so conspicuously when older was the result of the good and kind family training he received when a boy. Corot spoke jokingly in after years of his mother's business as a house " de frivolités et de fanfreluches qui nous ont donné l'aisance et même une petite fortune ; " and while he liked to gently laugh at the "fanfreluches" he was quite aware of the importance of the "petite fortune" which flowed so steadily from them. Not that he ever thought very much of money for himself, but he knew the power of gold well, and used it often as a reliever of the necessities of others. The possession of this establishment placed Corot's parents above the necessity of requiring their only son to commence work before he was properly educated.

It does not appear that Corot's artistic genius was in any way hereditary, but as we know little of his ancestors there is no precise ground to go upon. His grandfather, who was born in the village of Bourgogne, Mussy-la-Fosse, Côte d'Or, was one of the famous " perruquier-barbiers " of Paris before the Revolution.*

Although fairly well to do, Corot *père* was quite alive to a good bargain, and having a chance to send his son to a school at half the usual terms he

* A curious reflection may be made on this circumstance when the parentage of the contemporary English landscape painter Turner is considered.

embraced the opportunity; so that when Camille was ten years old he left home for the Lycée at Rouen. There he remained for seven years, and there he received his entire education. That this was sufficient to carry him comfortably through his sphere in life there can be no doubt. Besides the ordinary routine branches of education which he mastered, during these seven years he received artistic impressions which he never forgot. He was permitted to walk out on certain occasions with a friend of his father who lived at Rouen. This friend was a middle-aged, grave man, who preferred walking in solitary places—whose great delight was to stroll out in the evenings at twilight in the environs of the city.

Corot was always peculiarly obedient to his father, and although he felt the fire of the artist within him, he consented on leaving school, yet not without some persuasion truly, to enter the drapery establishment of a M. Delalaine, in the Rue St. Honoré, Paris. Soon after he went to another house in the Rue Richelieu. Here he had more leisure and frequently made sketches behind the counter where he was stationed. His employer discovered this bent and told Corot's father that he ought to make the youth an artist, for it was doubtful if he would ever become a good business man. But Corot's father had set his mind on his only son becoming a "marchand de rubans," or at least learning some similar business in which he might make money, and the young man with characteristic dutifulness remained a "marchand de drap" until he was twenty-four years of age.

Corot was considered far too conscientious as a man of business. It is related that one day he told his employer he had done some good affair, for he had sold a large quantity of a certain new kind of cloth, just introduced. "Ah," said the merchant, "that is all very well, but I want my assistants to sell the old stock and not the new," and he hinted very broadly that Corot would never be a skilful merchant.

Corot had for a friend in youth Achille Etna Michallon, son of the sculptor Claude Michallon. This young man had a real talent for art, and it is said

that it was from seeing him at work that Corot, the young cloth merchant, became imbued in his turn with a passion for the arts. When old, the master often told how he made his first attempt in painting, how he escaped to the country every holiday, and how in his rare times of leisure he painted the perspective of the roof and chimneys which he saw from his attic.*

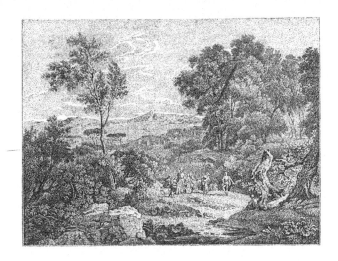

Frascati. By Michallon

How Corot at last obtained his father's permission to leave business is told in different ways, but Dumesnil's is the fullest, and as it came from the painter's lips to the writer, it may be accepted as the best.†

The unwilling draper when twenty-six years of age summoned up courage to again ask his father's permission to become a painter. It may be mentioned *en passant* that it is said to have been his custom to do this yearly on his father's birthday, but there is something of tradition only in this statement.

* " The aspect over the houses in Paris is at all times picturesque."—Ruskin.
† " Souvenirs Intimes," a most interesting little book.

The old man only understood business which led to commercial success and the making of money, and he was greatly displeased with his son's repeated demand. However, like the importunate widow, Corot the younger by his pertinacity and much asking prevailed on his father to give a grudging consent. The father agreed to grant the necessary authority on certain conditions. He said, "The dowries of your sisters have been duly allotted, and very soon I had hoped to put you into a good establishment, for you are now of an age to be the head of a business house; but seeing that you decline to continue to be a merchant and prefer to be a painter I warn you that during my life you will not have any of my capital at your disposal. I will give you an allowance of £60 a year, but do not count on having anything else, and see if you can pull through with that." Corot was quite pleased. " Je vous remercie," said he, " that is all I need, and you make me quite happy in doing this." Corot's father had hoped to reduce his son to obedience by letting him starve a little, not counting on the possibility of his being able to live on this not very large yearly sum.

As soon as Corot had obtained permission from his father to become an artist he began work close to the parental house; his first study being made from the low bank of the Seine under the Quay near the Pont Royal, looking towards old Paris.

Corot kept this sketch in his studio all his life, and nothing gave him greater pleasure than to tell the story of this "*première étude.*" One con. versation which took place in 1858 is recorded by Dumesnil. "At the time," says the narrator, "when he made this, the young girls who worked in his mother's house were curious to see Monsieur Camille in his new vocation of artist and they ran out from the work-room across the quay to look at him painting. One of them, Mdlle. Rose, ran over more often than her com. panions. "She is still alive," said Corot in 1858, "and has never been married, and even yet she occasionally pays me a visit. She was here only last week. Ah! mes amis," he would say, "what changes have taken place

since then, and what grave reflections they give rise to! My picture has not altered, it still shows the hour and the season when I made it, but Mdlle. Rose and I, what are we now?"

The sketch is described as being of a grey harmonious tone, and contains even then the germ of several of the best qualities of the accomplished artist.

Michallon, his early friend, was the first teacher Corot had, if indeed their intimacy can be elevated to the position of master and pupil. It was perhaps

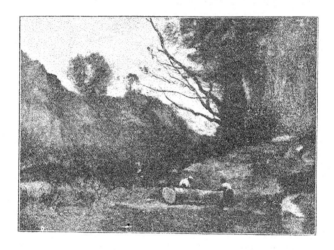

The Ravine. From the Picture by Corot in the Collection of Sir John Day

more the relation of a friend of almost the same age, but who, having more experience, guided the path of a young associate. In any case the relation, whatever it may be called, did not last beyond a few months, for Michallon died in 1822, the year when Corot left business. That Michallon had consider-

Louis-Philippe at the close of the Salon of 1822 for £80. Michallon's teaching may be summed up in his words, "Put yourself before nature, try to render her exactly, paint that which you see and translate the impression you receive." He was to Corot very much what Girton was to Turner, and had he lived as long as Corot it is likely that he would have been his most formidable rival. In any case he was a fine classic painter of the Claude Lorraine school, although his last pictures, painted when he was between twenty-four and twenty-five, show signs of breaking away from the more conventional part of this style.

Michallon loved the Forest of Fontainebleau; and although we do not know if he lived at Barbizon, it is quite certain that he has some title to be called a pioneer of the school now named after that village.

After the few months spent with Michallon, Corot entered the studio of Victor Bertin, a painter of the purely classic school, one who "sketched well but finished badly," and in his pictures "put everything in order with a frigidity that was somewhat repellent." From him and from Aligny and Edward Bertin, Corot learned his early qualities of grandeur of composition, precision in drawing and solidity in painting, and so far these teachers were profitable. But for what Corot is now most admired, namely, his poesy, his exquisite tonality, his tender qualities of colour and purity of atmosphere, these teachers gave no help.

Towards the latter part of the period covered in this chapter, Corot painted a great deal near Ville d'Avray, about four miles from Paris, where his father had purchased a house in 1817; and in which, with his sister, he lived in summer for many years. This house was situated near a small lake, since removed; and often, when all the family were asleep, Corot would remain leaning out of the window of his room, absorbed in contemplation of the sky, the water and the trees. Solitude was there complete, no sound broke in upon his thoughts, and the future painter drank his fill of the atmospheric effects so skilfully transferred to his works. Being near the lake, the air

was charged with what might be called a visible moisture which floated lightly here and there in the semi-darkness of the night. There is no doubt that these influences greatly helped to make the Corot of future years. In fact, Corot himself considered that his taste for the mystery of nature which so pervaded his later works was chiefly acquired in these early contemplations; and he frequently referred to the impressions of these times, which seemed to have been engraved into his very soul. The method, indeed, was characteristic of Corot, for in after life he was much accustomed to sit down and make careful mental notes, leaving the actual realisation of them to be carried out in the studio.

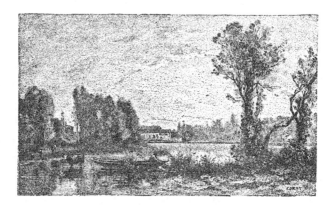

The Pond at Ville d'Avray: Corot's house seen in the centre
From a Lithograph after Corot.

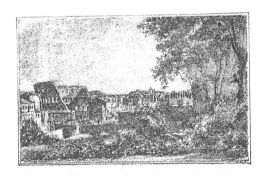

The Coliseum. Painted by Corot in 1825

COROT:—CHAPTER II.

A JOURNEY to Italy in the early part of the century was an undertaking of much consequence, but it was deemed absolutely necessary for the completion of the education of an artist. Many, of course, were forced to remain at home because of the great expense involved in the journey, and for the assistance of poor painters the chief prize of the French School of Fine Art was the Prix de Rome. This is still the highest point of achieve-ment a young French artist can attain, but curiously enough the gainers of it who have lived to be famous are in the minority. Most of the winners of the prize are superficially excellent painters, who have achieved early in life wonderful dexterity with their brush. But the painters who seem most likely to live have not matured early enough to gain the prize: not that the age for competition is limited, but that few painters over thirty care to compete. It

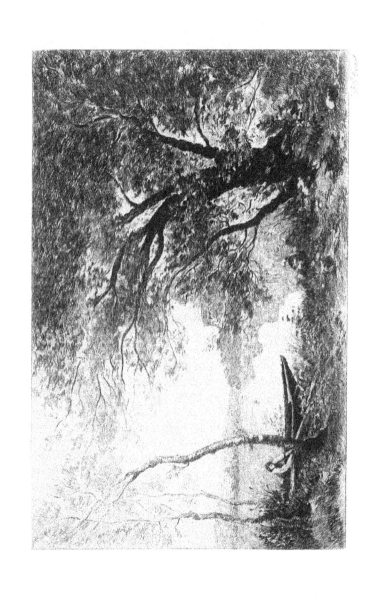

is a fact that not one of the great artists treated in this book gained the prize, and so far as we know only one ever seriously thought about trying for it. This was J. F. Millet, who was only prevented from competing by what he considered the unjust treatment of Delaroche, his nominal master at the time.

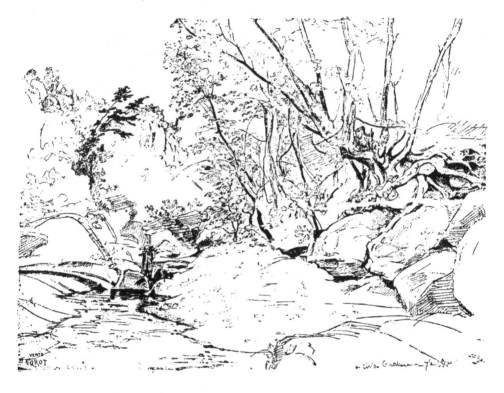

Sketch at Civita Castellana. Corot, Sept , 1827. From Jouast's "Peintres et Sculpteurs Contemporains."

Corot, however, had not to seek in this way for the sinews of war to take him on the artistic grand tour. His father's allowance of £5 a month, although not very much, was sufficient to help him on the way, and it is understood, although it is not so stated in so many words, that in 1825, when in his

D

twenty-ninth year, he went by sea from Marseilles to Naples. In any case he arrived in Rome at a time when many painters afterwards famous were pursuing their studies. He seems to have speedily found himself at home, and he remained long enough to get a thorough training in what was then considered essential for a painter.

But the artists whom he met did not treat Corot seriously. They knew him only as a friendly fellow who could sing a good song; and as he was older than most men in commencing artistic work they looked on him more as an amateur, or at least as the son of a well-to-do merchant who did not need to paint for his living unless he liked. He was a cheerful companion whom they loved. It was not until later that he was recognised as an artist whom they should respect. Aligny was the first who welcomed him as a brother artist. Corot was painting a study of the Coliseum, the small picture now in the Louvre.* While Corot was painting this study in Rome Aligny passed by, and looking over the painter's shoulder saw at a glance the artistic worth of the picture. Examining it carefully for some time he said at length that he was greatly pleased with it, and found in it some of the qualities of the first rank. He warmly congratulated Corot; but as the young man thought his friend was joking, and seeking to make sport of him to the others, he was rather inclined to resent Aligny's little speech, though he submitted at the time without remark. The same evening, however, Aligny took a favourable moment to speak of Corot's work before the other artists. He praised it highly, giving substantial reasons for his opinions, and concluded by the remarkable assertion that he saw so much real talent in the young man's painting that, although at present he was still undeveloped, the time would probably come when he would be admitted to be the greatest of them all. After this, of course, everything was changed for Corot. Aligny was looked on as a severe critic, and his praises were all the more valuable.

* This picture, which was left by the artist to the French nation, is painted on panel 13½ × 9 inches, and is dated December, 1825.

Corot was, therefore, promptly admitted as an artist and fellow-worker to the innermost society of those at Rome.*

Aligny, who thus early befriended Corot, and who was the first to give decided encouragement to him, was a native of Chaumes Nievre, where he was born on February 6th, 1798, so that he was two years younger than Corot. Aligny first exhibited in the Salon in 1827, and many of his works were shown there periodically until his death at Lyons in 1871. There are several examples of his work in the Luxembourg and in various French museums. In the church of St. Etienne du Mont, Paris, there are two landscapes by him, and one of his best landscape views, taken at Amalfi, was in 1889 badly hung in the Palace of Fontainebleau. He was, for many years, the chief of the École des Beaux-Arts at Lyons. Corot never forgot the kindness of Aligny, and he showed his esteem for him in various affectionate ways.

In the two studies by Corot, " The Coliseum " and " The Forum,"† now in the Louvre, as will be seen from our illustrations at the beginning and end of this chapter, the work is altogether different from that usually associated with Corot's name ; it is hard in outline and "tight" in technique. It is in every way opposed to the style adopted by the master in later years. But it will be asked—and difficult it is to answer—would Corot have been as able to paint the pictures which have made him famous, if he had not thoroughly gone through the training manifested in these early works? Some of our younger artists are starting with the idea that the power to finish highly will come with experience, but that vagueness of anatomy and looseness of outline are sufficient to begin an artistic career. Corot's path, designedly or otherwise, led him first to draw carefully and finish minutely, and in this he is accompanied as well by the Raphael of the old masters, as the Turner or Maris of the new. When he saw Constable's pictures at the Salon in 1824, he found what landscape art really was, and he gradually

* Dumesnil's " Souvenirs Intimes." † Dated March, 1826.

acquired the tender subtlety in his painting which is now so greatly admired.

Corot remained in Rome for about two years, returning to Paris in 1827, where he took rooms in 39, Rue Neuve des Petits Champs. He made a special friend of Edward Bertin, as well as of his champion Aligny. This Bertin was afterwards director of the *Journal des Débats*, and Corot occasionally spoke of the keen insight he had for a good subject for painting. When the three went out together to sketch, as they sometimes did, it was always Bertin who found his place first, and it was always the best place in the neighbourhood. Corot also arranged with E. Bertin to go to Rome with him in 1834, but this was found impossible because of Corot having unexpectedly to return to Paris.

The Salon of 1827 contained two pictures by Corot, the first he exhibited there, one of them being the Campagna and the other a view taken at Narni. These were hung close to examples of the work of Constable and Bonington, the two English artists who were then receiving so much attention. In 1824 Constable had received the gold medal at the Salon for his picture, "The Hay Wain," now in the English National Gallery. Bonington was also a gold medallist of the same year. He was, however, as much a French painter as an English, because from the age of fifteen he studied at the École des Beaux-Arts in Paris.

Constable, as we have insisted on in our General Introduction, was the true origin of the revolution of art in France at this period. Delacroix, the finest French painter who was in full power at the time, felt the influence of Constable so strongly that he repainted in four days his great picture "Scio" in the same Salon.

When Corot left Italy for the first time he returned by Limousin, the Auvergne, the Dauphiné, the Morvan, and Brittany. At the sale of his work after his death there was a sketch of Civita Castallana, dated September, 1827, which was in the Retrospective Collection of 1889, and which we reproduce

on page 17. His elementary style of painting ends with his return to France in 1827. Up to this time he painted hard outlines carefully made out and precisely finished, the little Louvre pictures being favourable examples of this manner. Now he was to develop more ambition, the size of his canvases was to increase, his style was to become more his own, although he had yet many years of hard work to accomplish before he reached his best period.

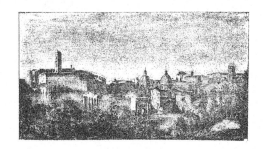

The Forum, Rome.　Painted by Corot in 1826.

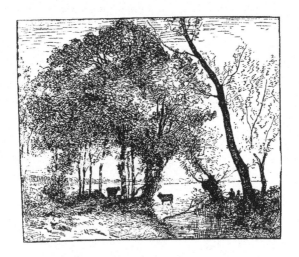

Sketch of Corot's Picture, "The Lake"

COROT :—CHAPTER III.

THIRD JOURNEY TO ITALY; FIRST PATRONS; FONTAINEBLEAU; FRIENDS, 1828—1847

THE exhibition of pictures usually called the Salon did not take place in the years 1828—29—30, but in the collection opened in 1831 we find that Corot had been hard at work for some time before. His subjects then shown were "Vue de Furia, on the Island of Ischia," "Convent on the Borders of the Adriatic" (showing he had visited the eastern side of the peninsula during his first voyage to Italy, a circumstance that has been disputed), "La Cervara," and finally, and most important of all, a view in the Forest of Fontainebleau.

Very early in his career Corot discovered the beauties of the grand old

forest so near to Paris. He appears to have executed many studies before either Rousseau, or Millet, or Diaz went there. His friend Michallon, whose love of Fontainebleau has already been mentioned, had probably spoken of the fine subjects to be obtained in the glades, and it is very likely that in the brief period during which they worked together, in 1822, they went occasionally to Fontainebleau. In any case Corot was fascinated with the forest, for in the Salon of 1833 he again exhibited a Fontainebleau subject. In 1834 he would appear to have become somewhat ashamed of repeating the title, so he called one of his contributions that year simply " A Forest," but doubtless it was from the same place. That year's exhibition also contained a sea-piece and a " Souvenir d'Italie," a subject he often liked to paint in after years, although his manner of treatment varied greatly in each picture.

The painting he sent to the Salon of 1833 gained him a medal of the second class. This "Vue de la Forêt de Fontainebleau" showed that he then had begun to feel that his elementary classical style was not to be the goal of his final aspirations in art, and that he must commence to apply to his pictures the actual results of his really excellent system of study. A new period of his art had indeed begun in earnest. He felt it to be true, more and more every day, that outlines well defined and strong exist mostly in the imagination, that sentiment must depart where hardness of form steps in, and that, after all, poetry and feeling were of more value than imitative correctness of outline. The reward of the medal was, at this time, a great encouragement to him, and even his father began to think that after all perhaps Camille had not done wrong in his choice of a profession.

In 1834, he went to Italy on another visit. But, as we shall presently see, he did not get very far into the country. This time he went by land, and painted several pictures in the Italian Tyrol. Tuscany, also, he visited, and Venice, but he does not seem to have got to Rome, although to reach that capital was, of course, the purpose of his journey. It is likely that it was during this voyage he painted a large view of the Grand Canal, which,

although one of his earlier pictures, was not painted in the very "tight" method of the little Roman studies in the Louvre. He also collected a number of sketches which were afterwards useful, and several of his pictures in succeeding years were the fruits of this curtailed voyage.

While Corot was in Venice, he received a letter from his father telling him that he missed him greatly, and that he hoped to have him back again in Paris. Corot was greatly embarrassed, and did not know what to do. He was pledged to meet Edward Bertin at Florence to travel with him to Rome, and he looked forward to this with all the eagerness excited by keen friendship and prospects of much enjoyment. Yet he had ever been obedient to his parent's wish, and the tone of the letter seemed to imply that his father earnestly and seriously wished him to return.

Meeting Leopold Robert, the painter, in St. Mark's Square, when he was yet undecided what to do, Corot asked him, as an older man as well as an artist, what he should decide. Robert, after reading the letter, recommended Corot strongly to return. "Your parents are old, do not worry them by going against their wishes." The advice went with Corot's own better feelings. He abandoned his journey, and returned to Paris the same year. Such an action could have been performed only by as dutiful a son as Corot.

On his return, he took up his studio at 15, Quai Voltaire, which remained his Paris address for the next fourteen years. He sent to the Salon of 1835 a classic "Hagar in the Wilderness," together with a view at Riva, in the Italian Tyrol. He now became a constant exhibitor at the Salon, and from this time until his death, every exhibition there had contributions from his brush, at least one and sometimes three or four, and even as many as nine in 1848, and seven in 1857. His work was beginning to be recognised, although it was yet to be long before he was admitted to be a master.

In 1831, he had been, for the first time, mentioned by the critics. Not that this is much of an honour, but it tells something of the growing reputation of the artist. A. Jal, who was the first to write about Corot, said,

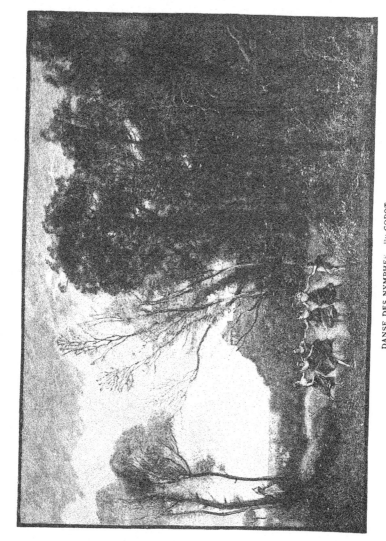

DANSE DES NYMPHES. By COROT

From the picture in the collection of I. G. ARTHUR, Esq.

"MM. Aligny, Corot, and E. Bertin who otherwise are distinguished painters, seeking to employ art in the way of Giotto, fail in their mission as colourists. They make their paintings flat and without elasticity (*sans ressort*"). This, it will be remarked, is very faint praise indeed. Again, in 1834, in his "Causeries du Louvre," Jal says, " MM. Bertin, Aligny, and Corot have been for their particular walk in art what Ingres has been for the grand

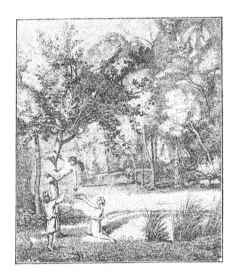

" Morning." From a lithograph by Français, after Corot, in the Album du Salon, 1842

style ; they have made the picturesque revolutionaries ashamed of their excursions, and have shown them that nothing can be made with effects without form." This is a criticism now somewhat obscure and difficult to understand.

In the "Album du Salon de 1842," there is a lithograph by Français, reproduced above, after one of Corot's pictures in the semi-classic style which dates from this period. In an orchard beside high rocks seen in the back-

ground three children gather apples, one boy, entirely nude, is half-way up the tree and stoops down to hand some apples to the girls below.

The *Revue des Deux Mondes* noticed him in 1836 by a few, very few, words of encouragement written by Alfred de Musset.* Corot was so pleased with these words that he at once set about painting a picture, "The Star of the Evening," now in the Walters Collection, Baltimore, which was suggested to him by a well-known verse written by the poet. He was now forty years of age, but not yet in the full strength of his painting powers. He had been singularly tardy in his development, and his pictures met with no commercial success. He could never have existed if he had not had the money allowed him by his father, for even a bachelor, as he was, could not live without selling some of his works. In these days of hot pursuit of popularity and money, it is a lesson to think of Corot's admirable patience and pertinacity in pursuing his Art. At forty, many men have made a fortune and are thinking of retiring, but Corot at forty could only look forward with hope that he would become better understood and appreciated as the years went by.

It was about 1841 that Corot's first purchaser appeared. The incident is related by Emile Blavet. This client came in the form of a friend, who, without saying very much, wanted to carry off a newly finished picture, and laid down 250 francs (£10) on the table to pay for it. Corot who was, of course, quite unaccustomed to receive money, thought that this was a delicate piece of generosity on the part of his visitor, and wanted to decline the payment. It was necessary for his friend to swear to him in quite a solemn way that he was the intermediary of a real "amateur" who wanted to purchase one of his pictures. The artist was much concerned at this unexpected good fortune and actually sought to add, for the same payment, two or three little canvases to the one selected for his first patron.

All the same, Corot wearied sadly for a little encouragement from the

* "Corot dont la 'Campagne de Rome' a des admirateurs," were the words.

artistic public. Karl Girardet, one of his friends at this time and a well-known painter, used to tell an anecdote bearing on the point. Corot had a picture shown at the shop of some dealer with whom he wanted to stand well. " Go," he said to Girardet in a joke, " there is some money, go and buy my picture," the idea being that by this means he might hope to create a little demand for his works.*

In 1843 Corot took his third and last journey to Italy, going by way of Marseilles. Ever since his enforced return, nine years before, he had been dreaming of Rome and the other Italian cities and their many treasures. But he now remained in Italy only five or six months, and he never seems to have sought to go back again. In the year following he sent a Campagna landscape to the Salon, as well as some semi-biblical subjects which at this time interested him.

He painted two very large panels for the Baptismal Chapel in the church of St. Nicholas du Chardonnet, in Paris. They are very much in the style employed by Aligny, and doubtless it was with the recollection of Aligny's work in his mind that he began them. One represents the baptism of the Infant Christ, and is a canvas well filled with foliage, with a river and landscape and a city. The figures are by far the most important part of the work, and number nine in all, the full size of life, well drawn, well grouped, and telling their story well. The other composition is " Christ healing the Blind," which is equally important and imposing. These are signed simply, " C. Corot," and reveal the fact that he could have found some success as a figure painter. In any case these and others of the same character dispose once and for all of the unjust statements of ignorant people that Corot painted indefinite landscapes because he was unable to draw. This may be partly true of some of his imitators; but Corot was as well able to draw figures firmly and clearly, as he was to paint the mists of the morning landscape or the dews of the evening twilight.

* Anecdote related in 1848 by Karl Girardet to G. Loppé, painter of Alpine scenery.

In 1846 Corot sent another " Forest of Fontainebleau " to the Salon, and the same year, his fiftieth, he was appointed a Chevalier of the Legion of Honour. When the announcement of this appointment was made, his people

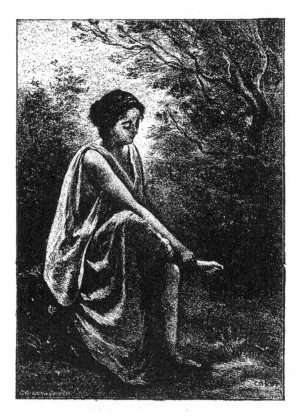

at home began at length to understand that Corot was really a great man. For the previous twenty-five years they had been inclined to think rather better of him, but when honour began to flow to him and he was spoken of as the centre of a new school of painting, his relatives saw they had been mistaken. His father, who was the very last to give in, was heard to say, "I think it will be necessary to give a little more money to Camille," while, as Silvestre points out,

A Wood Nymph. From a lithograph after Corot.

Camille Corot was by this time a grey-haired man.

Thoré, a critic of much acuteness, spoke repeatedly of Corot in early times. In 1844 he made some observations on Corot's " Paysage avec figures," which showed how thoroughly he appreciated the painter's work.

In 1847 he spoke thus of a landscape:—" Stop and examine a little picture. It has at first the air of a confused sketch, but presently you feel the air gentle and almost motionless. You plunge into the diaphanous mist which floats over the river and which loses itself far far away in the greenish *nuances* of the sky at the horizon. You hear the nearly imperceptible noises of this quiet piece of nature, almost the shivering of the leaves or the motion of a fish on the top of the water. You find all the sentiment of an evening when, seated alone at

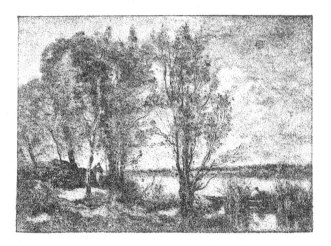

By the Side of the Water. From a lithograph after Corot

the side of a lake, after a wearisome day, you have waited until the night has lit up the first great stars of evening. If the chief purpose of painting is to communicate to others the impressions felt by an artist before nature, the landscape of Corot fulfils the conditions of art." This was really a remarkable and prophetic criticism and might have been written twenty years later, when Corot's pictures had made their full force known to the art world.

The picture described by Thoré, which was simply called "Landscape," made Corot many friends, and showed that his style was changing for the second time, so that the approach of his third period could be foreseen. One of the best friends the "Landscape" brought him was Constant Dutilleux, who resolved to buy this picture even though he himself was only a poor artist hindered with heavy family responsibilities. The story is told in Chesneau's "Peintres Romantiques" (1880). Dutilleux, going round the Salon of 1847, was arrested by this wonderfully painted Landscape, and he was so profoundly struck with its beauty that he purchased it at great personal sacrifice. Although a complete stranger to Corot, he wrote to him, and in an unusually enthusiastic way. This letter by chance fell into the hands of Corot's father, and it completed his faith in his son's artistic faculty. Corot's father had even then, when his son was over fifty, some lingering doubt as to whether or no his son's lifetime was being practically lost. But when he found a sensible man like Dutilleux, who himself was forty at the time, writing in such a flattering manner, he at last finally gave way, and became entirely reconciled to his son's long-chosen path.

Begun in such a way the friendship between Corot and Dutilleux never cooled, but continued fervent until Dutilleux' death in 1865. To visit Dutilleux in the north of France Corot sometimes went to Arras, for the provincial painter was always extremely anxious to have the one he called his master to visit him in order that they might paint in company. Several times also Dutilleux visited Corot at his father's house at the Ville d'Avray, and they went to Fontainebleau forest on painting excursions. Later, they went together to Holland to see the famous Dutch collections, and it was then that he probably sold the small picture in the Van Gogh collection of which we give an illustration opposite page 32. One letter of Corot to Dutilleux dated 14th January, 1849, is particularly worth perusing, as it shows the quiet simplicity of Corot's life.

"Paris, 14th January, 1849.—Your letter has given me great pleasure. I

thank you very much for repeating your invitation to me to visit you, and can assure you that though it be but for a few days, it will be a fête to me to make this little journey when the bright days return. I communicated your letter to my mother, who, after what you say, cannot fail to give me the permission to come to you. We can then admire together for a few days that nature so

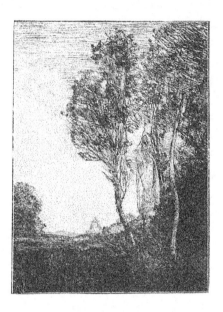

Souvenir d'Italie. Reduction of an Original Etching by Corot, 1865.

good, since she presents herself so beautiful and ravishing to everyone who searches after her."

Chesneau remarks also, and it is an observation only a Frenchman would think it necessary to make : " That which touched Corot above all was that **Dutilleux** gathered from his pictures his integrity and uprightness, and opened his home to him without restriction." Corot himself was pleased to tell of this confidence and is said to have used the words : " Without knowing

me, without having ever seen me, this dear friend, who had several daughters, judged by my pictures that I was a virtuous man, and put his house entirely at my disposition."

Equal with his love for Corot, was Dutilleux' admiration for Delacroix and it is interesting to read his comparison between the two. " I do not know whether Corot is superior to Delacroix. Corot is the father of modern landscape. There is not one landscapist, whether he knows it or not, but what proceeds from him, but what imitates him. I have never seen a picture of Corot's that was not beautiful, a line which was not something." "Among modern painters," he added, "Corot is the one who, in colour as in other things, has the most points analogous to Rembrandt. The shades are golden with one and grey with the other, but both use the same means to procure the light and show off a tone. In appearances their processes seem contrary, but the wished-for result is the same. In a portrait by Rembrandt all the details disappear in the shadow to force the gaze upon a unique point, a point lingered over and retouched, often the eyes. Corot on the contrary sacrifices the details which are in the light, extremities of trees, etc., and always brings you back to the place which he has decided shall attract the eye of the spectator."

Dutilleux was one of the first of the great enthusiasts who delighted in Corot's works, and he showed his admiration by purchasing, as we have seen, a fine example of his work. At another place Dutilleux gives the end of a long conversation he had had with Delacroix. At first he had feared that perhaps Delacroix would not care for his adored Corot, and he said, " ' I willingly leave you all the landscapists but Corot ! ' 'Oh, that one,' exclaimed Delacroix, strangely moved (he had these ways sometimes), 'he is not a simple landscapist—he is a painter, a true painter ; he is a rare and exceptional genius.' I felt as though delivered of a great load ; so great was my admiration of Corot, that it would have hurt me to find myself disagreeing with Delacroix and on this point alone perhaps." This comparison and criticism were made after Corot had become better known, but before the time when his fame reached its zenith.

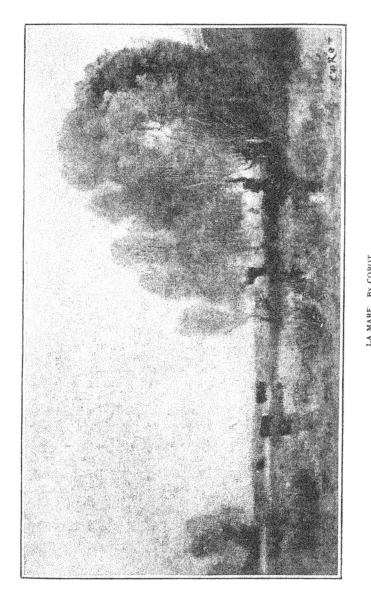

LA MARE BY COROT
From the V Giou collection.

Up to 1847 Corot was still hardly known outside his own little circle. Even although he had been made an officer of the Legion of Honour and had been medalled he could scarcely find buyers for his pictures. He did not grumble, however, although he was not always gay, but he went on as happily as possible, wondering, doubtless, if the time would come when his pictures would be accepted as works of art without discussion and without dispraise.

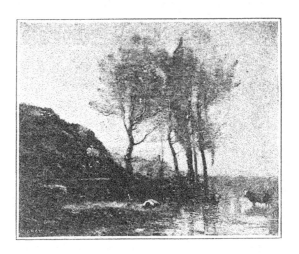

Landscape by Corot. From the Picture in the possession of C W Lea, Esq.

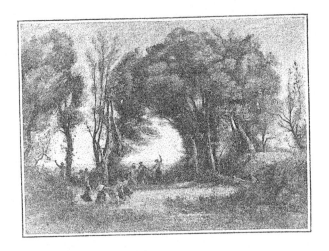

Une Matinee. Painted by Corot in 1850. Now in the Louvre.

COROT:—CHAPTER IV.

REVOLUTION; THE SALON; FAINT PRAISE; PATRONS; PICTURES, 1841—1867.

THE Revolution in politics was naturally followed by an alteration in the arrangement of art exhibitions and the objects for which pictures were required, such as the apotheosis of the Republic, and kindred subjects, so that the change almost amounted to a revolution in artistic matters also. Up to this time the annual Salon was managed by the Academy of France, and the members of this institution, whether artists or not, were the sole judges as to what pictures should be accepted and hung. With an amateur jury like this misunderstandings were sure to arise, and many of the best artists declined to submit their works to its judgment. Rousseau, who had with many others been steadily rejected for some time, had not sent pictures for some years. But the Revolution of February brought a change, and within five days it was already arranged that the whole of artistic France should unite, and select a jury of artists, who should be the judges in the choice and

classification of the works sent in. This is much the same arrangement as that which at present exists and which up to 1889 was found to work fairly well, although by no means without friction

The artists accordingly assembled and seventeen painters were chosen as the picture jury, amongst them being Corot, Rousseau, Delacroix, Meissonier, and Jules Dupré, with Paul Delaroche for president of the jury. Corot received three hundred and fifty-three votes and stood highest of the landscape painters. The Salon, which was at that time held in the Louvre, opened on March 18th, 1848, and in it were nine pictures by Corot. This collection, which comprised works by so many painters almost totally unknown to the general public, was a real revelation, and raised a storm of discussion which resulted in great good for the Barbizon School of painters, although they had at the same time to stand the brunt of much frivolous and absurd criticism. Corot's large number of contributions included a "Souvenir d'Italie" as well as a "Ville d'Avray," two evening effects as well as two morning effects, and a forest scene, which were all well received; and he was awarded a medal of the first class. But Corot was never a favourite with the officials of the Bureau des Beaux-Arts; and he never received any commission for pictures, as did many inferior but more easily understood artists.

Corot was also very little of a politician, and in fact he was too much wrapped up in his art to think of anything else. He was a republican of a moderate type, but not a communist. He always dreaded the extreme party, and none the less when Courbet was one of its leaders in 1871.

It is said that during the 1848 Revolution Corot remained in his studio quietly working. After there had been three days' firing he came down from his room and said to the concierge, "Ah, it appears that they are not content." What the concierge replied Corot did not hear, for in a few minutes he had mounted his stair again, and had seated himself before his easel.

Yet he was sufficiently well known to many people of the lower orders for

them to respect his works, and the following anecdote is vouched for as being true. The Duke of Orleans, on the recommendation of Ary Scheffer, had bought some of Corot's pictures, and they were hung in the Tuileries. On the 24th February, when the people surrounded the Tuileries, the doors of the Duke's Cabinet were forced open by the mob. Then a young painter, Gustave Frèmy, having perceived the pictures of Corot which decorated the walls, sprang before the intruders and barred their passage, calling out, "Respect to Art, these are Corot's." The mob contented itself with admiring them and passed on.

But although the artist did not care to mix himself up with political strife, he took an intelligent interest in affairs going on around him. When Haussman, the Prefect of the Seine under Napoleon III., was changing Paris, Corot occasionally went up to the Buttes Chaumont to see the work of one of his own admirers and personal friend, Alphaud, who was a landscape gardener employed on the improvement. Corot one day said to Alphaud, when walking amongst the work then going on, "But you know you are killing landscape work on canvas! How can you expect the painter who has only his palette to contend against artists who make terraces, prepare gardens, and fix points of view for people to see their beauties. Why, you manufacture nature." "Oh, Maitre," replied Alphaud, "these are your pictures that I try to copy!" A rather unexpected reply, but one that could only be pleasing to the painter, however embarrassing it might be to have his landscapes repeated in a garden actually under construction.

Although at this time Corot was beginning to be appreciated by the more enlightened connoisseurs, he was still far from being liked, or even understood, by the ordinary visitors to exhibitions. For example, in the Salon of 1850-51, the last held in the Louvre, his picture, "Une Matinée," was badly hung in the entrance hall and no one seemed to think of looking at it. Corot would go, as artists sometimes do, to watch or overhear the effect of this work on the public, but no one even cast a glance at it. So he thought he would try the

experiment of standing looking at it himself, thinking to induce someone else to examine it too. This result came about very soon, for a couple went up to the picture, and the young man said, "That is not bad; it seems to me that there is something in that." But the young lady took hold of his arm and said, "It is frightful, let us get on!" And Corot said to himself, "Are you content to have wished to hear the opinion of the public? So much the worse for you." And still, as Dumesnil relates, this same picture, although it remained unsold at the Salon, and lay for many years in the painter's studio, and though it only fetched frs. 700 (£28), when it did find a buyer was sold for £480 at a public sale in Corot's lifetime. The purchaser at this second sale gave a dinner to his friends and invited them to come to see his acquisition. Corot's own reflection in this matter was, " It is not that I paint better than I did, nor is it I who have changed; but only that my principles have triumphed and I now join in the good fortune."

This picture, now in the Louvre, hung for many years in the Luxembourg. It is a very full composition, as will be seen from our headpiece to this chapter, and its great charm lies in the subtlety of colouring in the foliage and in the exquisite distance.*

Corot was always rather diffident in stating the prices of his pictures to purchasers, and he often asked his patrons to fix themselves the value. Once, however, he thought that by way of a joke he would ask a long price. On the opening day of the Salon succeeding the Exposition of 1855 he received a telegram asking if a certain picture was for sale, and if so, what was the price. He knew nothing about the person who sent the telegram. His own words in telling the story were: "I do not know what I thought at this sudden request at the opening of the exhibition, but it seemed to me that this method of purchasing showed I had had a success, and that I could ask what I liked. So I replied—also by wire—' Picture at liberty, price frs. 10,000'

* When residing for a short time in Paris in 1880 the writer made a study in oils from this canvas, and the fortnight's close examination of the picture has been of great service to him since in the consideration of Corot's work.

(£400). Within an hour I received another dispatch announcing that my picture was accepted with pleasure. I could not believe it and thought there must have been a mistake in my figures, and that I had left out an o. In order to keep the matter clear I wrote by post, this time giving the price in words, but that made no difference." The picture was bought on its merits, and, in twenty years after it was exhibited, must have realized a good profit to the enterprising purchaser

In 1850 Corot changed his residence to 10, Rue des Beaux-Arts, and in 1853 to 58, Rue de Paradis Poissonnière, the latter where he continued to live during the remainder of his life. To the Salon of 1853 Corot sent his " St. Sebastien—paysage," a large picture 96 inches high by 48 inches wide, of which we give an illustration. This was afterwards in the Exposition Universelle of 1867, and still later was the leading theme in an interesting episode in 1871, as will be narrated further on. The picture is now in the collection of Mr. Walters, of Baltimore, Maryland, in whose catalogue the story of the picture is told. Corot began this picture in 1851, for on September 23rd of that year he writes to Constant Dutilleux, " I am at this moment working upon an historical landscape embellished with a St. Sebastian succoured by some holy women. And with care and work I hope, under the guidance of Heaven, to make a lovely picture."

Theophile Silvestre describes this painting in his " Artistes Vivants," and gives some excellent ideas of its fine qualities. " In a landscape there are no more two identical colour values to be found, than are there in nature two faces, two clouds, two trees, two lights, two drops of water, absolutely alike. Let us take as an example of Corot's work his picture, ' St. Sebastian,' but first let us understand its general intent. Two holy women draw out the arrows from the body of the martyr and support him in his agony. He lies in the heart of a mysterious wood, in the shadow of mighty trees growing at the base of a hill which rises like a Calvary. His executioners have abandoned the martyr in this gloomy spot where no prying eye could

ver them, and they are just seen, their horses in a walk, passing over a

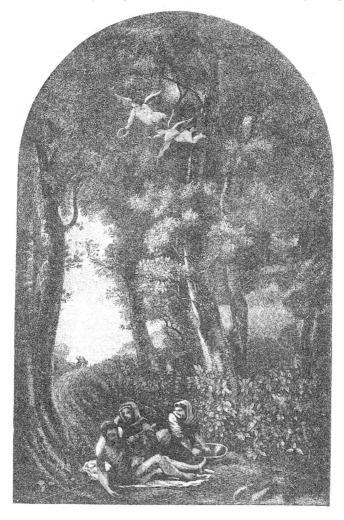

St. Sebastian. By Corot.

mmit into a valley which suddenly plunges beneath the line of the horizon.

But the two holy women have heard the groans of the victim, and watched the departure of his torturers. Two angels, light as butterflies, and bright as spirits, fly through the shivering leaves, bearing the palm and the crown. Corot has poured out all his talent and all his heart into this picture, so religious, and so touching." He painted a replica of this picture, also of fine quality.

The first great French Exhibition, held in 1855, was not in any special way a success for Corot. He exhibited six pictures and was rewarded with a first-class medal, which was voted to him by the International jury, so that the compliment was higher than if it had come from his Parisian confrères. In the next Salon (1856-7) his best pictures were the " Lot and his Daughters " or the " Burning of Sodom," and the " Nymph playing with a Cupid," the latter probably being the painting about which the anecdote of the sale by telegram has been given, although this is not quite certain.

" L'Incendie de Sodome," or " Lot and his Daughters," as the picture is now usually called, was purchased from the artist by M. Durand-Ruel in 1868, for 10,000 francs (£400). In 1873 it was sold to the Count Camondo for 13,000 francs (£520), and at his death M. Durand-Ruel again bought it from the Count's son for 100,000 francs (£4,000), an immense sum even for such a well-known picture. In 1889 the picture was sold, presumably for a still larger price, to an American collector.

Our reproduction opposite will give some idea of its merit, which, in Corot's own eyes and in the judgment of many of his friends, was his finest picture in the semi-classic style. If a fire were to happen, Corot said frequently, " that is the picture I would try to save," pointing to " Lot and his Daughters," during the years he had it beside him in his studio. Not having seen the original picture the writer cannot profess to give a definite judgment, but from the large photograph published he frankly confesses that he prefers Corot's simple poetic landscapes to his perhaps more ambitious performances in classic compositions.

The pictures which Corot exhibited at the Salon of 1859 were marked

LOT AND HIS DAUGHTERS
By permission of M. Durand-Ruel

by great variety, and were illustrative of all the styles in which he painted. There was a landscape with " Dante and Virgil," a " Three Witches appear-

ing to Macbeth and Banquo," a " Tyrolian Landscape," a " Souvenir de Limousin," and a " Ville d'Avray." In the Shakespearian motif (the only one from the English poet he tried, although Corot was familiar with Shakespeare's works) he represents Macbeth and Banquo arriving on horseback and finding themselves confronted by the witches who point their scraggy arms at them. It is quite opposed to theatrical tradition that the travellers should be on horseback, but it is none

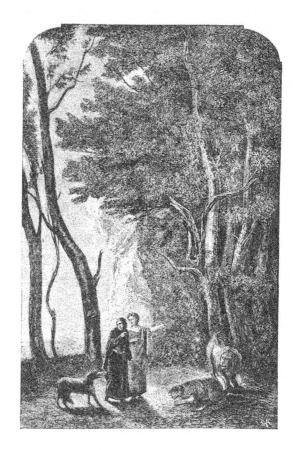

Dante and Virgil By Corot.

the less appropriate. We here give an etching of the picture, which in 1873 formed part of M. Durand-Ruel's collection. The " Dante and Virgil," of which we give an illustration above, show these personages entering Hades

at the time when Virgil says to his companion, "It will be best that you follow me, and that I be your guide." The figures are placed in front of a sombre mass of trees and rocks occupying the right of the painting.

Corot passed most of the winter of 1860 hard at work in order to study a background for his picture of "Orpheus and Eurydice," which was in the Salon of 1861. The figures occupy the right in the foreground, and the Elysian fields, which fill the background, are painted in a silvery tone, very subtle and wonderful. In connection with this picture Corot was led to think of the worldly troubles of others, and he concluded by saying, "If painting is foolish work it is a kind of folly very good for human beings. In looking at my face and considering my health I defy any one to find there the traces of anxieties, ambitions and remorses, which wrinkle the faces of so many men. This is why I love art, which gives calmness, moral contentment, and even health to its disciples."

All this time, and especially since 1848, when artistic matters changed so much, the officials of the department of the Fine Arts purchased nothing from Corot. In 1860 they asked him the price of one of his pictures and he responded 8,000 francs (£320), and this they evidently thought too much, for he heard no more from them; though he considered that sum a fair value for his work. When he sent a picture to Lille which the city thought of buying, the negotiation failed, but he took a noble revenge in sending the picture to the museum as a present. There it hangs, "La Fête Antique," one of the painter's best pictures.

To the International Exhibition in London in 1862, Corot sent a landscape, the property of the Viscomte David, but it excited little or no attention. Corot was, however, mentioned in the brief official preface to the catalogue of the foreign schools of painting as one of the artists whose pictures "show that France is rising to power in landscape."

During the summer of this year Corot visited England for about a week. He came chiefly to see the Exhibition, but also visited the neighbourhood

Wallis, the well-known painter and archæologist,

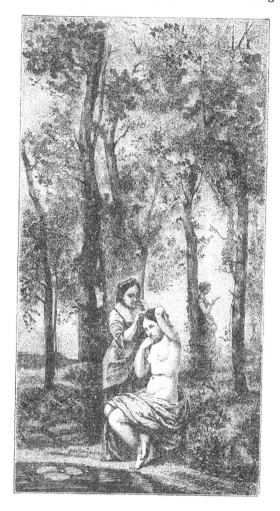

La Toilette. By Corot.

els in all. Although slight, those are fine works

of art, and are now distributed in various collections. One, " The Wild Man of the Woods" belongs to Mr. James Cowan of Glasgow, and another to Mr. G. A. Drummond of Montreal.

In 1865 Corot again commenced studying the human form more carefully than he had done for some time, and during this year he painted some fine figure pictures. In the same year he received a commission from Prince Demidoff for two large panels (two having also been commissioned from Rousseau) for his new mansion, and these were painted together, within three months, at Fontainebleau. The subjects were " Night" and " Dawn," and they were entirely successful. Corot's pictures at the Salon this year were particularly liked. They were " Le Matin " and " Souvenir du Lac Nemi " (see p. 46), and were painted in his best manner. Many of his artist friends wished him to be awarded the medal of honour for the year—the chief award of the Salon. There were a considerable number of ballottages, and again and again Corot came out near the highest, but at the end it was found that Gérôme was the most popular man.

To the Exposition Universelle held in Paris in 1867 Corot sent six pictures. But his full recognition by those who would not spare time to consider his works had not yet arrived. His brother artists of France would gladly have given him a first-class medal, and perhaps even the highest of all, the médaille d'honneur, but the visitors from other countries did not understand Corot's method of work; the *Art Journal*, for example, said, " Such painters as Corot scrub in a subject with dirt for colour,"* and this feeling was still strong enough to weigh heavily with the jury. Corot therefore was awarded only a second-class medal, although all French painters were ready to acknowledge that this was only a sop to popular passing prejudice and uneducated taste. At the conclusion of the exhibition Corot was rewarded with promotion to be an Officer of the Legion of Honour as a solatium for not receiving a medal of the first class.

* *Art Journal*, 1867, p. 169.

" La Toilette," of which a wood engraving is given on p. 43, was one of the pictures at this exhibition. It had been painted probably half-a-dozen years earlier. For many years this picture was in the collection of Mr. James Duncan, of Benmore, in Scotland, and it was the first Corot publicly exhibited in that

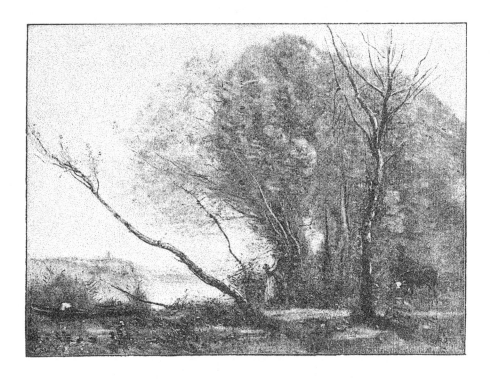

The Bent Tree From the Picture by Corot in the Collection of Alexander Young, Esq.

country. In 1872 it was hung in the Glasgow Institute, where it gave rise to much discussion. Although interesting it is not an attractive picture, and the result of the landscape having been painted outside while the figures were added in the studio, makes it a very uncomfortable kind of picture. The

painting of the flesh colour is very fine, and the difficult drawing of the raised arm is very well overcome. It would have been better, perhaps, if Corot had painted two pictures, one with the figures, and one with the scenery alone, for the landscape is independently very fine in harmony.

During the years 1848 to 1867 Corot made immense strides in his art, changing from a slightly constrained style to a broad and flowing method of painting; he had taken his position clearly as a master, and in France, as has been observed, this position was generally acknowledged. Before 1848 Corot was unknown, but the twenty years up to 1867 covered the period when he rose from this state of obscurity to the position of one of the first landscape painters of his day.

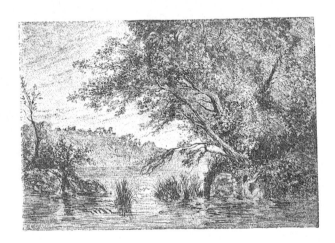

Le Lac de Nèmi By Corot. 1865

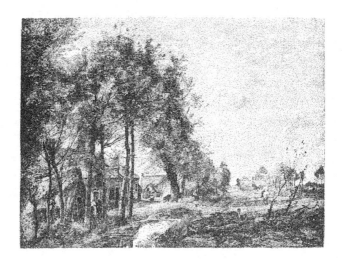

The Village of Sin, near Douai By Corot

COROT:—CHAPTER V.

LATER YEARS; THE WAR OF 1870; LAST DAYS; DEATH; FUNERAL.
1868—1875.

WE have now come to the latest period in Corot's long career. We have traced him as a youth, earnest and devoted to his parents and seeking their countenance before he would become a painter. Then when he had obtained the necessary permission, we have found him going into lengthy and serious study until, after many grave discouragements and the long exercise of patience, he had come to be recognised as a master of the highest class. Not, certainly, even now recognised by strangers to Paris, for that did not take place until after his death in 1875; but by those who knew him and his pictures best, he had at length, an old man of over seventy, come to be understood and appreciated.

Corot had a strong love of his country, and although, as we have seen, he was no politician, he was deeply affected by the events of the German invasion.

He could not bear to think of the humiliations through which his unhappy country was dragged, and as we shall see, he opened wide his purse to help the poor people who lost their all in the general confusion of the time.

After the war, Corot visited Arras, and afterwards settled down to work in Paris. He painted at this time even better than ever ("The Boatman," of which Mr. Walter Sickert has made an etching, being of this period), and we have in him one of the few examples of a painter living a long life, who even to his dying day went on improving in his art. His pictures of 1823 and 1873 are much farther apart than even the fifty years they cover. They differ in sentiment, in power, and in everything that makes a picture ordinary and extra-ordinary. The first shows the student searching for minute correctness, yet scarcely obtaining general truth ; the latter displays the master putting forth his power in general expressions of the various phases of nature, and thereby adding greatly to the charm produced by minute finish.

Corot continued to exhibit at the Salon and to work industriously after the excitement of the 1867 exhibition had blown over. To the Salon of 1868 he sent only two pictures, an "Evening" and a "Morning at Ville d'Avray," where he still went every summer to paint ; and in 1869 he again exhibited at the Salon a "Souvenir de Ville d'Avray," and also a "Girl Reading."

In 1869 he sent a picture to the Royal Academy in London, which created some stir and much discussion. The *Art Journal*, which may be taken as thoroughly representative, at that period, of the Philistinism of England, said, "It remains that we notice a production anomalous, and to English eyes possibly repulsive—'Figures with Landscape,' by M. Corot. This picture claims to be in a poem, yet is the atmosphere smoky, and the trees, of a dusky olive, are somewhat dirty. But we must admit" (—here the writer seems to have caught a transient gleam of something he could not

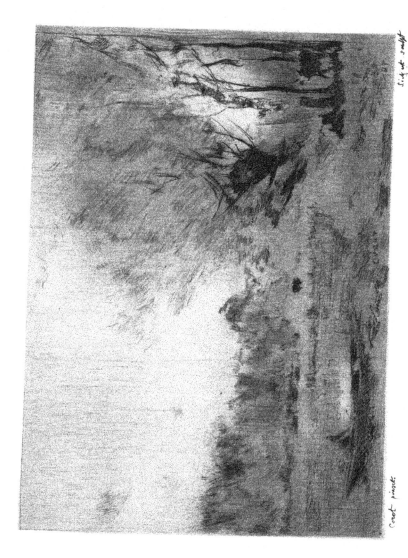

Corot pinxit.

The Bewitdesen

Sidy at midght

grasp—) "that the work is eminently artistic in balance of composition, in apportionment of light and shade, and in pervading unison of tone. M. Corot has in France a great repute. A man of genius, though an alien to England, and" (—here the Philistine again breaks out—) "even to nature herself, is generally worthy of attention."

This is an example of writing representative of art criticism in England in 1869—a combination of would-be liberality and breadth of view, with a narrowness which yet was quite unable to place itself out of its own well-worn groove; where a certain degree of praise was as it were extorted, this praise was grudgingly given and as quickly repented of, as if the writer were afraid he might have said too much. That any one with a tolerably well-trained eye could speak of Corot's aerial effects as smoky, and of his foliage as somewhat dirty, is in view of the general clearness and gemlike quality of Corot's painting difficult enough now to understand. Let any one who doubts it examine any of Corot's pictures of this or of a later period.

In 1870 there was published a series of twelve lithographs after Corot by Emile Vernier, with a notice by Philippe Burty. This folio publication, although consisting only of lithographs, is perhaps the most desirable of the publications of Corot's work. The twelve subjects have been well chosen by Vernier, he has worked for the love he had for them, and the process of lithography was probably never seen to greater advantage. The best is "The Meadows," then belonging to Rousseau, which we reproduce in a small size. The Corotesque feeling that Vernier has put into his lithograph is delightful, and the whole print sparkles with a feeling of colour. Another subject entirely opposed in character to this is the "Shepherdess Reading," which was possibly an effort in the direction of Jean François Millet, but one which Corot did not fortunately strive too hard to attain. It is only referred to as an evidence of Corot's width of view, but artistically it is far below his landscapes. Another figure, from A. Sensier's collection, is also illustrated (page 28). This "Wood Nymph" shows a woman seated after bathing

<center>H</center>

drawing on her stockings. It is more artistic than the "Shepherdess Reading" and more pleasant in every way.

Corot remained in Paris during the siege, having entered the city on the 29th August, 1870. He occupied himself in painting nearly all the time. "Without it," he said, "I believe I would have gone mad," and some curious stories are told of him at this time. Ludovic Halévy, in his "Notes et Souvenirs de Mai à Décembre, 1871," tells that on Monday, the 4th September, he noticed a sort of peasant, attired in a blue calico blouse, seated before an easel commencing to paint. He proceeds to tell the story :—

"I was riding back from Versailles; I had taken the longest road through Marnes and Ville d'Avray. When passing through the pretty wood that bears the name of 'Fausses Reposes' I suddenly perceive a man got-up like a countryman, in blue calico blouse, corduroy trousers, broad-brimmed straw hat and all, seated before an easel, under a white parasol. I pulled up, a little surprised. Who on earth was this old chap, painting away at his landscape? I recognise Père Corot. There he was all alone, working in this deep silence, broken only by the birds singing overhead. Nature and he looked like two old friends, accustomed to live together as old cronies understanding and loving one another thoroughly.

"Suddenly Corot rises, begins to hunt in his pockets, pulls out an old pipe and an old pouch crammed with tobacco. Slowly, carefully, lovingly, he fills his pipe. He was a mighty smoker before the Lord. After which a fresh hunt in his pockets, and now the old man is seized by a lively anxiety. He hunts and hunts, and finds not. 'Tis no longer anxiety, 'tis despair. He had forgotten his matches! To go back home for a box, or spend the day without a pull at his dear pipe, as he used to say—a poor choice! I had some matches! A little box of wax matches with a portrait of M. Thiers, the whole for a penny. An ingenious negotiation at once came into my head. What a tempting speculation! Say to Père Corot, 'Give me this little landscape, and I, in return, will give you this little box of matches, with a pretty

portrait of M. Thiers into the bargain! Picture for picture!' Perhaps Corot would have agreed—but I dared not. I approached. Hearing the dry leaves crackling under my horse's hoofs, Corot turned round; I saw his eyes gleam. Ah! if only this gentleman should have a light—that's what Père Corot was saying to himself. And I generously gave him my little box of matches. I never remember receiving such heartfelt thanks. I went off through the wood at a walking pace. At about fifty mètres' distance I turned my head. The old

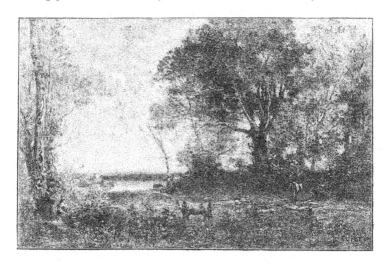

The Meadows. By Corot.
From a Lithograph by Vernier after a Picture once in the possession of Théodore Rousseau.

countryman had set to work again, but between the painter and his picture arose the wreaths of a light column of smoke. Père Corot had lit his pipe."

Corot got the idea somehow that the siege of Paris would end with an assault by the Germans, and a general conflagration in which the Louvre would probably be demolished. "Is it not shocking to think," said he, "that there are men who would be found to destroy the Louvre and to put in the

place cannons, corpses, and petroleum." " Compare this savagery with art," he would say, "which after all is founded on love." Corot made a fancy sketch of Paris in flames and wrote on the back of it, " Paris supposed to be burned by the Prussians in September, 1870."

At this time he was making some experiments with a transfer paper of a peculiar kind. This paper permitted a drawing made in it autographically to be transferred directly to stone, and this gave off impressions exactly similar to the original with all its subtlety and precision. After the siege Corot took up this work in earnest, and as a rest from painting he produced twelve facsimile drawings from which only 50 sets were printed from the stone. The preface of the publishers to the work is as follows :—" We offer to the lovers of the talent of M. Corot, which is so much appreciated at present, a collection, entirely unpublished, of twelve drawings and compositions drawn upon a kind of transfer paper by himself and carried by us [the publishers] directly on to the stone. In this way we have under our eyes the personal work of the master without its being translated by any intermediary process, and we urge the interest possessed by this process because there is always in the work of an artist such as M. Corot an indefinable something of poesy that no other pencil can ever be able to render. It was after having passed the whole time of the siege in Paris M. Corot went in April, 1871, to seek rest in the north and to make, sometimes at Arras and sometimes at Douai, several studies and even some important pictures ; between times, and in order to vary his occupation, he drew with that richness of imagination which everyone knows the compositions and drawings which we have brought together and of which we have printed only fifty numbered copies."

The confidence expressed by the publishers in the sketches is amply justified by the quality of the drawings. They are all rapid sketches with no attempt in detail, but they are complete compositions, and three or four of them are very fine. The best is probably the " Willows," a large design of which we give a reduction, with some willows dashed in with great vigour,

but with all the essential points of the tree visible and the grey shimmer of the leaves felt in the rough brown-coloured sketch.

During many years Corot's charity had become proverbial and when the siege was over he did all in his power to ameliorate the condition of the distressed. It is stated that he subscribed as much as 50,000 francs (£2,000) to the fund to relieve the sufferers from the siege. When it was proposed to raise a national fund for the liberation of the territory invaded by the German armies, Corot sent at once 10,000 francs (£400). This project fell through, however, and he was asked to receive back the money he had given, but at this result he was rather annoyed. "They speak," said he, "of new taxes, and I believed that the State had need of money and why not

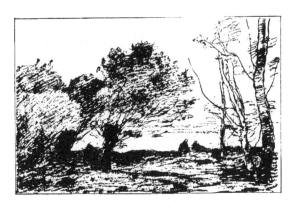

The Willows. By Corot. From a Lithograph.

then lay a tax on paint brushes. I would pay it joyfully, for if I am not able to paint any more and make my little branches in the sky with the atmosphere so that the swallows may pass, it appears to me that I should very soon die." *

The picture, "St. Sebastian," mentioned as having been in the Salon of 1853, had been returned unsold to the painter, and he did a good deal more work to it. It went to the Exposition of 1867 but again came back and Corot once more set to work on it, as he felt there was a lack of aerial perspective in the subject. He opened up the trees and lightened the picture throughout

* Dumesnil's " Souvenirs."

and in several ways improved it. In 1871 he presented the picture to the promoters of a lottery held to aid the orphans left by the victims of the war. He was offered the usual number of tickets for the lottery gratis but declined them. The picture fell to a foreigner who did not know how to appreciate it, and it very soon found its way to Mr. Durand-Ruel. By him the picture was offered at a moderate price to the Administration of the Beaux-Arts, but the nation was not then a purchaser of such works. Afterwards it passed into England and it is now in the collection of Mr. Walters, of Baltimore.*

In 1872 Corot had been fifty years a painter, and had achieved much, although he had gained nothing like the fame his name has since acquired. The celebration of his fiftieth year as a painter was delayed until the spring of 1874, when the friends of the artist assembled at Bougival, near Paris, in the house of Dr. du Borgia, to celebrate the event. It was really a little more than fifty years since Corot had left commercial life, but it was exactly that number of years since he painted his view, " St. Catherine, near Rouen," his first picture of special merit. The meeting was very harmonious and the jubilee was celebrated with all the honours ; Corot sang a number of songs after dinner, " Couplets de la St. Jean," Christmas carols and Norman *rondes*, which were greatly applauded by the company ; many jokes were made on the occasion and one even dared to hint that perhaps they would yet meet to celebrate a second jubilee. " If you will," replied Corot, " let us put the fête no further than next year, that would be more sure." But even this was denied to the painter, for ere another year was over he was in his last resting-place.

To the Salon of 1872 Corot sent his picture, " Pastorale—Souvenir d'Italie," of which we give an illustration (opposite p. 56). This beautiful picture is one of the most complete that Corot painted, containing as it does a memory of his earliest *motifs*, with the dexterity of handling and wealth of colouring of his maturest time. The figures lend gaiety and motion to the subject, which has been found very difficult to translate into black and white.

* This picture is illustrated at page 39.

In 1874 Corot paid his last visit to the Salon; when, as a writer in a newspaper said at the time, he looked like a well-to-do peasant, large and thickset, robust in his ample frock-coat of blue king's cloth, with a lively complexion, freshly shaved, in a solid collar emerging from a cravat of black satin ; his eye clear and sharp—good and smiling under the thick eyebrow, the lip slightly mocking, and his hat planted slightly upon the back of the head, discovering a beautiful forehead, surrounded with white hairs. He appeared the old *maître* full of days and years to come, he appeared as if called to the glorious longevity of Titian.*

Twice during Corot's life was the chief honour of the Salon almost within his grasp and twice it eluded him.· In 1865 and again in 1874, the year before his death, a great number of *scrutins* resulted in the Medal of Honour being given to another, although it was well known that Corot's name was among the highest.

In 1874 this so disappointed Corot's friends that they resolved to present him with a medal of their own, and a committee was formed, with Corot's old friend, M. Marcotte, at its head, to organize a public subscription for this purpose. The movement met with liberal support in many quarters, and it was arranged to present the medal to Corot at a dinner given at the Grand Hôtel, Paris, on the 29th December, 1874. The meeting consisted of three or four hundred people, Corot arriving about nine o'clock, leaning on the arm of M. Marcotte. He was much applauded, and there was general emotion. When quietness was established and the *maître* seated at the end of a room near a table on which was placed a small casket, the president of the meeting pronounced these few simple words : " Gentlemen, there will be no speech, I should have too much to say upon the man and the artist. This medal will speak for us." This was pronounced well adapted to the occasion, considering the character of the man they were entertaining. M. Marcotte embraced Corot and presented to him the casket containing a gold medal, the work of

* E. Chesneau, in the *Paris Journal.*

M. Geoffroy de Chaume. This medal is about two inches in diameter, and has on one side the effigy of Corot in profile, surrounded by this inscription ·
" A Corot ses confrères et ses admirateurs, Juin, 1874." On the reverse are the attributes of painting, a palette and brushes in a wreath of laurels. Corot's health was then drunk, and he said softly to M. Marcotte, " I am very happy to feel that I am loved like this."

"Those who personally knew the master then went forward to congratulate and shake hands with him. Alas! how changed he was. His sunken features denoted his suffering and his old looks had fled. Nervous and feeble, he was making efforts that were beyond his strength. Speaking with animation and trying to stand, he said to me: "I feel well this evening—exceptionally well. I have attacks which seize me after dinner and last till over nine o'clock, but this evening at eight I was fresh, strong, and ready to start." *

The medal thus given to the painter, in the last days of December, 1874, was presented just in time, for Corot's health had already begun to give way. He was now in his eightieth year, and therefore frail in physical powers. His sister's death, in October, 1874, affected him visibly, and from that time forward his friends felt that he would not be very long in following after her. This sister, Madame Sennagon, had been more than a sister to him all his life, and it was to her that he confided such troubles as vexed him. She was his counsellor and friend, and, being without a wife, he felt when she died he had little more to live for. His nurse Adèle, in whose arms he was afterwards to die, was still with him, but although a faithful servant for twenty-five years, she could not take the place of his dead sister. Yet Corot loved life, and used to say he hoped to become a centenarian and work on until his very last day. For, he would say, his success might be an encouragement for the timid, showing that good fortune sooner or later smiles on courageous hearts. And his name might survive as one who was an illustrious master, and his memory as an example for the impatient and the disheartened.†

* Dumesnil's " Souvenirs." † E. Blavet.

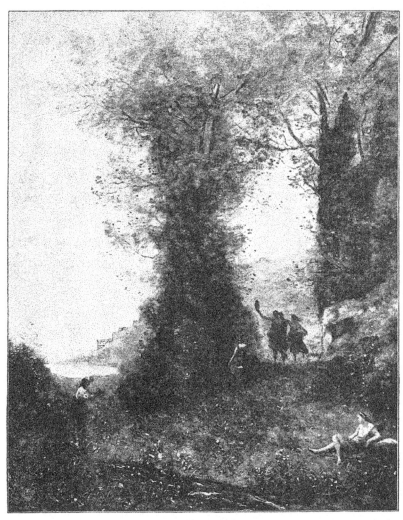

PASTORALE—SOUVENIR D'ITALIE. By COROT. From the Salon of 1872.
From the picture in the collection of J Forbes White, Esq.

Corot's wonderful strength rapidly left him when he returned from the country in the autumn of 1874. For several months he dragged on without complaining, but also with the full knowledge that his end was approaching. Towards the last, when he could not take nourishment and was unable to quit his bed, a few friends were still permitted to visit him. But he could

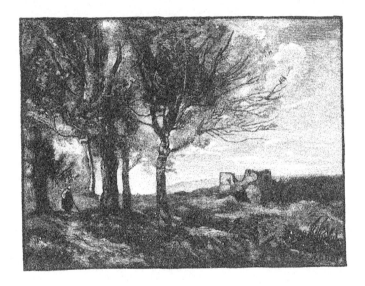

The Ruin.
From the Picture by Corot in the Collection of R. T. Hamilton Bruce, Esq.

not speak, and his eyes alone expressed the greeting which he had not the strength to pronounce.

On one of the last mornings which preceded his death Corot said to one of his friends, "I have seen last night in a dream a landscape of which the sky was altogether rose-coloured. The clouds also were rosy. It was delicious. I recollect it very well. It would be admirable to paint." *

* Burty's note to the 1875 Catalogue.

Adrien Marx gives the most complete account of Corot's death, and we quote it nearly in full —

" Let us think," he says, " about the death of this man of genius, who was also a man of goodness. A cancer in the stomach, complicated with other things, compelled him to keep to his bed. The Doctor Sée, who attended him for six months, made an operation which gave him so much ease that one began to hope. But the invalid, who could not stand more diet than a few drops of milk, lost his strength. The illness triumphed over his constitution, and overthrew this oak, in the bosom of which the sap was no longer circulating. Some days after the operation, which was followed by a misleading improvement, Corot had the window opened, gazed at the sky, and said with a feeble voice, *'* When the spring comes I will paint a beautiful picture ; *'I see a sky full of roses.'* The friend went to weep in a corner ; delirium was commencing. The master had nevertheless periods of lucidity ; he could at times confess to the curé of Coubron, and say with his eyes to Daubigny, his most beloved pupil, all the tender adieux which his tongue could no longer pronounce. He could at the last kiss the portrait of his sister, whose death had affected him so greatly, and murmur in the ear of the ' religieuse ' who gave him his medicine, ' Useless remedies, my good sister ; I have no need of that for the journey I am about to undertake.' The agony of the excellent man was long and painful. It was remarked that he was constantly moving the thumb of the right hand, after the fashion of painters who would indicate the dominant touches of a picture. It must not be forgotten that Corot painted with the thumb—he used it as a palette knife — to expand tones upon his canvases, or to extinguish notes too vigorous. A few minutes before his death he moved himself upon his little cane bed, turned towards the bedside, regarded fixedly the wall where hung his dear medal of honour, and gathering his fingers together as if holding a brush, he made a movement as if he was painting. The ' religieuse ' who was watching went towards the bed to see if he still

breathed—Corot was dead! Often death ennobles the lineaments, in other cases it deforms them. It depends upon the illness to which one succumbs. Here it was so much of a radical change that it was impossible to those of his friends who had not seen him for some time to recognise the lineaments

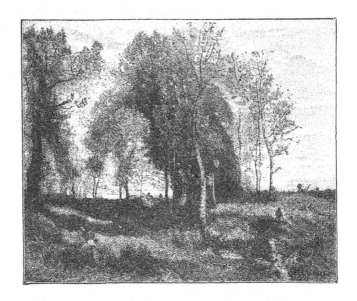

An Evening in Normandy.
From the Picture by Corot in the Collection of R. T Hamilton Bruce, Esq.

of the beloved master. An expression grave, austere, and rigid, had replaced on his pale mask the jovial and almost infantile roundness which characterised his face.''

Corot died in his studio in the Rue de Paradis Poissonnière, in the midst of his friends, and surrounded by those pictures which he had destined for the next Salon, but which remained unfinished.

The funeral of Corot was unfortunate in raising a little excitement in the

church of St. Eugène, where the obsequies took place. This church is near
the Conservatoire of Music in the Faubourg Poissonnière and is close to
where Corot died. The incidents were related in one or two of the news-
papers at the time, and the whole fault seems to have been laid to the charge
of the curé of St. Eugène on account of certain indiscreet remarks which
were uncalled for, and which led the service to be seriously interrupted.

The church was filled with a concourse of all the artists, amateurs, and
dealers in Paris, about three thousand persons being present. At the
beginning of the service an impressive silence reigned in the congregation,
and it was evident that many were deeply affected with the solemnity of the
moment. The curé mounted a chair to make the *panégyrique du mort* which
is usual in France, and after some sentences in praise of the painter he
permitted this unfortunate phrase to escape him : " Plusieurs de ses adversaires
le qualifièrent de crétin " (" Many of his enemies have called him an idiot ").
These remarkably unbecoming words were resented by those present and a
protest was heard which the sacredness of the place could not restrain. A
little further on the curé said : " I have read all the journals ; everyone
speaks of M. Corot as an artist, but none speak of him as a Christian."
Another version gives the words thus : " I have run through all the public
prints ; and, sign of the perversions of our times, have found only one which
has not dared to say that Corot was a spiritualist, not one that said he was a
Christian." The murmurs now increased, and several people, amongst them
the curé of Coubron, an intimate friend of Corot, were seen vigorously to
protest ; but still the unfortunate preacher went on. Then a note was handed
to him by a choir boy—this was a note from the sacristan advising him to
conclude at once. Doubtless the sacristan at the door heard more of the
protests than the preacher and feared a serious disturbance.

Corot had been passionately fond of Beethoven's music and constantly
attended the concerts at the Conservatoire. One day in coming out after
hearing the illustrious composer's symphony in " A " (No. 7), he said to

Professor Elwart, " Do you know, I should like to be buried with the sublime andante of that symphony." Professor Elwart always remembered these words and he had made an arrangement in this symphony for a " Pie Jesu " ; and Faure, the celebrated baritone, sang this at Corot's funeral service in the church of St. Eugène. Faure had arranged to take a " Pie Jesu" of his own composition, but having heard the wish of Corot, he willingly sang the symphony the painter had so much liked. Faure executed his part in a way that showed he felt as much as his dearest friends the death of " Père Corot."

At a quarter-past one the cortège left the church and arrived at Père Lachaise about two o'clock. It was a wretched day, those who walked found their feet sticking in the mud of the streets, and it was a long and tedious journey to the cemetery. The painter of early morning with rosy hues and tender clear atmosphere was buried in his last resting-place on a dreary muddy winter afternoon without sunshine and with a cold and miserable look-out. What a contrast to the happy and cheerful life of the artist and to the ever-delightful landscapes he produced.

M. Le Chennevières, Director of the Beaux-Arts, delivered an oration over the grave; for, as is common in France, however neglectful the Government officials have been to a painter, one of the chief personages attends the funeral and delivers a speech eulogising the man otherwise scarcely noticed.

From 1867 until his death Corot's style did not alter very much. He painted rather in a higher key than before, and " The Bent Tree," of which we give an illustration (page 45), is an example; and his picture of this period, " The Pastorale," exhibited in the Salon of 1873, and illustrated here opposite page 56, is a wonderfully light-toned picture, full of the finest subtleties, and in a gay colour throughout. Equally lovely although smaller in size is the picture "An Evening in Normandy," of which we give an illustration on page 59. This is from the charming

collection at Edinburgh belonging to Mr. R. T. Hamilton Bruce, who invariably welcomes all true art-lovers and connoisseurs. "The Ruin," at page 57, is from the same source, but is an earlier example of Corot's work.

As we noticed more than once Corot continued even up to the end to improve and his latest pictures are the best. We know how often the reverse is the case and that a painter's last works are not usually the best to choose. Turner, for example, ran riot altogether in his colour, even Titian was not always equal at the end, but Corot, probably in some degree because of his manner of carrying on a picture in various stages, with sometimes years between each, managed never to show that his hand had lost its cunning.

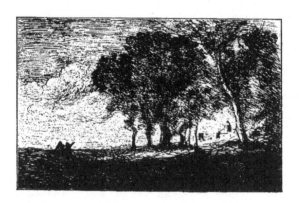

Reduced fac-simile of an original Etching by Corot.

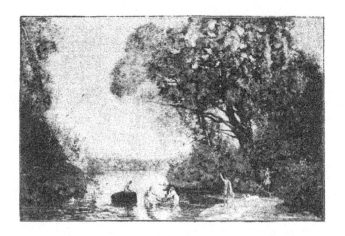

Diana and her Nymphs From the Picture by Corot in the Bordeaux Museum

COROT :—CHAPTER VI.

PICTURES ; METHOD OF PAINTING ; STYLE ; STUDIO.

IT is not of much utility to give a list of the chief works of Corot, because the titles of his pictures are so similar that the mere enumeration of them would convey very little in words. From the illustrations presented in this volume some idea will be obtained of the character and style of his best paintings. Many pictures have also been mentioned in the course of the narrative of the artist's life when they were specially bound up with incidents of the time.

There are, however, a number of somewhat notable examples which deserve a few words. This does not mean that these works are the greatest pictures of the master, but that they are paintings which will bear further exami nation and consideration, and help the reader to understand and appreciate the enthusiasm for the works of Corot.

Some connoisseurs have endeavoured to classify Corot's painting into well-

marked divisions, the usual arrangement being into first, second, and third periods. The first period was that influenced by Michallon and Aligny, in what is termed the classical style of landscape with strong outlines and carefully designed details. This is considered to have lasted until shortly after 1840, and examples may be seen in our illustrations on pages 8, 16, 21, and 25. After a time of transition the second period was in full development from 1847 onwards, this being marked by more attention to aerial perspective and less carefulness in completing unimportant details. The subjects are mostly early morning or sunset or in the gloaming, the trees being mostly painted in dark tones, while frequently nymphs are dancing or a castle is seen in the far distance; both these latter characteristics, however, being quite usual with Corot during all his career. An excellent example of this style is to be found in the Louvre, " Une Matinée," from the Salon of 1850-51, of which an illustration is given on page 34. The third and last period of Corot's works was developed by 1860, and all his finest artistic efforts were achieved about or after that time.

But it should be clearly understood that these so-called periods of style are somewhat arbitrary, and that the arrangement described could be attacked and defended with much reason on both sides. That the " Coliseum " study of 1825 differs entirely from the " Matinée " of 1851, and that again from such pictures as the "Lac de Garde," belonging to Mr. J. S. Forbes, Sir John Day's " Ravine " (page 13), Sir Frederick Leighton's four fine examples (see illustrations, pages 88 and 89), or Mr. Young's " L'Arbre brisé," and others in the famous collections on the other side of the Atlantic, cannot be doubted.* But that any one could say precisely that from one particular date Corot changed his manner of treatment we do not think possible. The fact that Corot kept many works in hand at the same time, and sometimes finished a picture many years after it had been designed and begun, would alone

* There being none of Corot's last and best style in any museum, it is necessary to name those in private collections.

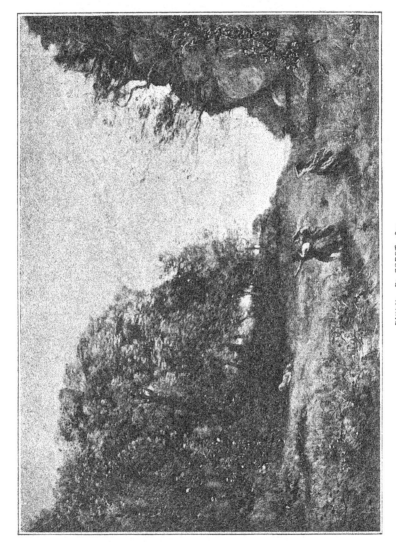

BIRDS BY COROT, 1874
From the Scotsman Collection.

prevent this precise definition, even if it were desirable, which after all is somewhat doubtful.

It is of course impossible to say which is the finest of Corot's pictures, for every work to which he gave serious attention in the last twenty years of his life was a masterpiece. The very last picture on which he painted, the "Biblis," is as fine as anything he ever produced. This picture was in the Secrétan collection and is now in Brussels. We give an illustration of it opposite page 64, which is wonderfully true in the delicate half-tints. Again Mr. A. Young's magnificent "L'Arbre brisé," of which we give an etching opposite page 8, is a pure transcript of nature, far fresher and more brilliant than Corot as a rule was wont to paint. In its style this fine work cannot be surpassed, although Mr. Young has half a dozen others equally worthy of attention. M. Mesdag's "White Cliffs," which, with the sombre and stately "Battelier," is hung in the now superb collection at the Hague, is one of the most charming of the smaller works of Corot and is quite different in subject from what was usually expected from the painter. Mr. Murrieta has also some fine examples. The most easily understood Corot is that of the "Lac de Garde," in Mr. J. S. Forbes's gallery in Chelsea. From our etching (opposite page 16) it will be observed that the composition is well considered and the values delicate and delightful. The tender tones of pearly purity exhibited in this fine picture entitle it to rank very highly among the important examples of the master. In the Bordeaux Museum there is a Diana and Nymphs (see page 63) of large size, which is an early but magnificent example of Corot's work, and a small picture, which we illustrate on page 33, in the collection of Mr. C. W. Lea, possesses some delicate qualities. We also give illustrations of the charming example in Mr. G. N. Stevens' collection (page xi), two (on pages vii and 13) from Sir John Day's collection, which is singularly equal in fine quality of pictures, as well as two more from Mr. Forbes's collection, on pages 3 and 7. All these possess individual charms, which render them interesting. "La Saulaie," or The Willow Bank, from Chauvel's well-known etching, forms

the frontispiece to this volume; and we would ask the reader to accept this as, in our mind, an almost perfect decoration for a room in which one lives. In a bedroom the charm of this etching is never ending in its freshness and variety. The Museum of Metz has the " Petit Berger," and may we not hope some day to have one in the British National Gallery or the South Kensington Museum ? The church at Ville d'Avray, close to St. Cloud, Paris, has Corot's St. Jerome ; and the Church of St. Etienne du Mont, near the Luxemburg, has some wall painting by him which, though of a timid and tentative style, is remarkably interesting. Our etchings of St. Ouen from the Durand-Ruel collection (opposite page 80) and the Landscape opposite page 72, are also interesting.

Although Corot is celebrated only as a landscapist, he was also a figure painter of some ability. Never certainly did he excel in figures as he did in landscape, but in an artistic estimate of his work these subjects must be taken into account. In winter he frequently worked from figure models, improving his drawing and colouring.

The " Lot and his Daughters " (opposite page 40) is the most favourable example of Corot's figure work, and is interesting not only as the design of one who was chiefly a landscape painter, but from its exceptional intrinsic merits. Corot's figures and animals are, however, sometimes not very well drawn, and where he did not do them from life they are occasionally very bad. One critic, otherwise very well disposed to him, namely, Théophile Silvestre, characterises some of these " memory " figures as " having something of the archaism of gingerbread men and animals or of German toys." Corot also made a few water-colour drawings, mostly in his earlier days, and in his later time he occasionally made an etching, two of which we reproduce, but in neither of these methods did he specially excel.

At the sale after Corot's death there were over two hundred oil pictures sold, many of them complete, while some were only studies of no great importance. There were also nearly four hundred sketches, drawings, and

etchings, and these account for the large number of unfinished pictures by Corot which have been in the market since his death. Besides these, Corot had a small collection of eighteen old works, mostly copies after Claude, Correggio, Rembrandt, and Titian, also a number of modern pictures by Aligny, Michallon, Bertin, Delacroix, Jules Dupré, Daubigny, and Troyon, as well as several bronzes by Barye.

An exhibition of twenty-one paintings by Corot in the Goupil Gallery in London, in March, 1889, was for the British lover of Art the commencement of a new era in Corot's work. Up to that time he had been seen only here and there in single examples, and although the initiated knew him well, he was unknown to the great public of England.

British Art critics were very much struck with this collection of pictures, and they combined to praise Père Corot. The remarks of the writers were altogether of an appreciatory nature, and showed a knowledge and love of Corot's work which certainly did credit to their judgment. No French writer could have said more than several of these critics, and their decision was arrived at from solid study of the pictures, and were not passing sentiments to serve the hour.

Continued examination of these twenty-one pictures, several being of the master's finest period, increased more and more our opinion of Corot's artistic merits, if that were possible. When day after day, in sunshine, shade, or gaslight, an artist's pictures continue to grow more attractive, it is certain that their merit is not of an ephemeral kind. Many visitors found themselves unable to understand the pictures until they calmly sat down and let their glamour have its way over them for a little time. Several old people acknowledged they would like to love them, but they could not, for all their artistic training had been in another direction. The decorative quality of Corot's works was well exemplified in the room, where each picture was shown to advantage and no ill effects of hanging so many together were observable.

There were examples of the light-toned feathery Corot, of the blue "Parisian Corot," of the idealized and realistic Corot, of the evening, morning, and mid-day Corot, and of the curious but not always perfect Corot figures. Landscape predominated and the trees of Corot were seen in all their variety. A great many had water, either as lake, pond, river, or marsh, while the tones of the pictures varied from the dark "Danse des Nymphes" to the marvellously light and atmospheric "Cliffs," from M. Mesdag's collection, of which mention has several times been made.

The collection of Corot's pictures in the International Exhibition at Paris in 1889 embraced no less than fifty-two examples, several of which are illustrated in this book. The landscape pictures were in many instances altogether satisfactory but the figures were not so successful in comparison. The "Studio" was particularly interesting. Before an easel in Corot's own studio stands a girl, her left hand on an easel touching a *toile* by Corot which she examines. Behind her is the stove of the atelier with the square, black, ugly stovepipe faithfully delineated, but done in such a way as to be quite agreeable. Stucco models and little sketches are strewed about, and the whole gives a glimpse into the interior of the painter's studio.

The similarity of title in Corot's pictures which has been noted does not imply that the subjects of Corot's pictures are like each other, except in the sense that all trees are like each other, because they have branches and leaves. Corot had infinite variety in his work, and although he excelled in certain silvery landscapes, yet, as already shown, he painted many other kinds of pictures, figure, animal, and landscape. It is also to be observed that Corot's later method of painting differed in its results from any style that had been seen before. With a classical feeling for correctness of composition inherited from the old masters of France, allied to a love of nature received from the school of Constable ; as well as allied to the Impressionism

(in the best sense of that term) of the middle of the nineteenth century, Corot, so far as Art has developed, stands almost alone. His earliest works were a faithful reflex of his master's pictures, much dryer than his later paintings, but after he acquired a character and a style of his own in painting, he became quite unconventional and unlike anything that had been previously produced.

This difference of treatment was indeed so marked that it took Corot many years to become acceptable even to his own friends and associates. As we know, he was over forty before he found any market for his pictures, and it was not until he neared sixty that he was acknowledged to be one of the masters of French painting. Even then, as we have related, his works were more frequently misunderstood than liked, and up to the day of his death his detractors were strong enough to keep him from obtaining the chief medal of the Salon.

Since then his reputation has progressed amazingly, and in every part of the civilised world his name is now known as that of a master. The battle is not over even now, however, for it is not until the ordinary intelligence grasps the intention and feels the soul of the painter, until the people as a whole recognise Corot, that we shall be able to say that his triumph is complete. But when we have certain choice minds in Holland, Denmark, Spain, and Russia joining with others in France, Britain and America, with whom they have not otherwise very much in common, in chanting pæans of praise to Père Corot, we may conclude that the final triumph is not very far off. Corot's Art is still the Art of the future, and many now think that the association of ideas having made such progress, Corot's Art has become the Art of the actual present.

The principal difficulty that lies in the way of Corot being accepted by all as a great master is that many people come to his pictures expecting to understand them forthwith. They refuse to devote a few minutes' consideration to them before deciding upon their quality and value. Because all the beauty of one of his pictures does not leap to the eye at once, they rush to

the conclusion that they all are not complete works of art or worthy of sincere admiration. They also think that because every leaf on the trees and every blade of grass in the field cannot be observed with distinctness that they are unfinished and that this method of work was adopted by the artist because he could not draw well and minutely. Their pictorial sense has been destroyed by the examination of photographs and such things, and they believe honestly that a picture which conveys the feeling of a scene, however true it may be in general, cannot be good as a whole, because of the evident want of detail in all parts of the design. They will not believe this is intentional, and they continually sneer at what they call the shirking of careful finish, the scamping of a lazy or incompetent painter.

Mr. George Moore, the novelist, relates that he once stumbled across Corot painting in one of the woods near Paris. Mr. Moore was then studying Art, and was naturally interested in seeing the famous painter; so, emboldened by Corot's well-known kindness to youth, he approached the artist, and was rewarded by being permitted to see the painting progress. After a time, however, Mr. Moore ventured to say, "Your picture is very fine, Maitre, but I do not see where it is in the scene before us!" "Ah!" replied Corot, "my picture only commences its foreground over there," and he pointed to a spot fully two hundred yards ahead. Corot was, in fact, only painting a very small portion of the landscape. With this clue the student at once saw the composition that the artist was putting on his canvas.

People who know little or nothing of art, looking at Corot's pictures, sometimes say that there seems no great difficulty in producing effects which have so little apparent finish. But these critics are ignorant of the long drudgery Corot necessarily went through in his earlier days. He did an enormous number of well-studied sketches when young, taking immense pains in the search after tones and values. We give, at page 17, a sketch made in 1827 (from " Peintres et Sculpteurs contemporains," Jouaust), in which the roots of the trees are very carefully drawn. In these the drawing was so precise,

and in colour the tones were so just, as almost to entitle him to be called
a pre-Raphaelite. They were, as we have already said, hard in outline and
"tight" in finish, and, in fact, were altogether opposed to the style gradually
adopted by the master in his later years. It was only after fully twenty years
of laborious study that, in the forties, the genius of Corot distinctly manifested

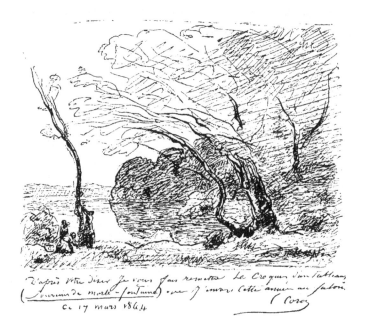

Fac-simile of Original Sketch by Corot for his Picture, "Souvenir de Morte-fontaine," in the Salon, 1864.
With Corot's autograph note and signature below

itself as we now know it. But these years bore good fruit. From long and
ardent observation he was able to penetrate to the very soul of Nature in
her grandest poetry. Inspired by a passionate love of art, he became a leader
and no more a follower; a creator and not a repeater or imitator.

To the student of art it is peculiarly interesting to know about Corot's technical methods of painting, and, fortunately, something of these has been recorded in a series of interesting statements made by Corot to a pupil, which are recorded in M. P. Burty's brief but charming introductory note to the catalogue of the Corot Exhibition, 1875. Corot appears always to have painted on canvas fastened on keyed stretchers, not strained too tightly, and also not covered with any heavy preparation which would make them easily crack—half primed canvas, English artists would call it. The preparation was sometimes lightly tinted, and he was always very careful in choosing the finest quality of canvas. Having placed the canvas on the easel, Corot seized a piece of white crayon, and, after pausing a moment to consider his subject, he traced with peculiar masterliness and facility the chief masses of the composition. This outline at once became understandable to the onlooker, and from this the artist scarcely deviated in his finished picture, except to fill in details. From this first idea he himself used to foretell the fortunes of the subject. "Look there," said he, "something which shall yet be famous," and then leaving this canvas, to vegetate as it were, he would go to another, or carry forward a third, or complete a fourth, just as he felt inclined.

First ideas were only taken up again after undergoing a certain period of incubation. They were then put once more on the easel to receive the first painting or the sketch of the subject in oil colours. Armed with an ordinary palette, not very carefully arranged, and composed of decided colours, without half-tints, furnished with brushes strong and supple, the painter laid in his groundwork with raw umber, with black and white heightened by raw and burnt sienna and other scientifically good ochres; never, be it observed, with bitumen of any kind. Thus the first plan of his pictures was settled from the point of view of the values and the effect required, by fixing from the first on two extremes—the greatest light and the greatest dark. He emphasized also the principal masses with a firmness sometimes approaching violence, which he toned down afterwards with light transparent colours.

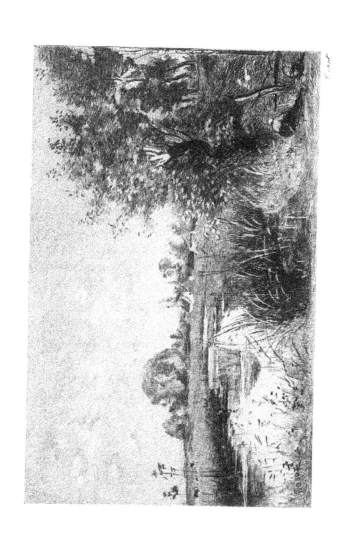

After this the canvas was again put away. Then, when the first painting had become solid enough to be worked upon, the artist sought to produce the complete harmony of his subject by transparent and semi-transparent colours.

It was Corot's habit to say when it became too dark for him to work, "Very well, you see *le bon Dieu* has put out my lamps for me," and he would take off his blouse, which was stained with all the colours of the rainbow, and go out to dine. He always ate a hearty dinner, for during the day he only took a dish of soup, very rich, full of small pieces of bread and smaller pieces of various kinds of vegetables. This was served by Adèle, his faithful housekeeper for twenty-five years, who placed the food in a corner of his studio, on an old table which, as was well known, would not stand steadily because one of its legs was shorter than the others.

In the morning before beginning to paint, Corot would look carefully over the large number of canvases, more or less finished, which encumbered his studio. He examined them one by one until he came to a subject which seemed to harmonise with his feelings that morning. When he felt gay and happy and was humming some old tune it would be a spring scene that would captivate him, and he would revel with his brush in a field of flowers, on a smiling river with the willows and reeds moving with the breeze. At other times he inclined to the severely classical landscape, grave and grand and full of sobriety and dignity.*

Corot always sang while he painted. The tune that was the accompaniment of the labours of his brushes was usually taken from music such as Glück's, or perhaps it would be a "*mélodie champêtre*,"—a song of the fields—like those one hears in France in the evening near the villages when the harvesters return from their labours. When he was painting the details of a landscape, he would raise himself, consider well his canvas and resolve what was necessary to be done. In these few minutes he observed carefully

* Albert Wolff, in *Le Gaulois*.

L

what was required and re-seating himself before the easel he would touch here and there to complete the picture, all the while humming and singing,— "Let us put that there—tra la la, tra la,—a little boy,—ding-dong, ding-dong,"—and the brush called into semblance *le petit garçon* at the same time he finished his tune. Then again he would sing, "Oh! a little boy, he wants a cap—la la la, tra la; the cap is there—*voilà*—tra la la, tra la," and the cap too by this time was finished, and so he went on nearly all the day, ever happy and cheerful.

A. Marx, in *Le Figaro*,* set down a very interesting conversation he had with Corot, giving a valuable account of his method of working. It may be freely rendered thus:—"People are surprised that painters should know what effect will be produced by colours some yards off, although they are painted without the artist going any distance away." "Yes," Corot said, "that is entirely learnt by experience. When a youngster commences to paint he makes a daub, and then he walks back from his easel in order to judge of the effect of the mess some yards off. Then he returns and seats himself again and tries new tones and colours; then back he goes again, and again returns, and so on until the picture is finished. My first pictures have caused me to take so many paces backwards and forwards, that each one represents over a hundred miles. Then, getting accustomed to painting, I gradually changed my method, and, of course, went a less number of kilomètres for each. To-day my hand acts almost always just as I want it to do, and indeed, I could mention certain pictures which truly I never really saw until they had been signed, framed, and paid for." Again he said: "At first I often felt sorely tried when, wishing to paint a sky from nature, I found the clouds stealing off too quickly. 'Stop!' said I, trying to do as Joshua did with the sun. But Joshua had a command over the firmament which very evidently I had not. My clouds continued to drive along, the sky changing in colour and form, and setting me at defiance by the metamorphosis. One morning,

* February 24th, 1875.

in my vexation, I went to them, calling, ' *Nom d'une pipe*, remain there for a minute before me, for I do not want to paint you wrongly.' It is with shame that I confess these memories, for a sky standing still is not a sky at all. The talent of the painter consists rightfully in rendering the changing tints and majestic movements of the luminous masses in light or shade which float in the atmosphere, driven gently or strongly by the strength of the wind. And we have a proof of this in that we feel pleased when a connoisseur says to us when we direct attention to the clouds in our canvases, ' *Mes compliments*, your clouds move well.' "

Corot wrote a letter to Mr. J. Graham, describing the feelings of a landscape-painter during a long and beautiful day in the country. He begins at three o'clock in the morning before the sun has reached the horizon. The sun rises, the flowers open, the birds sing, and the leaves flutter, and the mists of the morning gradually mount and float away. Then the morning passes into bright day, and the full sun into the afternoon, and evening approaches, then sunset, and afterwards the stars commence to twinkle.

" Do you see," Corot wrote, " it is charming—the day of a landscapist. One rises early, at three o'clock in the morning before the sun rises, one goes and sits down at the foot of a tree, one looks and waits ; he does not see much at first—Nature resembles a white tablecloth, where he can hardly distinguish the profiles of some of the masses. Everything is scented, everything trembles with the fresh breeze of the dawn.

" Bing ! the sun is clear ; it has not yet torn away the mist behind which is hid the fields, the valley, the hills of the horizon. The nocturnal vapours still float like silver clouds over the benumbed grass. Bing ! bing ! a first ray of the sun, a second ray of the sun. The little flowers seem to awake joyously. They each have their dewdrop which trembles ; the leaves shiver in the morning breeze. In the trees the invisible birds are chirping. It seems to be the flowers offering their prayer. The lingering loving breezes gently sweep the fields and undulate the high grass. One sees nothing, but

everything is. The landscape is entirely hidden, although altogether there, behind the transparent gauze-like mist which rises, rises, rises absorbed by the sun, and permits in this rising the river to be seen like a blade of silver, with the fields, the trees, the cottages, the distance flying from you. One distinguishes at last all that one guessed before.

"Bam! bam! the sun has risen. Bam! the peasant is passing the end of the field with his cart harnessed with two bulls Ding! ding! that is the tinkling bell of the leader of a flock of sheep. Bam! everything glistens, everything is brilliant, everything is in full purple light. The backgrounds of simple outline and harmonious tone are lost in the infinite expanse of sky through a breezy and azure air. The flowers hold up their heads, the birds fly hither and thither. A countryman mounted on a white horse is soon lost among the trees. The small round willows mark the windings of the river.

"It is adorable and then one paints, one paints! Oh! the beautiful chestnut-coloured cow, standing up to the belly in the marshy grass. I will paint it Crack! there it is—splendid, splendid; goodness, how striking it is! Let us see what this peasant will say, who stands watching me paint but is too shy to approach. 'I say there, Simon!' Good! here is Simon approaching and looking. 'Well, Simon, what do you think of that?' 'Oh, really, sir, it is very beautiful.' 'And do you see what I wished to represent?' 'I think I see what it is; it is a large yellow rock you have placed there!'

"Boum! boum! midday—the full sun burns the earth,—Boum! everything is heavy, everything becomes grave. The flowers hang their heads, the birds are quiet, the noises of the village reach us. There are the heavy works—the blacksmith whose hammers resound upon the forge. Boum! let us go indoors. One has seen everything, there is no more. Let us lunch at the farm—a good slice of the household loaf, fresh butter, eggs, cream, and ham!

"Boum! work, my friends. I myself will enjoy the siesta and dream of a morning landscape. I dream my picture, later on I will paint my dream.

"Bam! bam! the sun descends towards the horizon, it is time to return to work. Bam! bam! the sun still sinks in the midst of an expanse of orange yellow, fiery red, cherry and purple—ah, that is pretentious and vulgar, I do not like it. Let us wait, let us seat ourselves at the foot of this poplar near this pond as smooth as a mirror. Nature has a tired look—but the flowerets seem reanimated. Poor flowers! they are not like us men who grumble at everything. They have the sun at their left—they have patience. Very well, all right, it is well, they say ; by-and-by we shall have what we want—they are thirsty, they wait. They know that the sylphs of the evening will moisten them with vapour from their invisible watering-pots ; they still take patience in praising God.

" But the sun sinks more and more behind the horizon. Bam! he throws his last ray, a streak of gold and purple which fringes the flying cloud. There, now it has entirely disappeared. Bien! bien! twilight commences. Heavens, how charming it is! the sun has disappeared. There is now in the sky only that soft vaporous colour of pale citron—the last reflection of the sun which plunges into the dark blue of the night, going from green tones to a pale turquoise of an unheard-of fineness and a fluid delicacy quite indescribable. . . . The fields lose their colour, the trees firm but grey or brown masses . . . the dark waters reflect the bland tones of the sky. One is losing sight of everything—but one still feels that everything is there—everything is vague, confused, and Nature grows drowsy. However the fresh evening air sighs among the leaves—the birds, these voices of the flowers, say their evening prayer—the dew scatters pearls upon the grass, the nymphs fly, hide themselves and wish to be unseen.

" Bing! a star from the sky which plunges into the water—charming star, of which the shivering water augments the twinkling. You smile at me—in winking the eye your twinkling brightens. Bing! a second star appears in the waters, a second eye opens—welcome, fresh and smiling stars! Bing! bing! bing! three, six, twenty stars. All the stars of the sky meet in this

happy pool. Everything is again darkened—the pond alone glitters—it is a swarm of stars. The illusion is produced—the sun having gone to bed—the sun of the interior soul, the sun of art, rises. Good, there is my picture completed.''

So far as we have been able to discover, Corot made few replicas, except of very important pictures. For example, '' L'Etoile du Soir '' is in Toulouse, the small copy in Baltimore, and ''Danse des Nymphes '' appears often to have been repeated. One of the most complete of the last-named subject, '' Danse des Nymphes,'' is in the collection of Mr. T. G. Arthur of Glasgow. We give a wood engraving of it opposite page 24. It is interesting to compare the design of this picture with '' Une Matinée,'' from the Louvre, illustrated on page 34.

It has been related that when a patron desired to have a repetition of one of his subjects, Corot painted it without reference to the original picture or sketch. He would sometimes say, ''I preserve in my heart and in my eyes the copy of all my works.'' In this, however, the painter was probably a little in error ; he might make his second canvas similar or near enough to please his buyer, but he would unconsciously make variations. '' The Wood-man's Cottage,'' here illustrated, is a reproduction of Corot's work in black and white from nature. Corot made a mistake in not keeping all his sketches. His earliest ones he appears to have retained, but of his later ones some were certainly sold.

Corot had a considerable number of friends and followers, who called themselves his pupils. The chief of these were Appian, Auguin, Charles Boulogne, Chintreuil, Delpy, Dieterle, Daumier, Damoye, Louis Français, Flahaut, Charles Le Roux, Lavieilli, Lacroix, La Rochenoire, Lépine, Masure, Oudinot, Petitjean, Renault. Besides these there were a number of young painters who became self-styled friends and pupils of the great painter, although they based their claims on somewhat scanty grounds. It is always

attractive to certain minds to declare they were intimate with a great man, and the world is full of such instances. But Corot was a man with so many acquaintances, that with very little self-deception, each and all might consider themselves as amongst his intimate friends.

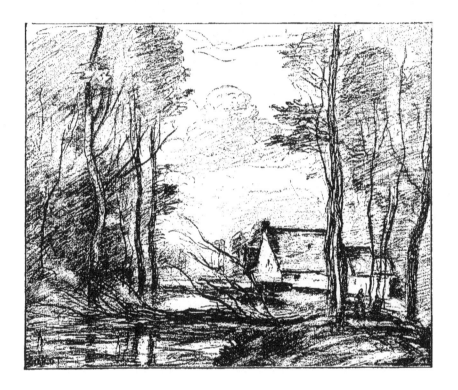

The Woodman's Cottage. From a Sketch by Corot, 1870.

Corot's relations with his pupils were of the friendliest description, and he never wearied in trying to inculcate in them lessons of truth in painting. He would say to his pupils, " If before nature God does not speak to you, it means that your hour has not yet come or that you have mistaken your way.

Go and search elsewhere." " In an artist's career, conscience is necessary, confidence also in himself, and perseverance. So armed, the two things in my estimation of the greatest importance are : severe study in drawing and in learning values in painting." Such were his favourite sayings, and we may conclude by quoting an anecdote of a deaf-and-dumb pupil accepted by him in 1865. At the first lesson Corot summed up all his theories in a single word—CONSCIENCE—which he underlined three times. This was, in short, the sum of all his labours and the end of his artistic existence.

From Corot's Sketch-Book.

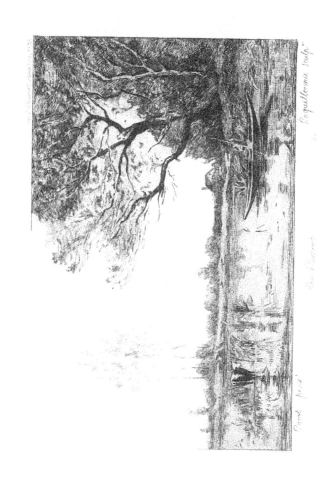

Corot and his Pipe. From an Etching by Bocourt.

COROT: CHAPTER VII.

CHARACTER ; PERSONALITY ; CHARITY.

THE character of Corot was one of the most perfect imaginable. He does not seem to have had a single personal enemy, although his work was in such direct and constant conflict with many of those who were considered the first painters of the day. His pictures were laughed at, sneered at, and openly despised by a great number of people who professed ability to judge, and whose verdict was accepted by the ordinary public. Yet he never retorted angrily, nor lost his temper during the long-continued strain of waiting to be understood. He went on calmly and serenely, but not too provokingly, and the result was that he was entirely free from the petty personal jealousies and squabbles of the art world.

M

Having no touch of jealousy in his nature, he was always pleased to see the works of a friend and the efforts of his followers. He visited the Salon every year, and took time to judge of everyone's labours, however hasty these others may have been in judging of his. He spoke of Théodore Rousseau as an eagle compared to himself, who, in his own estimation, was only like a lark singing songs amidst the quivering trees and gently moving clouds. And many a young artist could tell with gratitude the words of help and comfort Corot had spoken to him. The universal name for him among the students was Père Corot; he was so upright in character, so full of love and sympathy, so sincere, so happy, so helpful, in short, so like an ideal father. He had nothing of the haughtiness sometimes found amongst great painters; he was sweet simplicity itself, compared to some of the Academic School, but with all his gaiety, his brightness, and his sympathy, he never lost his influence and his dignity. His modesty and general good feeling disarmed those who envied his position, and those who might have been willing to say uncharitable things had any opportunity been found.

In personal appearance Corot was much more like a farmer than an artist. He dressed as he felt inclined, without reference to fashion, and was thus always to be remarked when he appeared in Paris. At his home in the country, his farmer-like appearance suited him well, and the country-folk never spoke of him but as one of themselves. Corot is described by Dumesnil as "a well-made, robust man, of iron constitution, healthy aspect, frank and free to all, with a happy expression of eye, which won all he met, his accent a pleasing mixture of *bonhomie* and courtesy, and his whole appearance ruddy and well-favoured, altogether much more like a well-to-do country gentleman than one having any connection with the Fine Arts."

As we have said, he was descended from farmers and vine cultivators, and his grandfather on the paternal side was the son of a cultivator at Mussy-la-Fosse, near Semur, in the Côte d'Or. He visited this district about 1860, and he was a little astonished to find his name so common. " The country,"

he said, "is full of people who have the same name as I have, and I was always thinking they were calling me."

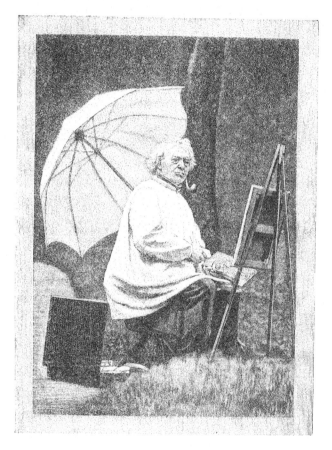

Corot at Work. From a Photograph from Life

At sixty he walked as erect as a man of fifty, with shoulders square and chest expanded. His looks were manly, with a somewhat prominent chin, always well shaved, pronounced cheek-bones, a mouth which frequently

M 2

carried a half-comical smile, and often laughed gaily, but which in repose betrayed strength of will as well as a shade of melancholy. White hair, fine as a skein of silk, covered a forehead that glowed with a kind of patriarchal grace. His eyes were dark blue, quiet, limpid, and a little unrestful, like those of a young infant. When he was animated in enforcing a doctrine or defending an argument, his eyes threw out glances like flashes of fire. In his studio, Corot's headpiece was a little bonnet of striped cotton, his dress a blue blouse, his neck having a large collar well starched and stiffened.

No one was less pretentious than Corot, but he was quite unable to bear stupid enquiries about his pictures, or the reproach that any one thought they were not finished enough. This perhaps annoyed him more than anything else He knew well what drudgery he had gone through to acquire his power, and the fact that his ability to restrain himself from finishing too much was his chief difficulty, made him rather impatient with those who accused him (meaning to find fault) of doing what he had carried out with set purpose. He could have niggled up his pictures had he thought it advisable, but all his experience and knowledge showed him that this finish was unwise, and was not in his opinion to be thought of, in the preparation of a good work of art.

It is certain that amidst all the gaieties and temptations of Parisian life, Corot preserved a simplicity and purity of life altogether remarkable. His mother's home, and afterwards his sister's counsel, seem to have been his chief delight, and up to the last their attention did not fail to satisfy him. Corot having lived for many years amongst the most Bohemian circle of Paris, a question forces itself upon the attention even against the will. The answer is contained in a paragraph of a letter written in 1889, by one who was for many years personally intimate with the painter. " Corot was purity itself. He had never any mistress but one, a true, a great mistress, an idol visible and palpable to every one ; from her he received from youth all his purity, his chastity, his passionate attachment to nobleness and worth. You know her as

well as I, she is ' Dame Nature.' " The sensual element was indeed singu-
larly undeveloped in Corot's character, and his pictures show that his purity
was sincere and without affectation. Together with a love of music there
is no doubt that Corot had the religious sense very strongly, and some of his
intimate friends were ministers of religion. In Paris where it has so long been
the fashion to be sceptical and anti-religious, the weak-kneed critics of the
Parisian press have found themselves forced to speak of Corot's religious
feelings as if they were a defect. In English-speaking countries this shame-
facedness in such matters may well be despised, for we can readily acknowledge
and believe that Corot was eminently a religious man. His pictures show it,
and his actions prove it. No one could accomplish what he did, unless they
believed in *le bon Dieu*, about whom he would often reverently speak. Moreover,
whatever the French critic may affect, we English Protestants at any rate do
not think any the less of Corot because he wished to receive the last
sacrament of the Roman Catholic Church on his deathbed. It was only
in keeping with his general character, and a fit ending to a long and noble
career.

One of Corot's best friends was the priest of the village of Coubron, near
Livry, within ten miles of the north-east of Paris, where Corot often spent his
time. They supped frequently together, and the master, who was an intrepid
drinker, did not fail to joke, always in measured terms, upon the sobriety of
the Abbé. " When the cheese came on," says A. Marx, " he sang with his
excellent tenor voice airs of Glück, his favourite composer, and he mingled his
singing with suitable quotations from Virgil."

The same writer tells a characteristic and interesting anecdote of Corot and
a celebrated preacher, Father Monsabré, who was introduced to him by Ber-
thelier, the singer. An appointment was sought, and Corot answered in these
terms to Berthelier, who had proposed the visit by a letter:—" Bring me your
illustrious friend, I shall be happy and proud to show him my studio. There

is, moreover, a point in common between us. Both of us, we try to make God loved, he in preaching his glory, and I in painting his nature! One more word: do not come on Wednesday—I have a nude model. I will await you on Thursday."

It happened that Berthelier lost this letter, and, confounding the days, landed at Corot's place on the Wednesday in company with the Dominican. The sitting was happily finished and the model had dressed herself, but the canvas was still on the easel showing in broad daylight the well-made form of the model. We can imagine the embarrassment of the master, the trouble of Berthelier. "Idiot," growled Corot, in his frank way: "will you always be absent-minded? You have put your foot in it. It was to-morrow you were to have come." "I read Wednesday, and it was Thursday," stammered Berthelier, with a piteous air. However, *le Père* Monsabré had approached the sketch, and was examining it with admiration, to the great wonderment of the two others. "This nudity," said the eloquent Dominican, "traced by the brush of a bad painter, would be ignoble and repulsive. But from the palette of M. Corot it has I know not what of ideal and seraphic feeling which transports me. In gazing at it I think of heaven and not of earth." "My reverend Father," said Corot, embracing him, "you are not only a great priest, you are also a great artist."*

Besides his many other claims to consideration Corot was in a position to think himself, if he chose, even a greater personage than a poor painter— some may think that it constituted one of his first claims to respectability—he was a landlord, and that to a considerable extent. With an income said to be as much as 200,000 francs (£8,000) per annum in his later years, being brought up to this amount by his many commissions for pictures, he had plenty of money and he had invested some of it in house property. But as he had nothing of the ordinary hardened feelings necessary, or at least usual in a landlord, he gave the guidance of his estate to a kinsman who "understood

* A. Marx, in *Le Figaro.*

business." But it sometimes happened—as was related by a French journalist in 1874—that in bad times the tenants could not pay. Then they would come to Corot and tell him their troubles, that the kinsman would not trust them, and that they did not know what to do. The generous landlord was more than once known, after hearing a doleful story, to go to his desk and give his own tenant the money to pay his own rent. "I cannot concern myself with all you tell me," he would say. "But, *mon ami*, run and find my manager, pay your rent, and I will have nothing to say. Only do not on any account tell him where you got the money, or I shall have a dreadful scolding." *

This story is a fit introduction to many anecdotes which have been told of Corot's charity. His giving was large and often indiscriminate, but he preferred to give to half a dozen who scarcely deserved help, if the seventh proved to be a case of real distress. His Christmas boxes were noted in the neighbourhood and by all the tradespeople who came to his door.

It has been related that Corot was working at his easel one day, when there entered a young man, unknown to him, pale and having upon his face traces of despair. "What can I do to serve you?" asked Corot. "Monsieur," answered the new-comer, "I have not the honour of being known to you, but I have heard of your goodness to fellow-artists. I am unlucky, requiring 500 francs, or I must blow my brains out. Here is my address—such-and-such a road, such-and-such a number—make enquiries and you will learn that I am an honourable man. But without the 500 francs I shall be obliged to kill myself." Corot stammered and said he had not the sum required. Upon this the young man retired, and the artist reseated himself at his easel. But his eye was no longer sure, his hand shook. "Well, no!" says he to a friend who was present; "no! I lied to that young man—I have the 500 francs, and I did not give them to him—this cannot be allowed to go on; let us see." He then ran to his desk, and quickly wrote these words :—"My dear confrère, come quickly; I have the 500 francs at your disposition.—Corot." Then he

* Albert Wolff.

returned to his work, saying to his friend, "Now then, it goes much better; you will see I shall paint a good picture."*

Another somewhat similar story was published at the time of Corot's death. A needy artist came to his place on three successive days, and within these three days drew from him 5,000 francs. The fourth day the borrower

returned, but Corot was absent, so he left a note wherein he informed the master that he required another 5,000 francs to prevent him being dishonoured. Corot, who enters very late, finds the note, goes to bed but does not sleep well. Early the following day he seeks the unhappy young man and says to him, "I have the pleasure to announce to you that yesterday evening I sold a picture, the price of which amounts to the half of the sum you require; you make up the other half yourself." This was done and Corot added, "Are we not lucky?—we have each gained 2,500 francs."

One day it was a lady who was waiting downstairs in a carriage for 1,000 francs which she required to pay her rent. "She is very well dressed," said the servant, who

Panel by Corot.
In the possession of Sir F. Leighton, P.R.A.

caught sight of her. "I cannot understand how one can borrow money with a similar toilet. In your place I would refuse." "Give her that, my girl," says the painter, handing her the note asked for, "and remember that the worst kind of misery is the misery dressed in silk."

Reference is made in an earlier chapter to an incident illustrative of his

* George Duval, in *L'Evènement.*

profuse liberality. He was summoned to appear at the bureau of his arron
dissement, to receive back 5,000 francs which he had subscribed for the libera-
tion of the territory still in the hands of the Germans. "I will not take the
money," said Corot; "nothing annoys me more than returning to my pocket
that which has once gone out; my purse would not like it, and, besides, it dis-

arranges my accounts." "Well, then,"
replied the Mayor, "would you like me to
give these 5,000 francs on your behalf to
the professional school for young boys?"
"Perfect!" exclaimed the landscapist, and
he went away, but had hardly taken twenty
steps before he returned. "Monsieur le
Maire," he said, tendering to the magistrate
five notes of a thousand francs, "there must
be no jealousy; you have also, no doubt, a
professional school for young girls?" and,
giving the money, he retired quickly.*

Panel by Corot.
In the possession of Sir F. Leighton, P.R.A.

Corot's assistance to young painters is
mentioned elsewhere. He judged with an
indulgence full of common-sense the studies
and pictures that young painters brought
to him, using an inexhaustible delicacy and
generosity to assist whosoever was poor
or disheartened.

In a room above Corot's studio, in the
Rue Paradis Poissonnière, there were stowed a considerable number of pic-
tures, good, bad, and indifferent, which had been given to him by artists whom
he had assisted in time of need—sold to him was what he called it. He always
said, on giving money in exchange for these unsaleable wares, "I am your

* A. Marx, in *Le Figaro.*

N

banker only. Some day these pictures will make my fortune." But of course when it is remembered that these works were executed by the artists in time of extreme discouragement and trouble, it is little wonder that few excellent ones were found amongst them.

Yet with all his charity Corot never overran his income, for he kept intact to his sister and her family the considerable fortune which he inherited from his parents. For many years his allowance of £60 kept him until he found customers for his pictures and he soon paid all this back. The money he earned in later years he fully employed in the various charities and pensions he kept up, without letting his left hand know what his right was doing. The £2,000 (50,000 francs) distributed to the poor people who suffered by the siege of Paris was, however, one he could not keep hidden.

It has been alleged that one reason Corot found so little encouragement in his early days was because he was a republican, but this is not the case. Exclusively occupied by his work Corot never had any political sentiments of a pronounced character, and he was so indifferent to all that passed outside his studio, that he did not even notice the *coup d'état* of December, 1851. It is related that two months after the establishment of the empire a political friend found him painting a moonlit forest with nymphs dancing. "You are happy," said his visitor, "you paint things gay and smiling, and we have just changed the government. There has been a *coup d'état* and we have strangled the republic." "My dear friend," answered Corot, "I have been so much occupied in making my nymphs dance in my forest, that it is three months since I opened a paper, and I was quite ignorant of the fact that we were no longer under a republic."* Corot was a republican, but of a very mild type, and more because he believed that every man should stand on his own merits than because he admired the republican form of government.

While Corot was delighted to help the poor and struggling, and to hold

* *Paris Journal.*

out assistance to the young artist, nothing gave him more entertainment than to treat somewhat disdainfully, yet politely as a gentleman would, the crowds of buyers of pictures who came in his later years. He received these "Philistines" and fashion-following friends in a spirit of slight contempt, and he always made them pay well for their purchases.

Only his more intimate friends found access to the studio, where he might have been bothered with visitors who would have hindered his work. Dealers in pictures were only permitted to enter at certain fixed times, and after they had received an appointment, while the private picture-buyers who in Corot's later years began to come about the studio which they had so long neglected, had to be content with very slender consolation. He would say to them in reply to the enquiry as to when they were to have their picture so long before ordered—"Yes! you will have your picture, Monsieur. When? I really do not know. I will write it in my *livres des commandes*—your number is 328." During his latest years, amidst the crowd of people who came worrying the artist to sell them a picture, Corot was easily able to discover a picture-lover worthy of attention. It is stated that when he found himself in the presence of a man who really loved pictures for themselves, and not for what they would fetch some day at auction, the old artist would lay down his palette, attentively observe his visitor—looking as if he would search down to his very soul—and if he found there genuine enthusiasm for the beautiful, the love of the greatest art, his heart bounded for joy. Then a few days afterwards he would escape from his studio, run into the country, and return at the end of a few weeks with a splendid subject, which he would sell at a moderate figure to the interesting visitor, in the teeth of the vulgar buyers who knew nothing of art and who had waited for some years.

Corot lived in a little apartment on the first floor above the entresol, 56, Faubourg Poissonnière, near his studio. "For work," he used to say, "it

* Albert Wolff, 1874.

N 2

is natural that you ascend; for rest, it is logical that you descend. In work it is the mind that raises itself. In sleep it is the body which lies down."

Nothing could be more prosaic and more bourgeois than this interior, which was in perfect harmony with the commercial and practical quarters of the Faubourg. The dining-room, which entered from a very small lobby, was floored by black and white marble squares. The furniture was in full mahogany, and in the empire style. One saw on the sideboards porcelain vases covered with glass cases to keep off the dust. On the walls were hung family portraits, painted by pupils of David or Girodet. The windows of the salon were curtained with brown damask. The bedroom was very light, as is that of nearly all people who like to rise early.*

Corot's studio was well guarded by a concierge who was famous for growling at strangers. This man invariably said, "*Il n'y est pas*" ("He is not there"), and it always was difficult to see the painter without appointment.

His studio afforded nothing very remarkable to the visitor, with the exception of a collection of sketches, which represented by the difference of their degree of finish the working of his talent. They did not see there the ancient furniture, the objects of art, the priceless tapestries, which encumber the studios of more modern celebrities. Everything showed work, from the low chair the straw of which stuck out, to the old sofa whose cloth was torn from the incessant contact of friends and visitors.

At the first easel near the door on the right Corot ordinarily sat working, with a sure eye and steady hand, without any mahlstick or support. Moreover, the four or five easels scattered about in the studio were nearly all furnished with canvases, and going from one to the other Corot worked now here, then there, rarely giving more than half an hour at a time to any of them. In unusual circumstances he has been seen to pass two or

* A. Marx, in *Le Figaro.*

three hours at the same work, but this in his later days was always an exception.

Assuredly one of the most singular of Corot's visitors was that of the country connoisseur who came to his place in the hope of buying a picture, and who is described by the old friend of the artist, M. Robaut. Struck with the number of canvases hung on the walls, placed on all sides upon easels and up against their feet, he found nothing else to say except, "But this is a manufactory, this is a manufactory;" and after having made this exclamation once or twice he could say nothing else but went away without making a purchase.*

In the drawer of the broken-legged table in his studio Corot kept his innumerable pipes for indoors and his cigars for out of doors, as well as his little parcels of gold and silver. It was from this drawer he took money when he went to the end of the passage to answer an importunate or secret beggar. After having satisfied the request he often returned with a tear in his eye, and, a minute after, would gaily recommence his work, humming, "The Lord grant my prayer! you will see pass upon my canvas the pretty branches and the little flowers—Ah, how good it is to be able to help a poor friend. It is there, I assure you, that I find what is the most beautiful thing in art. Here, now that you have seen what has passed, you will witness that I will recoup myself in one hour the double of what this unhappy man has received."

After J. F. Millet's death, and while it was still doubtful how his widow would be left, Corot added a gift of no less than 15,000 francs (£600) to the £48 per annum accorded to Mdme. Millet by the state.

And so Corot went on, almost all the day, ever happy, bright and cheerful, his heart running over with joy and good-fellowship; a thoroughly good man, with a full fountain of love for all humanity; a man adored by all who knew him, a friend to the poor, an example to the rich; one of the

* Alfred Robaut, *Le Monde Illustré*, 1875.

finest characters in private, and a splendid evidence that a man may be an artist of the greatest power while he remains modest, lovable, and kind. In short he acted up to the highest ideal in endeavouring on every possible occasion to do what was not only just, but also what was exceptionally generous; and he was rewarded by the strong attachment of a multitude of sincere friends.

La Chaumière. By Corot.

THÉODORE ROUSSEAU

Rousseau's House at Barbizon, 1850 Fac-simile Sketch, with Autograph Note
(From "Etudes de Th. Rousseau" Paris Amand-Durand & Goupil.)

THÉODORE ROUSSEAU:—INTRODUCTION.

WHILE the pictures of Corot demand a certain amount of previous knowledge before they can be enjoyed, the works of Théodore Rousseau appeal more rapidly to the untrained spectator. This arises from the greater conventionality of Rousseau in the composition of his pictures, and also because he never considered a picture finished until he had shown every detail possible on the canvas. The traditions of painting, as handed down from the old masters, are very apparent in Rousseau ; and as people have grown up to believe in certain methods of treating landscapes, so do they the more readily understand the aim of a painter who does not feel it necessary to disturb these traditions.

From Claude Lorraine, Hobbema, Van Goyen and others, including the

French painter, Georges Michel, who died in 1843, Rousseau learned some of the old-master style of rendering landscapes; and while he was able to carry their theories out through a purer study of nature, their influence remained strong to the last. He was also undoubtedly influenced, directly or indirectly, by the English painters who exhibited in the Salon of 1824, and thus he combined all the best qualities of both the old classic school and the new naturalistic school of painters.

Every original artist, in order to make himself understood, has to educate a *clientèle* for himself, as it were, and wait until this has been formed. Sometimes he waits patiently, but more often impatiently; for a man who is an artist must be sensitive and emotional. Rousseau came with the flowing tide, but he helped to guide that tide and the way in which it flowed even more than did his colleagues. With Diaz as his actual pupil, and Millet as a friend who greatly esteemed his criticism, his influence was very wide, culminating in 1867 when he was chosen chief of the artistic section of the Paris Exhibition. When Rousseau commenced his career, Constable's landscapes were on every French painter's lips, while Corot was only beginning life in a professional way; and none of the colleagues afterwards so closely associated were much more than beginners.

Rousseau's strength lay in his ability to depend entirely and absolutely upon himself. Except by Millet in his last days, Rousseau, after he had thoroughly realised his powers, seems never to have been moved by any disturbing influence. He knew what he wanted to accomplish, he resolutely set himself to do it, and patiently persevered until he succeeded. His art is somewhat stern and austere; *magistral* like a stately poem, grave like Gregorian music, seldom or never gay, yet always possessing a reserved force of cheerfulness and serenity. It is art which seems to walk in exalted footsteps, while it raises and even dignifies those scenes of the forest, the ravines, and the long open country which Rousseau was most successful in producing.

Rousseau's pictures are commercially more valuable than either those of

Corot, Daubigny, or Diaz, mainly because of these characteristics, and also because of the scarcity of fine and finished pictures from his brush. He was so conscientious and often worked so long at his picture that months would pass over before he allowed a simple canvas to leave his studio. Sometimes he continued to paint on his pictures long after they were really completed, and his friends had to resort to stratagem to take them out of his hands.

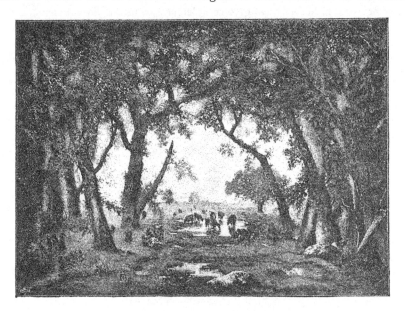

The Rising Sun. (Compare with Etching from the Louvre Picture of nearly similar subject.)
From a Photograph by Braun, Dornach.

His best pictures which can be readily seen are the " Marais dans les Landes " and " Soleil Couchant," in the Louvre. These are broadly treated and excellently studied. American collectors are said to prefer his highly finished subjects where the leaves and blades of grass may be literally counted on the canvas. Unfortunately there are none of Rousseau's works in any of the public galleries of Britain.

Rousseau preserved all his studies from nature, and would occasionally look over them, treating them as things too precious almost to handle. " He loved nature as a lover his mistress," Burty has said; and to this Chesneau added that he translated the grave and severe poetry of the vigorous earth, of the robust vegetation, in a way never before accomplished. He rather disdained "subject" in a picture, although, as a rule, he introduced figures or cattle in his works to give completeness, while he did not encourage the ordinary literary interest of telling a story.*

* Those who wish to know details of the minor incidents of Rousseau's life should consult Sensier's " Souvenirs sur Théodore Rousseau " (Paris, 1872), which contains some of the most reliable information on the painter and his pictures. Certain events in Rousseau's history are described in full, and as Sensier had great facility for obtaining information, his book may generally be relied on as correct in these details. The work is somewhat uninteresting, for it is without illustrations, and as it has been long out of print it is practically a sealed book to the English-speaking public. The volume is the leading authority for the historical portion of the succeeding pages.

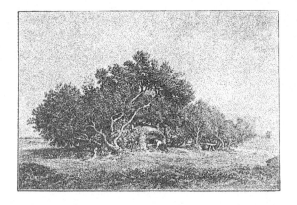

Une Lisière de Forêt By Théodore Rousseau.

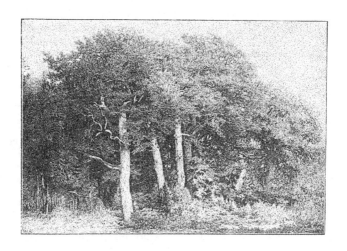

The Great Oaks of Bas Breau By Rousseau From the Drawing in the Collection of N. Mesdag

THÉODORE ROUSSEAU :—CHAPTER I.

COROT, as we have seen, saw the light in the Rue du Bac, and Daubigny, as we shall afterwards see, was also a native of Paris, although he was early removed to the country. Rousseau was, too, a Parisian, and born in the street now known as the Rue d'Aboukir, near the church of St. Eustache. The street was then called Rue Neuve St. Eustache, and there at No. 4, Pierre-Etienne-Théodore Rousseau was born on the 15th of April, 1812.

He was an only child of parents who were peculiarly amiable and affectionate, and who prided themselves on living in the old-fashioned way ; hard-working, active retail shopkeepers, loving their parents, children and relatives, and living lives full of unostentatious happiness. There are not many of the race left in Paris now, but even there they are still to be found, while such people are not uncommon in the villages away from the larger towns in

France. Like most men who have come to excellence, Rousseau had a mother of more than ordinary ability. She was delicate in health, however, and found her time abundantly occupied in attending to the affairs of her own household. She was the life of her home; and while her husband was devoted to her, Théodore, her son, had for her "a respect the most deferential and a passionate attachment which lasted all his life." The father was a *marchand tailleur* of sound integrity and good bourgeois position.

A considerable number of Rousseau's family had been artists, and there is little doubt the artistic instinct afterwards developed by Théodore was hereditary. He was amongst artistic affairs from his earliest, but there was the usual trial of commercial pursuits before his parents were satisfied that he too should follow art as a profession. Rousseau was not kept so long at business as was Corot, but still it was long enough to give him sufficient training, and proved of service in the future. As a boy he displayed aptitude in learning, and even unusual cleverness in his studies. One of the stories told of him is in connection with the school at Auteuil where he was educated. When a competition was being held, permission was given to the boys to take a walk during a certain interval. Rousseau was the only scholar who left his studies, while all the others chose to remain hard at work, but the fresh air did him good, and in the result it was found he was the winner of the chief prize.

During his holidays, Théodore was always particularly anxious to visit a certain cousin of his mother, whom he called Uncle Pau. This relation was a painter who occasionally exhibited landscapes at the Salon. When the boy was there he would beg some old bladders of oil colours—it was before the time of collapsible tubes—and with them try to make copies of his uncle's paintings. It was observed that he always represented the feeling of atmosphere in his copies, and this, says Sensier, came by instinct and was not taught to him. He copied engravings with fidelity, marking every detail with wonderful exactitude. He soon began to make sketches on his own account, and one which,

when quite young, he painted of the Place de la Concorde, although feeble in the forms of the details, was well rendered in the management of light and shade.

Rousseau's father had a friend, a sculptor, called Maire, who had conceived a plan of establishing a factory in Franche-Comté, in the east of France. This undertaking was for the purpose of selling wood taken from the forests of that region, and embraced a chain of saw-pits for cutting the wood near the spots where the trees were felled. Théodore at about twelve or fourteen was invited to accompany Maire as an assistant, to keep the books, conduct the correspondence, and probably also to take charge when the chief was out of the way. Rousseau, in fact, wrote many letters at this time, which showed such good business capacity and promise that his parents decided to make him a civil engineer.

During Théodore's residence at the saw-pits, he was continually amongst the trees, and his occupation sometimes took him into the very heart of the forest, where the hand of man was quite untraceable. Spending many days in their deep glades, Rousseau became imbued with the very essence of the forest. He drank deep of the feelings of grandeur and solemnity with which it inspired him, and he was greatly influenced in his future pictures of Fontainebleau by the lessons learnt in Franche-Comté.

Rousseau's father, however, had made his plans without calculating on his son's individuality, and on the youth's return from the country there was considerable discussion. Théodore's mind was made up to follow art, for, as we shall presently relate, he made certain trials of himself and felt satisfied this was the only labour at which he would be successful. After a little time, on seeing his son's firmness, the worthy tailor gave way, and after the decision was finally taken he never uttered a word of protest against the choice. Yet this decision was a great disappointment for the old man. Prince Talleyrand, who was his patron in 1815, had deposited some valuable securities with the tailor, and the Prince found, on the settlement of affairs, that they had been securely

kept and were restored in full. Talleyrand was grateful and would have helped the son, but, as we have seen, the youth decided to be an artist and nothing would dissuade him from it.*

Rousseau had felt the inspiration for the pursuit of art in his soul, and he had determined to prove it to himself before telling any one he wanted to become a painter. He purchased a box of colours and some brushes and went off one day to Montmartre, where Michel before him had found so many fine subjects. Rousseau sat at the foot of the old church and set himself to paint the scene there. He worked hard and did not seek to hurry himself, and in a few days he completed the little picture (10 by 8 inches) believed to be the earliest example of Rousseau's original work. It is dated 1826 and represents the old aerial telegraph tower, with a fine effect of distance. It was painted with great fidelity, the details being given with much minute care, and this picture, which still exists, contained promise of considerable mastery over the effects of atmosphere. The tower in the sketch was built on the ruins of an ancient abbey, but is no longer in existence. It was the sight of this work which had decided Rousseau's father, and the whole position changed. No more was thought of civil engineering or forestry—Théodore must be an artist like so many of his family before him.

Still, the parents were prudent, and after reflection they thought they would like to be sure their decision was for the best; so in 1826 they sent Théodore to his uncle Pau at St. Martin (where he had spent his holidays as a boy), and under the eye of this painter the youth made various studies. We may be sure Théodore did his very best under such circumstances, and in addition to showing by drawing and painting what he could do, no doubt he pleaded hard to receive the desired decision from his uncle. Pau counselled the parents to allow their son to follow his bent, and advised that the same year he should be sent to the studio of Rémond, whom he considered the

* Rousseau's father lived for more than a year after the death of his illustrious son. He retired to a house in one of the small villages in the Jura Mountains, where, at Salines, he had been born in 1787.

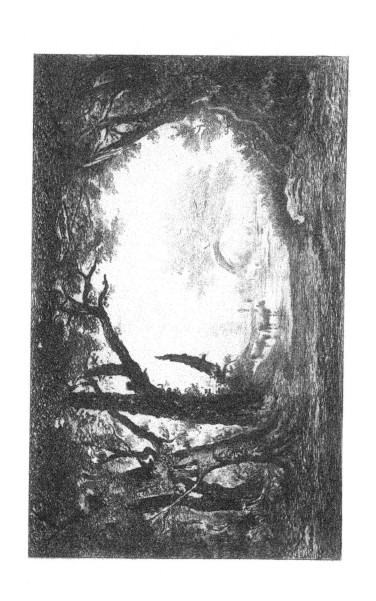

first landscape painter at the time. Rémond, however much esteemed in his day, is now well-nigh forgotten. He was a classic painter of the old school, and one who would teach care in composition as well as attention to detail, so that his influence was not very hurtful. It is certain, however, that the influence of Rémond upon Rousseau was almost nil.

While studying under Rémoud, Rousseau went sketching round Paris to Compiègne, Bas-Meudon and other places, and ultimately, in 1829, entered the studio of Guillon Lethière in order to study figure painting. This was another classicist of the old school, but much less stern in his ideas of conventionality and tradition than Rémond, and Rousseau and he always remained very good friends. When he was not engaged in this studio and the weather made it impossible to paint outside, Rousseau went to the Louvre to make studies from the old masters there, and it is specially interesting to note that the sunrises and sunsets of Claude Lorraine, and the animals of Karel du Jardin, as well as the landscapes of Van Goyen, were the pictures which interested him most. These paintings, as already said, exercised some influence over Rousseau—an influence which was to help to make his own pictures partake of the serenity and strength of the old masters, while they retained the unconventionality and interest of modern work.

In 1830 he made a curious study for a picture of the funeral of General Lamarque, which prefaced the republican movement of June of that year. It is described as an effect of sunset in the Cemetery of Père Lachaise, the sky livid and menacing, with crimson streaks from the sun extending over the tombs and cypress trees as well as over the crowds of people who were shortly to become revolutionists.

But Rousseau did not wish to spend all his days in or near Paris, and he determined to go farther afield. In June, 1830—the unsettled state of political affairs probably being the immediate cause of his departure, as he was no politician and only wanted to get out of the way of disturbances—Rousseau left Paris in search of nature in her wildest moods. He went straight to the moun-

tains of Auvergne, where, three hundred miles south of Paris, he found nature
untouched by human hands. Here he found a country and people who suited
his temperament well ; the rocks, the valleys, the streams, and the lengthy
level landscapes such as in his later life he so loved to paint. He spent whole
nights in the open air in order to observe the earth in darkness, and the
gradual appearance of light in the morning. He made friends with the
peasants, lived in their cottages, and did everything he could to arrive at a
correct understanding and estimate of the characteristics of the country. He
made many sketches in the Auvergne, which are usually marked with great
care in the values of their aerial effects. The compositions are often eccentric,
and the details are usually carried out with minute finish.

On Rousseau's return to Paris he showed the studies he had made to
Rémond, his first master, and the poor old classicist was greatly shocked at
the wide departure from tradition shown in their work. He was very angry
that his pupil had become so far left to himself, and there was a terrible
explosion. Rémond promptly if metaphorically consigned the young
naturalist to the shades below, and Rousseau was henceforth a stranger to
him. The parents of the young painter were sorely puzzled at first which
side to take, but their son's arguments were happily successful in converting
the old people to believe there were other ways of painting besides the
traditional one, and Rousseau with their consent was free to paint as he
liked.

The studies made in the Auvergne were taken by a friend to Ary
Scheffer, the Dordrecht-born painter who achieved great distinction in the
French capital, and who was then looked on as an eminently fair judge of
pictures. Scheffer, who himself painted figures in somewhat characterless flat
tones of much too even quality, was an intense admirer of the naturalist or
Romantic school of 1830. He constantly urged his own patrons to purchase
the works of Corot and Rousseau and others, believing they would stand the
test of time, and in many instances he was successful in finding buyers for

their works. Scheffer was greatly pleased with Rousseau's Auvergne studies, and had them hung in his own studio, showing them to all his friends as the work of a new and original painter. The assistance that an already established artist can render to a young painter is incalculable, and it is pleasant to believe that in no profession is more real kindness shown by the old to the young than in artistic pursuits.

Pursuing his studies during the day, Rousseau also went on with them in the evening, for in the studios of Guillon Lethière, where he occasionally returned, and of Gros he studied carefully the principles of perspective. The first-named painter was his great encourager, and especially pressed him to continue his studies as a landscape painter. Later at night Rousseau sometimes spent his time at a house of resort for artists, at 18, Rue Notre Dame des Victoires, where he smoked and listened to the other young artists who were rebelling against classic tradition, and who were in reality the Romanticists in Art and Literature of 1830.

Rousseau lodged at this time at 9, Rue Taitbout, St. Cloud, and there he quietly continued to paint, leaving to others the active discussion of theories in painting, wisely judging that these discussions were fruitless of real benefit to any one concerned. Rousseau at eighteen was at the threshold of his career, but he had already given promise of much capability for painting and many people were watching him with the belief that in a very short time he would be a great artist. He had comparatively few difficulties in the beginning of his career, and under the powerful patronage of Ary Scheffer he could look forward with confidence to the future.

In the Forest. From a Sketch in Oil by Rousseau. In the Collection of J. S. Forbes, Esq.

THÉODORE ROUSSEAU:—CHAPTER II.

FIRST PICTURE IN THE SALON; FONTAINEBLEAU; REJECTIONS; 1831—1843.

IN 1831 Rousseau first sent a picture to the Salon, then held in the Louvre. It was a landscape, "Site d'Auvergne," about forty inches long, representing "a valley surrounded by the mountains of the Cantal, in the centre a bridge in ruins, the arches broken, standing in a stream of water." The picture, though not much observed by ordinary visitors to the exhibition, was greatly applauded by the disciples of the new school of naturalistic painting, and was altogether a success. But the work itself has disappeared and is now probably in some old country mansion, and called, because of its classic look, the work of a much older master.

In the Salon of 1831, as we have occasion to mention elsewhere, there were contributions by Corot as well as Jules Dupré. No Salon had been held for three years, and all the younger men were trying to show their strongest works. The Romantic school, as the naturalists chose to call themselves, was now in full conflict with conventional classic compositions, and very soon the new theories were to greatly injure the old tradition.

Later in the year Rousseau went to Rouen, and travelled throughout Normandy, where he prepared about thirty elaborate studies, as well as a still larger number of sketches. In 1832 he returned again to the same quarter, and painted Mont St. Michel, but he only remained there for two weeks. He worked hard, however, and produced four well-finished studies and five times that number of drawings. It was at this period that Rousseau commenced preparation for his great picture of "Les Côtes de Granville," which was hung in the Salon of 1833. It was embraced in Rousseau's contribution to the great exhibition of 1855 and since then it has gone to Russia.

This picture revealed that Rousseau was one of the finest landscape painters of the time, and from henceforth he took his stand with the greater artists of the period. The "Côtes de Granville" was extensively criticised by the press and on the whole favourably. Lenormand, in "Les Artistes Contemporains," spoke of it as one of the strongest and truest landscapes the French school had produced, and said Rousseau's work was worth the labours of twenty of the most renowned of the landscape painters of the time.

Every movement in art as in politics requires to be written up in the press, and each revolution has its enthusiastic champion. In the revolution of 1830, so far as its artistic change went, the historian and general encourager was Théophile Thoré, a critic of much acumen as well as personal power of attraction. Thoré lived with Rousseau for some time, when they were both young, and up to 1848, when Thoré was exiled for political reasons, they were the very closest of friends.

Thoré held up Rousseau in the press as a great creator amongst painters, and sometimes in his enthusiasm went beyond bounds in his criticism. Yet Thoré has his place in the history of the school of Barbizon, and was the first to teach in literary form the beauties and strength of the painters with whom he became associated.

In Thoré's preface to his book on the Salon of 1844 he wrote, " Do you recollect the time when in our attics of the Rue Taitbout, seated at our small windows, our legs hanging over the edge of the roof, we looked at the corner of the houses and the chimneys, which you compared, with a smile, to mountains and large trees scattered about the ridges and slopes of the ground? Being unable to go to the Alps or to the joyous country you made for yourself with these hideous carcasses of plaster a picturesque landscape. Do you remember the little tree in Rothschild's garden that we could perceive between the roofs? It was the only verdure we were able to see. In the spring we interested ourselves in the growth of the leaves of the little poplar, and counted them as they fell in the autumn. And with this tree, with this corner of musty sky, with this forest of crowded houses over which our eyes stretched as over a plain, you created images which often deceived you in your painting on the reality of natural effects. You struggled thus by an excess of power nourished by your own invention which the view of living nature did not renew. Do you remember again our rare walks in the wood at Meudon or on the banks of the Seine, when we were able to put together the sum of frs. 2.50, and then at our departure we were almost mad? We put on our heaviest boots, as if it were a question of starting for a walking tour round the world, as we always imagined we were not coming back. But poverty held us by our bootstrings and dragged us back to the attic ;—we were condemned to see outside but one round of the sun. Our purse did not last, the air of the Seine is fresh and makes one hungry in the woods—What beautiful things we have seen together away beyond Meudon and St. Cloud. Nature made storms gratis and unexpected spectacles expressly for us."

Rousseau seemed to have been drawn irresistibly to the forest, and in November, 1833, we find him starting to go to Fontainebleau. He rested at Chailly on the outskirts, where he had, for two francs a day, bed, board, fire and lights. He made a number of studies, never properly settling down to paint, for he felt too much excited by the grandeur of the forest trees.

He did not return to Paris until February, 1834, in which year he sent to the Salon a carefully painted picture, " Edge of a wood, Compiègne," which was purchased by the young Duke of Orleans, probably, in fact almost certainly, at the instigation of Ary Scheffer. This picture was awarded a medal of the third class ; not a very high honour, but still sufficiently remarkable for an artist of twenty-two. Rousseau's difficulties with the Salon jury had not yet commenced.

At this time Rousseau made two large views—almost panoramas—of the basin of the Seine from St. Cloud, which are spoken of as remarkable performances. In 1834 also Rousseau went to Switzerland and the Jura Mountains, where his grandmother still lived, eighty years of age. He remained in the paternal village of Salines for four months. Mont Blanc was within full view, and he seemed fascinated with its grandeur. At this village also he met an old royalist, who acquired great influence over him, and who came from one of the first families of France. He was of excellent education, and of charming conversation. On the 17th August, 1834, Rousseau wrote to his mother a letter which shows something of his nature and inclinations at the time :—

" We form at La Faucille now a little colony where concord and happiness reign, and have not even for enemies the bears of the country. . . . We are situated in a very movable manner, however, on one of the mountains of the Jura, where the inn is the most remarkable building. The interior ornament is composed of a dozen cows, and their progeny in the shape of plenty of cheese, of an excellent hostess, of ten drinkers, of a good host who keeps order by a slight oath, and of three individuals each more estimable than the other, of whom I am one. For I must tell you that we enjoy the company of an unaccountable old man of sixty, who resembles poor Father Colombert as if it were he himself. He is of the ancient nobility.—He held the grade of General under the Restoration, having had possessions, which he has lost by the changes. He consoles himself now by carrying all his fortune

with him, a much rarer lot—it consists in good humour and strength and philosophy. I have never seen a more excellent man.—He is here to search for plants and stones."

Rousseau was continually studying, and his eccentric habits of going out at all hours attracted the attention of the simple but suspicious country folk, and at one time during this visit to Jura he was in danger of arrest as a spy, or, at least, as a conspirator against the government. The official sent to report on the matter came to see Rousseau, but after smoking the pipe of peace together and having a quiet conversation the official left, quite satisfied there was nothing wrong. He gave Rousseau a permit so that his work might not be hindered in the future, and no more was heard of the conspiracy.

In October of the same year Rousseau and a friend started to visit the Hospice of St. Bernard, and it was during this journey that Rousseau remarked the cattle descending from the high plateaux of the Jura Mountains to shelter for the winter in the warmer valleys. From this incident Rousseau received the first idea for his picture of "La Descente des Vaches," produced in 1835-6. Rousseau and his companion eventually reached St. Bernard's, and he there made several sketches, both of the interior and of the surroundings. After their return to the village Rousseau made some portraits of his grandmother and of others, and finally returned to Paris at the end of 1834.

When he again settled in the capital Rousseau immediately commenced work. He first finished a rapid design of the " Descente des Vaches," which he did in a few days in his studio in the Rue Taitbout. This is an admirable sketch and is in itself a careful picture.

He intended to realize his picture on a large scale, but he perceived that his studio, small and badly lighted, would not contain the canvas.

But Ary Scheffer visited him, saw his sketch, and was so much astonished that he said, " Come to my house, my friend : I have a second studio there which no one enters. There I will take you in and there you will paint this

masterpiece. If I can judge by your sketch you must not let yourself get cool; you are still burning with the mountain breezes, do not stifle their voices. To-morrow everything will be ready."[*]

The next day Rousseau began work in the studio thus generously put at his disposal, and in a few months he had finished the work.

This fine picture of the " Descent of Cattle " in the Jura Mountains, as well as the splendid sketch study for it, are both in the possession of Heer Mesdag, at the Hague, who has many fine examples of the pictures of the Barbizon School. We give a small reproduction of the sketch of this work. Unfortunately the large picture has become well-nigh destroyed through the bitumen

La Descente des Vaches. By Rousseau.
(From " Etudes de Th. Rousseau." Parıs Amand-Durand & Goupıl.)

employed by Rousseau in painting it. Rousseau knew little or nothing of the dangers of this very seductive vehicle or medium which is so pleasant to the brush and so easy to manipulate. It produces very quickly

[*] Sensier's " Souvenirs sur Rousseau."

Q

a fine, rich, masterlike result, so that few who have once used it can free themselves from its attractive qualities. Up to 1834 Rousseau had been very simple in the colours he employed, but Ary Scheffer, who had taken Rousseau well under his wing, had unfortunately taught him the unhappy trick of using bitumen, and the "Descent of Cattle" was painted with all the treacherous brilliancy of this most dangerous preparation. The result was a magnificent production full of apparently superb colour, transparent, juicy, and delightful, but this brilliancy was like the unhealthy brightness of the hectic cheek, and its existence was as short

In fact the chemical part of painting had never troubled Rousseau and he worked practically without system. This is somewhat surprising, for French painters are as a rule rather well informed in these particulars. Rousseau had been taught the use of bitumen by Scheffer, who thought he had found the palette of Rembrandt, and who also paid dearly for his error, for several of his finest pictures have practically vanished, or rather have so amalgamated on the surface of the canvas that the design can scarcely be distinguished. Many artists have similarly fallen victims to this deceptive stuff. Sir George Harvey's pictures, the property of the Royal Scottish Academy, are worthless, and his fame as a painter now rests nearly altogether on the engravings which were made while the pictures were new; and many other examples could be quoted.

At this time the Salon opened in January and not in May, as has since become the rule. Rousseau sent his "Descent" in November, 1836. But after all his care and anxiety his work was refused. It was not because of its unhealthy colour with bitumen, but because a certain painter named Bidault was the real ruler of the jury, and he and certain of his colleagues had solemnly agreed they would extirpate the heresy of the naturalists. In any case Bidault, as the representative of the old neo-classic school, was strong enough to fight the best artists of France, and in Rousseau's case he assisted to keep him out of the Salon for a dozen years. It was not, in fact,

until 1848 that Rousseau's work was again hung at the Salon, but it is to be remembered that there were not Salons in every intervening year.

Scheffer, who had permitted Rousseau to paint the large picture in his studio, as well as many of his friends, were positively furious at this rejection and the result was not the worse for Rousseau. Scheffer exhibited the picture in his studio in the Rue Chaptal, on the northern heights of Paris, and all the artistic world went to see it. The press got hold of the tale, and it was trumpeted forth that Bidault was at the root of all the trouble.

There is no doubt that Rousseau felt this rejection of his picture by the Salon jury very keenly. He had a kind of presage that this was only the beginning of troubles with the Salon, and when we consider what it means that an artist, however well he may paint, believes he is certain to be rejected, we cannot wonder that he loses heart; and after all to lose heart is almost to lose skill in art. However, Rousseau was well supported by friends' and by his father's sympathy, and besides he was by no means alone in being rejected, as Delacroix and others were in the same position with regard to the 1836 Salon.

After the turmoil of the exhibition of his picture at Ary Scheffer's studio and of the discussions consequent on its refusal at the Salon, Rousseau again went to Fontainebleau for quietness. There he found what he sought, and after a little wandering he reached Barbizon, where at last he settled.

Barbizon at this time was only a very small hamlet on the verge of the Forest of Fontainebleau ; but it was well situated for a painter, as all the finest parts of the forest are within range. Here Rousseau remained for a short time, but it was not until 1844 that he took a house for the summer, and not until a few years later that he settled there altogether to live, and ultimately to spend the best years of his life.

In 1830 Rousseau and Diaz had become acquainted in Paris, although it was about half a dozen years later before the two artists became really intimate. As related in our second chapter on Diaz, Rousseau's system of

painting trees puzzled him, and he resolved to ask Rousseau the secret of his work. After much hesitation Diaz requested Rousseau to tell him this secret; and almost to his surprise Rousseau at once took him with him on his journeys in the Forest of Fontainebleau, and revealed to him in a short time everything he had learned practically for himself, after an experience of several years' constant working. Diaz quite understood the generosity of Rousseau's act, and in the future was never tired of praising Rousseau and his pictures.

On the 15th April, 1837, Rousseau's mother died amidst rather distressing circumstances, for the luck of the family seemed to have vanished and nothing they did prospered. Rousseau *père* still struggled on, believing in his son's great future. Rousseau's mother was very carefully nursed by the painter, and she died in his arms. He never forgot the great lesson he had been taught by her, and his devotion to her had always been very sincere and great.

About this time also the steady rejection by the Salon authorities of pictures by the young French school led to all sorts of combinations against their actions. The artists of Nantes joined with others to organise an exhibition at that city, which was composed so far as possible of pictures refused in Paris. They called on Rousseau, and *le grand refusé*, as he then began to be called, willingly sent some of his best little pictures then in hand.

It was soon after this that he became interested in the country around Nantes, and he went there and made a number of excellent studies, and in particular he produced an exceptionally beautiful picture from memory of the old Château of Bressuire, quite in the romantic style and character.

In 1837 the Salon jury rejected the splendid picture, "The Avenue de Chataigniers," which had been a long time in preparation, and this further augmented the anger of Rousseau's friends, but they thought of a noble

revenge, and finessed to get the State publicly to purchase the pictures. We give a block, showing this subject. The "Avenue de Chataigniers" and the "Descente des Vaches," both rejected by the Salon, remained in Rousseau's studio as witnesses of the iniquity under which he suffered, and many went to visit them. Thoré, Diaz, and Dupré were unceasing in their protestations. Eugène Delacroix also went to see them and was deeply moved.

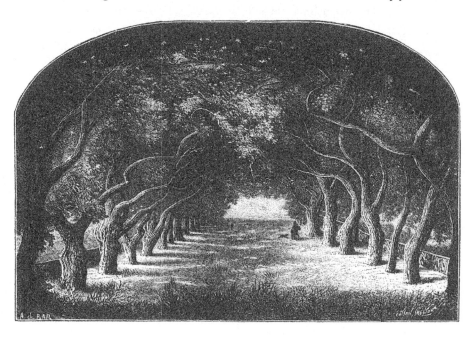

L'Avenue de Chataigniers (Chesnut-Trees). By Rousseau, 1837.

He was very friendly with M. Cavé, Directeur des Beaux-Arts. This official, whose character induced him to assist intelligent workers, had warmly supported Delacroix in his great decorative work in the Chamber of Deputies. M. Cavé, deterred at first by ministerial prudence, ended by obtaining from the Director of the Royal Museum the purchase of the "Avenue de Chataig-

niers" under the form of an official commission of 2,000 francs (£80). The letter of the minister was as follows :—" Monsieur, I have the honour to announce to you that M. le Ministre has ordered that your picture, representing 'An Avenue,' shall be purchased by his department at the price of 2,000 francs. I beg, sir, that you will hold this picture at the dis-position of M. le Ministre, so that the amount may be paid in your name."

But this State acquisition did not take place till 1840, after three years of struggle, during which there came to Rousseau no buyer, no help, unless it was the encouragement of his own friends and the unalterable confidence of the father in the talent of his son.*

Very soon Rousseau repented of his engagement. He felt that his picture ran great risk of being conveyed to the cellars of the State depart-ment, and he determined if possible to get away from the bargain. He thought about it until 1842, when he wrote to the secretary of the Beaux-Arts as follows :—

" Sir,—Be good enough to allow me to address to you a rather important request with regard to a picture inscribed at the Ministry as ' The Avenue,' which at one time you kindly ordered from me. This picture, begun from nature from something that struck me as giving full sway to the study of certain effects of light, I had a great affection for, because, after close application and study, it procured me congratulations from you, sir, and from a few others of delicate judgment ; it is true, also, it won me another cruelty on the part of the Salon jury of painting, which makes me tremble in this exceptional case at the official destiny of my work. I should wish, as well as for another I am now finishing, to be able to give myself in public the advantage of a composition still more developed, and lending itself more to general acceptation. With the help of your goodness and your clear discernment everything will be arranged for the best, as M. Paul Perier has offered me a place for ' The Avenue ' in his gallery, and I would

* " Souvenirs sur Rousseau."

arrange with you to occupy myself with a picture, the same in substance, but with a further development. If you think you can accept my proposition, as I hope you will, you will render me a great service, as well as to M. Perier, who honours me by anxiously wishing to have the picture of the ' Avenue.' And you will appreciate still more—by an encouragement which I appreciate

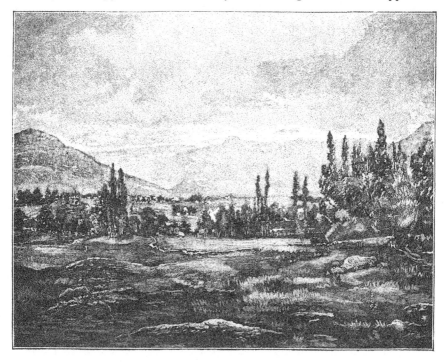

In the Auvergne. By Rousseau. From a Photograph by Braun, Dornach

too much to leave you the slightest fear—that all my strength shall be employed to justify your decision.''

The minister was good-natured enough to let the matter drop—perhaps he thought he was well out of the bargain—and Rousseau sold the picture for £80 to M. Paul Casimir Perier.

Rousseau's next work, "Vue du Parc et du Château du Broglie," was rejected from the Salon of 1838, and thus for the third time he was refused with very apparent injustice. These rejections touched him in quite a different way, for as he was not allowed to exhibit, so, of course, he found difficulty in selling his pictures. Thus he could not afford the money to travel, and even his excursions to Barbizon were curtailed.

Between 1837 and 1840 he made some splendid works in the Forest of Fontainebleau and went on painting and touching, repainting and retouching them when every one else thought they were completed.

Rousseau became fonder of Barbizon, and grew more and more attached to its beauties and solemnities. He lived there as long as he could, painting and studying continually. Indeed he became so fascinated with the charms of the forest that he could think of nothing else. "Ah!" he would say, "Silence is golden. When I was in my observatory at Belle-croix, I dared not move as the silence opened to me a course of discoveries. The families of the wood were then in action. It was the silence that permitted me, immovable as a tree trunk, to see the deer in their hiding-place and at their toilet, to observe the habits of the field rat, of the otter, of the salamander, those fantastic amphibious animals. He who lives in the silence becomes the centre of a world ; a little more and I could imagine myself the sun of a small creation, if my studies had not recalled to me that I had so much trouble to reproduce a poor tree or a cluster of rushes."*

In July, 1841, Rousseau went to Monsoult, on the borders of the Isle-Adam, where Daubigny and Corot often painted, and there with Jules Dupré he painted for several months. His studio was next door to Dupré's, whose mother became in some sense head of this artistic community of three, and very quiet and happy the time was found. Several artists visited them, such as Décamps and Barye, and this period of Rousseau's life is marked by great quietness.

* "Souvenirs sur Rousseau."

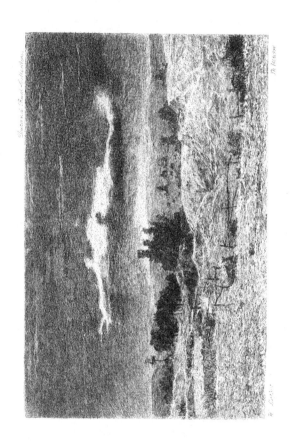

In June, 1842, Rousseau went to the River Creuse in the Berry of France. There at a hamlet called Le Fay, in the Indre, about 220 miles from Paris, he commenced again to exercise his pencil. Here he painted some fine pictures, notably the one called, "The Curé," the "Sunset in Stormy Weather," and others. He kept up a correspondence with Dupré, not returning to Paris until 1843. That year he devoted to finishing the pictures commenced in the Berry, and he was so fortunate as to sell several of them.

At this time Jules Dupré and Rousseau were the most intimate friends possible. They lived next door to each other in Paris, and Rousseau came to look up to Jules Dupré with the affection of a younger brother, and their friendship, as has been said, was of the closest character. Unhappily this friendship did not endure, as we shall see hereafter, but it is just to Dupré to say that it was sundered by Rousseau's fault, and only because of Rousseau's somewhat jealous nature.

Rousseau, we believe, did not wish to quarrel with Dupré, but he became jealous of Dupré's selling his pictures readily, while his own work remained on his hands. In any case the disagreement led to an entire break-up of the friendship between the painters, and their friendliness was never renewed.

Rousseau was in 1843 in his fullest strength as a painter, and from this time forward all his work was to be of the finest and strongest kind. He had still many difficulties to encounter, but he was now generally acknowledged as an artist of the front rank, and he was able to sell a work occasionally, if for only a small sum.

R

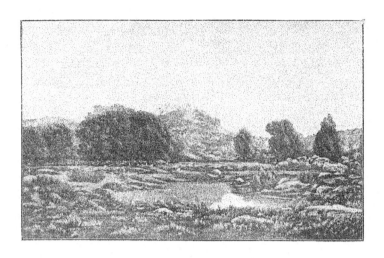

La Gorge d'Apremont. By Rousseau.
(From "Etudes sur Th. Rousseau." Paris: Amand-Durand & Goupil.

THÉODORE ROUSSEAU :—CHAPTER III.

"Marais dans les Landes;" "Le Givre;" Paris; Millet;
The Revolution ; The Salon ; Barbizon; Exposition; 1844-1855.

WE have now arrived at a kind of half way in Rousseau's years of strife with the Salon. Since 1837 he had been constantly rejected, and now in 1844 he had still four years to wait before, as affairs developed, his works would be received at the National Exhibition. In 1844 also he was to commence his studies for the "Marais dans les Landes," one of the finest pictures now in the Louvre collection.

At the end of April, 1844, Rousseau and Dupré started for the Landes, on the coast of the Bay of Biscay, fixing on the town of Begars as their central point. Here Rousseau commenced his "La Ferme" and "Le Four Communal," and then his well-known "Marais dans les Landes." He felt the strength of the colour in this new country so much that he did not trust himself at first to paint with a full palette, but he worked in a sort of monotone or grisaille.

The sketch of the " Marais " done in this way is very attractive to the connoisseur and artist, showing as it does the manner of Rousseau's work. The colour of it is a pale green and brown, with all the details well shown in darker colour, but it requires to be examined close at hand before its beauties are revealed. After the picture in the Louvre no more interesting work by Rousseau can be found in a private collection.

In *L'Artiste* for 1844, Thoré, the art critic, indited a long letter to Rousseau asking where he and Dupré have gone, and proceeds to recall in detail the happy days they had spent together. The letter finishes by saying that, notwithstanding all the defects in Rousseau's art, he may fairly expect to become ultimately one of the greatest artists. Thoré points out how already Rousseau's works were to be found in the best collections of Paris, and in a very pleasant way he comforts the artist as if he were fearful he would begin to despair of success.

In 1845, when they got back to Paris, Rousseau and Dupré found the city life not at all to their taste, and, ignoring even the claims of Barbizon, they went off to the Isle-Adam in the month of October. There Dupré exercised considerable influence over his friend, and did him real service by almost forcibly taking away his pictures from him when they were finished. Rousseau had a somewhat unfortunate tendency to continue to labour on his pictures after they were completed, but Dupré spoke to him so severely, acting, in fact, a little high-handedly, that Rousseau saw the error he was making and allowed his pictures to go. During this visit Rousseau painted in eight days—we have the authority of Jules Dupré as to the time—the exquisite harmony called " Le Givre," where the hoar-frost covers everything. This picture, of which we give an etching opposite page 120, was once M. Durand-Ruel's, and is now in America, where at the end of 1889 it was hung at the Barye Exhibition. The *Sun*, the New York newspaper, in an excellent article (dated November 19th, 1889) on the Barbizon painters, gives the following description of it :

" On this canvas, which has all the science and truth of Rousseau's other works, we read a poet as great, for once, as Corot himself. The composition is very simple : a broken stretch of moorland, dull green, and sprinkled with white spots of frost, a straggling wooden fence, the inconspicuous figure of a wayfarer ; beyond, low lines of trees rising into a little group of spiky firs in the centre of the middle distance, and, behind all, an expanse of heavy sunset sky, dull gray, with yellow and red stretches, where it breaks away near the low-placed horizon. It is such a scene as we may witness on many a winter night, and in our own country as well as France—such a scene as has been painted a hundred times, and made no impression on our eyes. But it is impossible to record the impression that Rousseau's treatment makes, impossible to describe the way in which it brings the feeling as well as the look of the scene before us—its coldness as well as its gloom, or the splendour of the colour wrought with notes so few and sombre, or the grandeur of the simple lines, or the intense dramatic poetry of the whole. No words can characterise such a picture. It seems when we feel its influence, as though no man could have painted it. And in truth it needed a Rousseau, and this means one of the two or three greatest landscape painters who have ever lived. It enlarges our knowledge of the boundaries of art and our realisation of what poetry may mean in paint."

On Dupré and Rousseau returning to Paris, they rented studios next to each other in the Place Pigalle, so that Rousseau might be on the spot to try to sell some of his pictures. The Salon being closed to him, he naturally found great difficulty in securing purchasers for his works, and his income must indeed have been small at this time.

Rousseau often went home to his father's house, and Sensier has told how—" I have seen him seize from the tailor's counter a sheet of invoice-paper upon which I read, ' Rousseau, marchand tailleur, Rue Neuve St. Eustache, No. 4, près la Place des Victoires, fait tout ce qui concerne son état dans le plus nouveau goût,' and trace, with feverish hand, sparkling arabesques

from his imagination, create shadowy lands, covered walks, joyous plains where fancy often distorted reality, but where, rising from this deceptive earth, he appeared to catch glimpses of the world to come "

After an unhappy love incident, to be referred to a little later, Rousseau shut himself up at Barbizon, and would not see any of his friends except Thoré, the critic. Here, in his house at the end of a garden, with small rooms for living in, and a studio converted from a barn, he worked alone. From thence he took long walks and continued to work regularly with his paintings. He made a little sketch at this time which is now in the Louvre. It is the "Plateau de Belle-croix," and, although very dark, it is yet very charming and strong in colour. This sketch was purchased for 600 francs (£24) by Charles Blanc, Director of the Beaux-Arts, in 1850 at a sale of some of Rousseau's works; and although for many years it was ignored,* it is now better treated and allowed to be something worth looking at.

It was about this time, 1845, that a very curious experience befell Rousseau. He was at work in his studio absorbed in his painting, when he was visited, interrogated, and apprehended by soldiers of the National Guard, who made him follow them to the famous "Prison des Haricots," for having too often neglected the requisitions of the service. Sensier speaks of this little adventure only because it furnishes him with an occasion to cite a letter of Rousseau, showing, as he says, that misfortune interfered with all his enterprises. It was the last letter that Jules Dupré received from him.

"Mon cher Dupré,—See if one ever escapes from fatality—I am in the prison of the National Guard. An hour ago, I was at my easel with great application—you know it was necessary—and I was obliged to follow three *alguazils*. Nothing could stop them. They have such orders that I think they would tear a dying man out of his bed. They carried me off without much ado from a picture just in fine condition to be finished, and I shall

* Even in 1880, when the writer made a study from it, other students copying pictures in the Louvre smiled when they saw any one taking the trouble to paint from it. '

probably never find so favourable a day as the one the law is taking from me. I think, also, I am in for three or four days. It is pitiable. I do not ask you to come and see me—it would hinder you too much; and, first, it requires a permission from the Etat-Major, and, secondly, you could come only between 11 and 5 o'clock."

Rousseau stayed ten days in irons, as he called it, accepting with patience his imprisonment, and drawing the sky and leaves he saw from his prison window, for exercise in his profession.

Dupré went to see him with M. Bouneau and M. Charles Jacque. They found him in the prisoners' parlour, making pencil sketches of his companions in misfortune. He had been named by these " Senior " and " Provost," by reason of his age, and called on to judge of differences and quarrels between the boarders of this curious " legal residence." Some of the conversation with his visitors is of interest. " I should think you got weary here," said Jacque. " That depends," returned Rousseau; " when you wish to do so, one can always find beautiful things to study and understand. Look here at this charcoal-burner before us, with his big felt hat, who is thinking of his sacks and of his faggots—see how the shadow of those large brims gives a clear yet grave tint to his face." " Draw him, Rousseau, in this pensive attitude," responded Jacque; " he does not doubt that he is handsome, and if he posed himself he would become repellent. See, here is a sketch-book, go on!" Rousseau immediately began to draw the profile and head of the sitter, and with a hand timid like that of a hesitating child he traced the face of his model. In half an hour the drawing was finished, and resplendent with force and truth. Jacque kept it a long time as an example of what Rousseau could do.

Rousseau and Millet became intimate in 1846 at Barbizon, at the time when Rousseau was considered an æsthetic outlaw and an artistic heretic, whose works would, in the eyes of the jury, dishonour the Salon of the Louvre. It has sometimes been said that the reasons for Rousseau's non-acceptance at the Salon were because of political differences, but this hardly could

have been the case with one who troubled himself so little about politics as he did.

Rousseau's and Millet's intimacy grew very slowly. Millet was as usual in difficulties with money matters, and he found opportunities to tell Rousseau, in a joking way, of his troubles. It was only later that Rousseau opened his heart to Millet, and at length they began to believe in each other. This interchange of ideas made some impression on Rousseau, and many of his sketches show this influence. In 1852 Rousseau would even consult with Millet as to his subjects, and Millet even dared to tell Rousseau his real thoughts—a difficult thing, we may believe, for Rousseau's proud and jealous spirit to accept.

The time was approaching for a great change, as well in the artistic affairs as in the political matters of France. The artists became more and more demonstrative in their designs against the constitution of the Salon jury. A good number of the best men refused to send their works, amongst others Décamps, Dupré, Meissonier and Barye, and the Parisian exhibition lost much of its distinctive character. The public began to murmur and to support the artists who abstained from sending their pictures. The press took up the question and discussed it openly, and many suggestions, some good, others unpractical, were ventilated. But nothing could move the intense antipathy of the jury as then constituted to the new school of painting. A *Nouvelle Société* was proposed, and was formed on the 15th of April, 1847, with the following notable painters supporting it:—Ary Scheffer, Décamps, Dupré, Delacroix, Rousseau, Barye, Jeanron, Charles Jacque, and Daumier, while Delaroche and Horace Vernet only waited for an opportunity to join.

Then came the year 1848 with all its changes, and one of the first things to be altered was the jury of the Salon. This shows how strong was the feeling against the old system, for within a week of the proclamation of the Republic a formal order of State was declared in the following terms :—" The Director of the National Museum of the Louvre proposes the opening at the

earliest possible day of the Exhibition. He proposes that all pictures sent shall be liberally treated this year. He proposes that the entire body of the artists be invited to elect a commission or jury, which will be charged with the hanging, the recompenses or medals, and the purchases by the State at the close of the Salon."

Rousseau and Jules Dupré were elected members of this committee, with Léon Cogniet, Ingres, Eugène Delacroix, Ary Scheffer, Horace Vernet, Robert Fleury, Meissonier, Corot, Paul Delaroche, Isabey, Drolling, H. Flandrin, Brascassat, Abel de Pujol, and Couture ; Paul Delaroche being the president.

Rousseau served on the jury, although he did not contribute anything to the Salon. It is to be wondered at that Rousseau could reject any one after his own experience. In the continued rejection of his pictures, it appears certain that the judges acted under prejudice, but also with incontestable honesty and good faith. Such facts make one reflect on the peculiar position held by those who themselves, long time the victims, have become in their turn the judges. One would think that an artist who, like Rousseau, had been so steadily rejected, would never be willing to refuse any picture, however absurd, with whatsoever eccentricity and audacity it had been produced. But, of course, the work had to be done by some one, and Rousseau, it is recorded, when he came to be on the jury dealt mercifully with all young painters.

The Republic seemed anxious in every way to conciliate the artists, and Rousseau and Dupré received commissions for pictures at 4,000 francs each (£160), large sums in those days for work by living artists. Rousseau's subject was the "Coucher du Soleil," first shown in the Salon of 1850-51, and now in the Louvre, one of the finest of his pictures. He painted two of the same subject, the later one (see illustration, page 99) being considerably altered in detail.

In June, 1848, when every man in Paris was summoned to help to keep

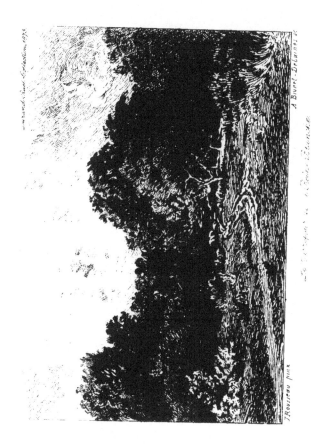

the peace, Rousseau and Dupré, armed with muskets, were posted in the Boulevards, where they spent a little time. But Rousseau was nothing of a soldier or politician, and as soon as possible he got back to his painting.

During the stormy time of the revolution, a change took place in Rousseau's domestic relations, about which there always has been some mystery. It is certain Rousseau never was married; yet when his friends re-assembled after the trouble of the political changes—for every one was scattered either in foreign countries or serving in the military—they found a young woman presiding over his little establishment at Barbizon. Who she was or what she was no one cared to ask, but when they observed the tender love and respect Rousseau had for her they concluded she was his wife in legal form as well as in reality. This was not the case, however, so far as the legality was concerned, yet in all truth this young girl became his wife, for richer, for poorer, for better, and for worse. When, according to the usage of the less virtuous part of the world, a man and a woman resolve to live together without legal tie, they almost always separate when storms and troubles arise; they fall out, they quarrel hopelessly, and seek other associations. Not so with Rousseau. Nothing indeed could be finer than the attachment of Rousseau to the one he always called his wife. When, having no children, in spite of great inducements to part from her, he still loved, honoured, and cherished her, when in fact she lost her reason and became a raving lunatic, he still kept her under his roof and refused to be separated from her—after all this, together with the fact that no other woman ever afterwards had any attraction for him, it is not too much to say that she was in actuality and in all sincerity his real wife. We shall, then, give her this honoured title whenever there is occasion to mention her in the future.

Some years before, Rousseau had been on the point of marrying a young girl who loved him in return, but some misunderstanding arose, and the marriage was broken off. Rousseau suffered greatly, but within himself, and only to one or two intimate friends did he avow his heart-ache. Never before

had a woman been known to disturb the serenity of his life, and not again did it happen until 1848.

Rousseau's wife was a native of the Franche-Comté, whence came his own people, and she had come to him in straits of poverty and ill-health; and in his assistance to her wants he found a certain pleasure until he became entirely attached to her.

Rousseau now settled down to work at Barbizon, and in the forest of Fontainebleau he painted many strong and masterly works, which from this time began to appear regularly at the Salon. In 1849 he had three important works in the exhibition, including a " Lisière de Forêt " with setting sun.

At the distribution of medals and honours he expected to be at least equal with his compeers. He thought of the Liberté, Égalité, and Fraternité, on all the walls of Paris, and he considered that in a veritable republic he could not be disappointed. But like many another believer in these scarce realisable doctrines, he found his error, and Jules Dupré and Raffet were honoured with the ribbon of the Legion of Honour, while he was left with only a first-class medal. He was hurt and angry, and in an unguarded jealous moment he thought that Dupré was somehow to blame in the matter. Nothing could have been further from the truth, but the proper explanation was not forthcoming, and Dupré and Rousseau separated, not to meet again for a long time.

On 2nd March, 1850, Rousseau put up to sale by auction fifty-three of the pictures remaining on his hands, but these, after all expenses had been paid, only realised about 8,000 francs (£320) of profit. Many of his friends attended the sale, and helped to raise the price he obtained, but when we know that the total of 15,700 francs only meant £12 for each picture, we can believe these friends did not do very much. It was at this sale that Charles Blanc, the Director of the Beaux-Arts, bought the " Plateau de Belle-croix " already noted as now in the Louvre.

To the Salon which commenced in December, 1850, and continued into 1851, Rousseau contributed the "Lisière de Forêt—Soleil Couchant," the well-known picture now in the Louvre, and of which we give an etching opposite page 104, as well as an illustration (p. 99) of the same design· as a sunrise, a difference not, of course, visible from the monochrome reproduction. On the evening before the Salon opened, Rousseau saw his picture well hung in a good place, and was much pleased with its appearance. What was his astonishment, the following morning, to find it had been taken away, and hung in a far less honourable position. Again he thought of a conspiracy against him, but again he was in the wrong; for although he accused the authorities of intrigues, and threatened all kind of things against them, he was persuaded to rest content; and afterwards he acknowledged that he had been mistaken.

Another incident was a great disappointment to Rousseau. Rightly or wrongly, we think rightly, he thought he was entitled to be chosen a Chevalier of the Legion of Honour as soon as his pupils, but at this time Diaz was named Chevalier and Rousseau was left out. Why this should have been so can only be accounted for by petty annoyance of the authorities at Rousseau's .hauteur, and because he refused to do anything to conciliate them. Diaz was as angry as his master, and wanted to send back his cross with an indignant letter, but this would have done himself injury without doing good to Rousseau.* So he took the more effectual and more morally courageous course of rising at the banquet of the décorés and proposing his famous toast. "Théodore Rousseau, our master who has been forgotten." With shame it must be recorded, but how natural it was every one will admit, that not one artist supported Diaz in his public protest. The other décorés were frightened at his daring, and left him in the breach alone. And this within five years of Rousseau being acknowledged at the great Exhibition of 1855 as one of the finest painters in the world.

* For a full account of the relation between Rousseau and Diaz, see the biography of Diaz in this volume.

Rousseau once more resolved not to send to the Salon, but under Napoleon III. affairs again changed, and he was persuaded by the official director of the museum, who came personally to make the request, to send again, and three fine works were duly hung at the Salon of 1852.

During these years now under review, that is, from 1850 to 1855, Rousseau was painting his best, and some of his finest pictures were the outcome of his labours during this period. He painted, besides the "Coucher de Soleil" and the "Marais dans les Landes," both in the Louvre, " La Lisière des Monts Girard," "Oaks at Apremont," " Le Four Communal," "La Ferme" (see illustration, p. 153), and "La Reine Blanche," of which we give an etching opposite page 128. " Le Petit Pécheur," of which we give a reproduction opposite page 136, was formerly in the Wilson and in the Defoer collections, and " Le Chemin," given on page 147, from the Secrétan collection, are also interesting examples of Rousseau's work.

The picture of the marsh in the district of France called " Les Landes " near Bordeaux, was projected by Rousseau when he was on the journey with Jules Dupré in 1849. It shows a great plain sprinkled with uncultivated fields and with small pools of water. In the middle is a troop of cattle, some in the road and some walking amongst the grass. They are going towards a little clump of stunted firs. The sky is a little leaden, but the utmost refinement is shown in the great expanse towards the horizon, where the snow-clad peaks of the Pyrenees are lost in the clouds of the distance.

This picture was sold on the 8th May, 1881, in the celebrated Hartmann sale, and was the cause of some excitement. In accordance with the French auction system, a sum was stated by an expert as to what was the value of the picture. This was put at 100,000 francs (£4,000), certainly a very fair sum. But the bids rapidly went past it, and stopped for a moment at 125,000 francs (£5,000), when an agent for a collector offered 500 francs more. The auctioneer then commenced to bid on behalf

of someone not present: 128,500 francs bid the dealer: 129,000 said the auctioneer, and to him it was knocked down for £5,160.

"Who is the purchaser?" everyone asked, but nobody answered. "Is it a foreigner, is it a Frenchman, or is it for the nation?" "The buyer, the buyer!" was shouted on every hand. "Messieurs," said the auctioneer, "I am unable to tell you who is the purchaser." But this only doubled the curiosity, and the "Pour qui?" was renewed on every side. "In face of your repeated questions," said the auctioneer, "I cannot longer continue to keep the secret. It is for the French nation that I have been charged to buy this picture." The applause was immense. "It is France who keeps the *chef d'œuvre*. It is the Louvre who has become the proprietor. Bravo!" said everyone. All the connoisseurs were greatly delighted, and with more reason than with a similar incident at the Secrétan sale of 1889.

Rousseau was now in his prime, although few people recognized this. Purchasers became more plentiful, and money was not so scarce with him as formerly. He felt this so strongly that he was grateful and thankful and generous enough to wish to share his prosperity with a brother artist. Several times we have had to acknowledge serious defects in Rousseau's character. While doing this frankly, let us be equally sincere in praising a very generous action. This is told in more detail in Millet's biography, but Rousseau's history would be incomplete without a passing allusion to the occurrence. Rousseau paid to Millet 4,000 francs (£160) for the picture of "The Grafter" (see the illustration in Millet's biography), at a time when he was only getting through his own monetary difficulties, and had every inducement to keep what he had earned. This story of Rousseau buying one of Millet's pictures is related in different ways. Most writers say Rousseau declared it was an American who fictitiously bought the picture, while others aver he said it was an Englishman. Rousseau occasionally sent purchasers to Millet, but one morning when Millet had left his studio, Rousseau carried off

the picture called "Le Paysan greffant un arbre." At evening Rousseau said to Millet, "You need not look for your picture. During your absence I have taken it upon myself to sell it to an Englishman * passing through Barbizon. Here are 4,000 francs in notes for it." Three years later Millet discovered the picture still in the studio of Rousseau. "Oh, yes," said Rousseau, when the discovery was made, " I am the Englishman. *Du reste*, you know the canvas is always at your service." †

The time of the Exposition Universelle of 1855 now approached, and every artist in France was striving his best to achieve distinction. Rousseau did not disturb himself greatly, but the moment was propitious for the Barbizon School, and a veritable triumph was at hand. For the first time Rousseau found universal artistic admiration. "All his pictures refused for the past twenty years came back like victorious exiles, and showed themselves in the cosmopolitan Salon. The reaction had come against the injustice of the classicists toward the School of 1830." It became in fact a perfect enthusiasm.

It went perhaps too far, and Rousseau, fearful of the future, dreaded the recoil of a movement too intense to endure. He was at this period more admired by artists than by ordinary visitors, who did not indeed pretend thoroughly to understand him. His pictures also suffered a good deal by being hung too closely together, but notwithstanding all this, he took a much higher place in the eyes of the public than he had ever done before. And he may now be considered as having achieved popularity as well as fame.

This marked a period in his career, for afterwards there is little to tell of his history except to give a record of his labours and rewards. During the remainder of his career he was only to go from one triumph to another.

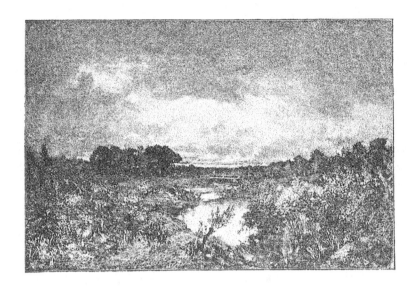

"Le Soir." By Rousseau From the collection of T. G Arthur, Esq

THÉODORE ROUSSEAU :—CHAPTER IV.

PICARDY ; WIFE ; TRAVELS ; PICTURES ; EXPOSITION, 1867 ; OFFICIAL NEGLECT ;
LAST ILLNESS ; DEATH ; 1856—1867.

THE years now pass quickly, and there is little to record except to
mention the chief works Rousseau produced. In 1857 he went to
Picardy, and there found the suggestion of his fine picture of the " Village of
Becquigny," which we engrave on a following page. This work, like Hobbema
in character, but broader in execution than the old master, is very delightful
and can be appreciated by every one, experienced in art or otherwise.

The quiet life at Barbizon was at this time broken by the death of the only
son of Diaz, and by the terrible illness of Rousseau's own wife. He mentions
these in the following letter written to Ziem, the painter of Venice :—" Since
receiving your letter everything has conspired to keep from me the leisure
and quiet which I could wish in order to answer you. I have also made

two journeys to Paris, the last one to attend the funeral of poor Emile Diaz, of whom you ask news. His poor father was almost mad with grief, which, however, we managed to calm. You were as if present, and our thoughts associated you with the sad scene. During the return my wife was taken ill, and day by day a neuralgic attack came on which has left her very feeble. I do not know what to do, my dear friend. At the commencement I had thought of leaving her at Martigues, but now her mental condition would not permit of my leaving her. She would be afraid of being ill without me there beside her. I think I had better wait until the result of this last attack shall have left her." But Rousseau's wife never was completely better, and she lived for a year after her husband, a burden and a trouble to all around her.

In September, 1860, Rousseau went to his father's country in the Franche Comté, where he had met his wife, in order to see if change of air would benefit her. Millet was with him; and, for the second time in his life, Rousseau left French soil, and spent a few days at Neuchatel in Switzerland. There he made one or two drawings in water-colour, a medium he seldom employed.

In 1861 he worked very hard for several months to finish and complete his studies made during his journey; and on 7th March, 1861, he held a sale at the Hôtel Drouot. This was still an unusual thing at the time, and was not at all well supported. After payment of the expenses—always a heavy item in auction sales in France, even although the purchaser pays five per cent. over and above his bids to help the same—Rousseau only received about 15,000 francs (£600), or an average of £25 each picture. This sum would probably have to be multiplied twenty times to purchase one of them in the last decade of the nineteenth century. Rousseau's difficulties became very heavy from the sickness of his wife, and the demands of his father and his other relatives, and he felt that as a painter he was not properly understood in France. He contemplated emigration, or at all events removal to some other capital, and Amsterdam was the first place he thought of, for the artists there had elected him a member of their academy. He also thought of Britain with its

LE PETIT PÊCHEUR By ROUSSEAU

fabulous riches, and even of the United States, whence came so many purchasers for his pictures. Français, his pupil and friend, was asked to see if he could find a suitable place in London. However, nothing came of this proposition, and Rousseau did not leave his native land. His wife's health— as usual, whenever he required her to be well—became much worse; and poor

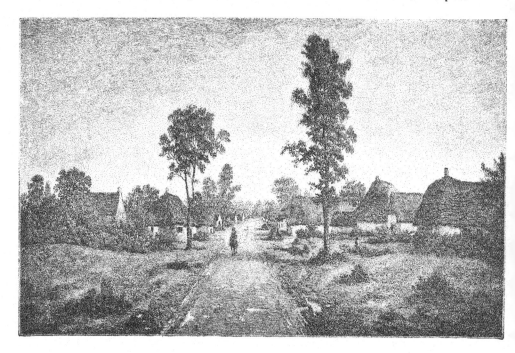

The Village of Becquigny. By Rousseau. From a Photograph by Braun, Dornach.

Rousseau had enough to endure at this time. However, he did not by any means yield, but continued at Barbizon deep in his studies. He again sent his wife to the Franche-Comté in order to try a change, and remained at home with a friend of his youth, Vallardi, who had come to him in sad plight and asked his assistance. Rousseau took his compatriot to his home, in the winter

of 1861, and by the end of 1862 he had become to all appearance a fixture in the Rousseau family circle. In November, when Rousseau found it necessary to go to fetch his wife home, Vallardi, left to himself, became in an unaccountable way melancholy mad, and on the 17th November he committed suicide, using a pair of scissors which were in Rousseau's house. Millet was called immediately: the scene was terrible, and wretched in the extreme. In a letter Millet describes graphically what had taken place. " This terrible end is ever before me. I imagine his death-agony. It is easy now to follow the events. Not being able to sleep again that night, he determined to end the thing. He went into the dining-room and took Madame Rousseau's scissors, and, standing beside his bed, he struck himself as often as his strength permitted ; his power exhausted, he fell with his face against the table and his knees on the floor, as one could see from the bruises on the nose and knees. The blow overturned the candle, which fortunately went out in falling. I imagine the efforts of the unhappy wretch, feeling about, trying to get up, slipping in the blood, and with infinite difficulty hoisting himself on the bed ! Fancy this terrible struggle in the dark. And if you could have seen how he had struggled on the bed. Indeed, he left fearful traces of his death. Could he have beheld, before killing himself, the hideous scene the dawn would disclose, I think he would have stopped ; it is a perfect miracle that the house did not burn down. The candle had fallen first against the sheets and then had rolled under the curtains, which it touched. And what an accident for Rousseau, for it would have been impossible, if the fire had broken out, that the studio, which is just above, should not have burned too. Think of Rousseau's canvases, sketches, drawings all on fire—all he had finished and begun, destroyed on his return—a heap of ashes ! I am bewildered. Do come, Sunday if you can ; I need to be cheered, for I have never experienced anything like this. How heavy is the atmosphere of suicide ! I am surrounded by an everlasting nightmare." *

* Millet to Sensier. " La Vie de J. F. Millet," Quantin, 1881.

Rousseau was struck with remorse, because he felt that had he not left Vallardi alone he might still have lived. He never afterwards spoke of the matter, although, as a kind of penance, he took this bedroom of the suicide for his own; and, as Sensier says, the bed of his friend ultimately became the bed of his death.

On the 17th of May, 1863, Rousseau sold by auction seventeen pictures, which realized 14,866 francs (£594), a sum which satisfied him, and at the same time gave him some money to purchase specimens of Japanese Art, with which he had lately become enamoured. In the autumn he started for the district of La Faucille, and there he made a number of sketches of Mont Blanc and the adjoining ranges of the Alps. Then the weather proved treacherous, and at Besançon he was attacked with inflammation of the lungs and became dangerously ill; so severely, in fact, that at one time he was scarcely expected to recover. This illness was a slight warning, for it thoroughly shook him, and only his iron constitution pulled him through.

When he got back to Barbizon, he was but the ghost of his former ruddy and healthy self. His sleep forsook him, and his nervous system became altogether upset. Night after night he would pace the room, as he could not sleep; and Millet and other friends frequently sat up with him, sometimes even all night.

The chief work which occupied him at this time was the "Village of Becquigny" (illustrated on page 137), and other two pictures "La Ferme" (page 153) and "Le Four Communal," for M. F. Hartmann, one of his most constant friends and patrons. Sometimes Rousseau did not make real progress with these pictures. He continued painting them until they changed and changed again, but they never seemed to become satisfactory to himself.

In 1864 he sent this "Village" and another picture to the Salon, and they were favourably received by the critics, for the "Village" is one of his finest pictures. Rousseau's wife gradually became worse mentally, and his

own health was far from good. In December, 1864, he had severe pains in his back. His friends persuaded him to send his wife away from him, but when the time came his heart forbade the separation, and there was nothing for it

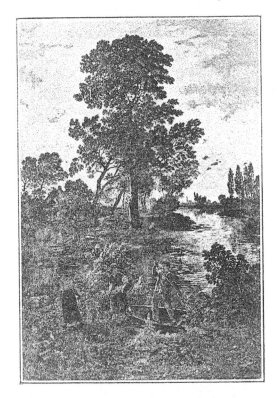

but to leave them together. It seemed cruel to think of parting them in one sense, although it was as certain that under the circumstances no artist could have worked with any certainty of success.

In April, 1865, however, Rousseau went to Artois on a journey with his wife, and at Boulogne and its vicinity he found much pleasure in wandering around the country. It is not likely that the country around Boulogne would charm him very much after the Jura and the Auvergne, but the fresh sea breezes and the ever-changing waters were a

A Spring Day. By Rousseau

great and invigorating change for the now ageing artist. His wife's influence as usual went in the wrong direction. Rousseau wished to make a series of studies of the sea and land; but his wife became even more than usually irritable and troublesome, and insisted, just when he had settled down, on their removing inland to Arras. Rousseau felt this interference with his

liberty and his art greatly, but he had given in his lot with his wife, and he resolved to support her wearisome worry to the end. They did not stay long in Arras,* but got back to Paris in May, too late for sending anything to the Salon.

There was, however, a great event in store for Rousseau this year, for the wealthy Prince Demidoff had resolved to have his house decorated by some of the first artists of the day, and Rousseau, Corot, Jules Dupré, and Fromentin each received a commission to paint two large pictures for the dining-room. These pictures were Rousseau's " Coucher de Soleil " and "A Spring Day," Corot's " Morning " and " Evening," J. Dupré's two forest boundary scenes, and from Fromentin a " Scene with Centaurs," and a " Diana

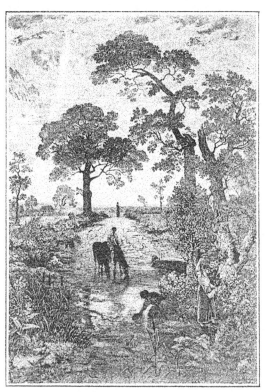

Coucher de Soleil. By Rousseau.

at the Chase." Each was to receive 10,000 francs (£400), and the painters all ardently set to work. Rousseau's pictures are here illustrated, and are the largest works of his later years. They have often been described as being of more than usually fine quality; but it must be admitted, after due considera-

* Corot was at Arras in 1849 and 1871.

tion, that they are not of such merit as might have been expected from the master at the time, 1865. It has to be remembered, however, that Rousseau was in bad health, that his wife's vagaries and illness were a source of constant trouble, and most of all, that neither of the pictures was completed. He made studies of the composition of these works in small size, and then gradually enlarged them until at the sixth operation, that is, after making six gradually enlarging variations, he settled the size, and commenced the actual painting. He allowed Prince Demidoff to have the pictures at the beginning of 1867, about two years after the commissions were given, but unwillingly, as he knew he could have done much more for them had his health permitted.

In *L'Autograph du Salon,* 1865, there is a sketch and letter from Rousseau, of which we give reproductions at page 166.

At this time M. Durand-Ruel and M. L. Brame made a joint proposal to Rousseau to acquire all the studies made in his youth as well as some of the completed pictures still remaining on his hands. They offered 100,000 francs (£4,000) for sixty canvases, of which some were only very slight sketches, as well as other 40,000 francs (£1,600) for a large number of unfinished works in process of completion. The proposition was flattering enough to Rousseau, but he did not know whether to accept it. At first he declined, but afterwards he closed with the offer—an offer which at the time was almost princely in its dimensions and daring.

In the following year, 1866, Rousseau was chosen for the jury of the Salon, and although he was very modest and retiring, and unwilling to express an opinion, the other members of the jury soon found out how quick he was to appreciate artistic talent, and his words had more weight than the strongly-expressed convictions of others. He now continued to work very hard, while the uneasiness of his home life was gradually telling more and more on him. In December, 1866, he wrote as follows to Sensier:—" The news of our health is not good. My wife has been in agony several times, but she is having a little rest now. As for myself, I am better in a certain sense, and

worse in another. I have still that feverish blood which runs through me, and which troubles my brain when my pains are most acute. I have again left off work, and again recommenced. Now I can do nothing, and it is killing me. I have a sort of erysipelas which is yet another trouble, but 1 hope that this illness will fly to the skin, for I shall then soon get rid of it. In this we are all warned we must have health for a motto. Therefore, take care of yourself to the end, and do not tire yourself too much. Usually you inscribe my name on the official list for the Salon towards the new year, and you will doubtless do it this year. As it is useless to make ourselves enemies in this way, this is what we must do : request Etcheverry to erase mine from the lists or I will send you cards to use as you think best." *

Notwithstanding the repeated advice of doctors and of his friends Rousseau would not live separately from his wife, and the artist who had suffered so much in his youth saw his riper years saddened by the incurable disease with which the tenderly-beloved woman was afflicted. " He wandered about without purpose as if his very soul was in pain, running from the woods to the sea, and never becoming settled. Above all and everywhere the image of his poor wife confronted him, between the eye of the artist and the subject he was painting. Again and again always came the figure of insanity. The hand of the great painter was always at work, but his thoughts were involuntarily elsewhere.*

The last public function fulfilled by Rousseau was in connection with the Exposition Universelle of 1867. He was elected on the jury in the usual way by the French artists, and the representative artists from the various nations met to name a president of the jury. After very little discussion Rousseau was chosen as president; for the fame of his wise decisions of the 1866 Salon had spread, and it was felt on every side that he was an impartial man, fearless and independent, and at the same time thoroughly capable of estimating the value of an artistic work.

* Sensier's " Souvenirs sur Th. Rousseau."

As president of the jury Rousseau had very important functions to fulfil; not the least difficult being the awarding of the medals. Each evening he brought home with him the notes of the day and studied them carefully and conscientiously, so as to be the better able to judge on the morrow. He wished his old friend and ally, Jules Dupré, to have one of the chief medals, but the jury were in a majority against him, and Dupré came out only as in the second rank. In this matter Rousseau's friendship undoubtedly over-powered his artistic judgment, for after all the jury was a good deal in the right.

Rousseau seems, on the whole, to have gone heart and soul into his duties on the jury, and done his work with more than commendable zeal. All the more unexpected, then, and all the more incomprehensible was the final conclusion of the Exhibition as regards Rousseau personally. The collection of his own pictures was unsurpassed, and drew general attention. A special exhibition of one hundred and nine of his studies was open at the same time in the *Cercle des Arts*, and altogether he was very much *en évidence*. On the first of July the distribution of "recompenses" was made, and Rousseau, with the others, duly received his medal of honour; but all his colleagues —Gérôme, Pils, Français and Corot—were summoned to receive the cross of the Officer of the Legion of Honour; while he, the president of the jury, was left without this distinction. For twenty-five years he had been an ordinary Chevalier of the Legion; and now, at the moment when he himself and everyone who knew him expected him to receive promotion, he was delib-erately ignored. It was more than flesh and blood could stand. Rousseau was always inclined to be jealous, and his old sensitiveness in this way did not render him any the more easily satisfied. He became thoroughly angry, and there is no doubt that this disappointment was his death-blow.

It is worth while for a moment to pause and reflect on the end of the lives of Corot and Rousseau. Both were disappointed in what they had the ambition to attain. Corot wished, and justly thought he deserved, the medal of

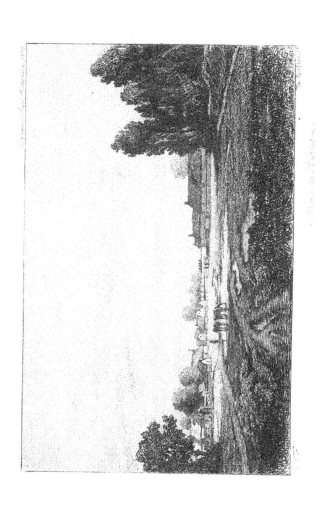

honour of the Salon of 1874, Rousseau that he deserved the promotion to be Officer of the Legion of Honour in recognition of his talent as a painter, and as the successful president of the jury of a great International exhibition. The evil influence of the classicists was still strong against him.*

Rousseau was so angry that he thought of petitioning the Emperor, and commenced to draw up a memorial, which, however, he never completed. His health was entirely shattered, and a change for the worse was apparent to all his friends. On August 1st, exactly a month after his disappointment, he was seized with an attack of paralysis, and this was the beginning of the end. He was taken to Paris by Millet and that artist's wife, who, like the kind friends they were, attended him constantly, but the change did no good, and on the 2nd of September he returned to Barbizon. There his wife made life hideous by her constant cries, but Rousseau preferred to have her near. On the 26th of September he had another stroke of paralysis, and again another in two days thereafter.

Thus things went on until the end of November, when Rousseau, gradually losing strength, began to sink under the attacks. He sometimes, even yet, spoke of taking up his brush again, and he never seemed to forget his art, but of course painting was under the circumstances quite impossible. Many of his friends went to Barbizon to see him. As the last month of 1867 progressed he became weaker and weaker, until at nine in the morning of the 22nd of December he died in the presence of Jean-François Millet and Tillot —the latter a mutual friend living at Barbizon. His sufferings at the end were terrible, and are very painful to dwell on. Let us rather think of the painter in his power than of the human being in his fearful death-struggle.

In the last hours of his life Rousseau continued to trace with his hands the

* This bitter feeling of the academical painters against the naturalists is still very strong, and in 1889 two of the most famous painters in the world said they would again reject Rousseau or Millet if they had the opportunity. It is not a question in any shape of politics; it is the apparently irreconcilable difference between the styles of painting and drawing.

visions of beautiful landscapes which he saw. So let us leave him still in the act of seizing and retaining that which was beautiful as well as worthy.

It had been while absent with his wife at Vichy, in the summer of 1867, that Millet first heard of the illness of Rousseau, but he did not think it was so serious, not knowing that it was softening of the brain. He wrote to Rousseau a kind and hearty letter, which concluded as follows:—" The day after we parted, I went to see your exhibition. I must tell you that, although I knew your Auvergne studies and those preceding them, I was again struck, in seeing them together, by the fact that a power is a power from its very beginning. From the very first you show a freshness of eye, which leaves no doubt as to the pleasure you have in nature ; one can see that she spoke directly to you, and that you saw by your own eyes. It is *yours* and not some other's, as Montaigne says. I am not going to follow your steps, picture by picture, down to the present. I only want to speak of the departure, which is the important point, for it shows that a man is of the true breed. You were, from the beginning, the little acorn which was destined to become the great oak.''*

When Millet reached Barbizon at the beginning of July he realised the gravity of the trouble, and on the 12th of August he wrote to Sensier :—" Rousseau continues better, though yesterday he was not very well ; to-day he is better. The doctor seemed encouraged. I hope for his recovery, though perhaps it may be very slow. Alfred Stevens came this morning with Puvis de Chavannes, to tell Rousseau that he is elected officer [of the Legion of Honour]. We received them—my wife and I—on the stairs, begging them not to go up lest his quiet should be disturbed. I told him, and he seemed very much pleased.''* Then when the fatal event took place, Millet was almost overcome. He wrote to Sensier from Barbizon on the 22nd of December, 1867 :—" I am trembling and overwhelmed. Our poor Rousseau

* Sensier's " Vie de Millet." Quantin, 1881.

died this morning, at nine o'clock. His death-struggle was very painful. He often tried to speak, but his words were stifled by the rattle in his throat. Let those know whom you think should be told. Tillot telegraphed to Besançon. I write to Silvestre at the same time."

Rousseau was buried in the little cemetery of Chailly, about two miles from Barbizon ; next to the spot where, a little more than seven years later,

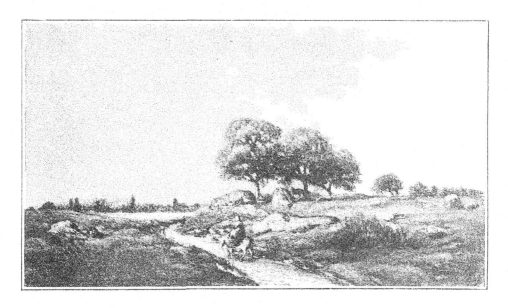

Le Chemin. By Rousseau. From the Secrétan Collection

Millet was to be laid. Millet was the truest friend Rousseau ever had ; and when this connection became to be well understood, in after years, it was a charming idea to have Rousseau's and Millet's profile carved on the same tombstone. This tombstone is supported by rocks and trees from the forest of Fontainebleau. Millet took charge of its erection, and he also took care of Rousseau's wife in her unhappy malady. When she died in February, 1869,

he wrote :—"The terrible death of poor Madame Rousseau fills us with distress. It stirs up many things in the past. The poor thing has been hardly used by events. I cannot think, without emotion, that she used to take care of me at times when I was ill. God knows I remember all the good she has ever done me." *

A few days before his death Rousseau dictated his last wishes. He named Sensier and Silvestre his executors, and he directed them to make a choice amongst his works, and to have them published in a portfolio after the manner of the "Liber Veritatis," or "Liber Studiorum." This last request was fulfilled by the production of the "Etudes et Croquis de Théodore Rousseau," an excellent portfolio of twenty-four reproductions,† of which a number are given in this book; also by a series of photographs of equal quality from Rousseau's pictures and sketches, published by Braun, of Dornach. His funeral to the neighbouring village of Chailly was attended by many friends.

Thus died one of the most noteworthy landscape-painters of the nineteenth century, the one member of the Barbizon group who had the most to grumble at in his career, but who in general kept his thoughts and grievances to himself. Rejected by the Salon, with few pecuniary resources, and heavily weighted by a wife who helplessly dragged him down in place of cheering him on, it is a constant wonder that he was able even so long to continue his daily struggle and maintain the strong self-possession he usually showed. It is not surprising that he at times let his feelings overcome him, but rather that he did not more often give way to jealousy, despondency and even despair :

> " What's done we partly may compute,
> But know not what's resisted."

* Sensier's "Vie de Millet." Quantin, 1881. † Published by Amand-Durand & Goupil : Paris.

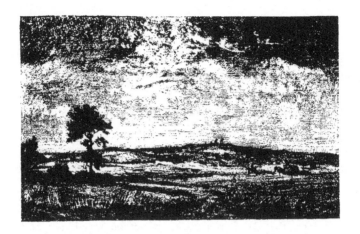

"Effet d'Orage" By Rousseau. In the Louvre

THÉODORE ROUSSEAU:—CHAPTER V.

METHOD OF WORK; PALETTE; BITUMEN.

IT is certainly doubtful if, after all, Rousseau lost very much by the steady rejection of his pictures by the Salon jury. It obtained for him much notoriety, if not fame, and it is possible that if he had been treated with ordinary courtesy and had been accepted, he might, at least for some time, have been lost in the crowd of exhibitors; but when all the world knew that he had been badly treated, and when year after year the public listened to the story of his ill-usage, then by the time he did become an exhibitor it is certain that a greater interest was taken in his works than would otherwise have been the case. Besides, Rousseau was thus given time to think out his plans at leisure; so that it is possible his absence from the Salon was not all loss either to himself or to art.

Rousseau's method of work required thinking out. He worked long and laboriously on all his pictures, and he never seems to have become thoroughly satisfied with their appearance, however much work he may have expended

on them. Hence it is not very often that a completely finished picture by Rousseau is seen. The "Marais dans les Landes," in the Louvre, is probably one of the most complete; while the "Coucher de Soleil" has often been said to be unfinished, and in some pictures the canvas is, in fact, still visible.

Let us take an example of what Rousseau underwent in the preparation and production of one of his works. We quote freely from Sensier's "Souvenirs," which is full of such information, although the want of a proper index makes it well-nigh useless.

Sensier relates that M. Leroux, with whom he was living at the time (1836), pressed Rousseau to paint one of the two avenues of the family residence. This is the "Avenue de Chataigniers," of which we give an illustration at page 117. Rousseau began his work by drawing it in charcoal on white canvas with scrupulous exactitude, and then he went over his first outline with ink; and, with that indefatigable patience which he displayed in all his careful works, he strengthened all his charcoal marks with the pen in a yellowish ink which he got from an old inkstand in the village. It was insipid work, but he persevered, and the drawing was finished with the same ink and the same pen. He did not wish that even the hidden part of his work should be of different tints, and that his eye should be caught by outlines in tones that did not agree. The picture was then first painted by transparent glazing colours in a powerful fresh monochrome, the trunks of the trees alone being made up with the knife and palette with surprising realism. He had used the dangerous chrome colours, and played upon their terrible key-board with remarkable success. M. Leroux was every day more and more surprised, for Rousseau, always within his prescribed limits, often modified his harmonies and then made them still more resplendent. Each tree possessed its droopings, its division of twigs, its clusters of leaves, and each separate trunk mingled its head, its branches, its profusion in an homogeneous and shadowy *ensemble*. Rousseau, however, found himself too

much distracted by nature. This verdant arch had ended by enchanting him and stilling his hand, so that he could no longer work outside. He confined himself in a room of the manor of Souliers, where, alone with his idea, he pushed on with his work, and till December he did not leave his work except to make a little excursion to the Sables d'Olonne, where he sketched in watercolours a few of the marshes and willows of the seashore. He returned in December, but stopped at Blois, the castle of which he drew with the precision of an architect, and painted with the vigour of a son of Rembrandt. Returning to Paris at the end of September he rested at Sologne, in the hills of Romorantin.*

One of the pupils of Rousseau, Monsieur L. Letronne, made notes of his lessons from him, which are both interesting and instructive. When Letronne went to the studio he knew nothing of painting, although he had learned drawing. For his first lesson Rousseau made his pupil copy one of his own pictures, a view of Mont St. Michel, and then an old picture by Van Goyen. Rousseau, being satisfied with the result, now sent Letronne to nature. "You will go to Montmartre," he said, "and when you return this way you can show me what you have done. Do not be afraid of troubling me. I am always at your service."

The first study from nature which Letronne showed to Rousseau† was not approved by the master. He explained to the pupil that drawing does not consist wholly in the exactitude of the outlines ; that every tree was not like a fruit tree spread against a wall, showing all its branches; that it had masses, as also had the various parts of the landscape, the water and the atmosphere ; that the canvas only was flat ; that it was necessary immediately and from the first turn of the brush to make this flatness and uniformity disappear.

* When the " Avenue de Chataigniers " was finished and had arrived at Paris, it excited the admiration and enthusiasm of connoisseurs, and they did not doubt that Rousseau's picture would create a sensation in the Salon. But when it was presented before the jury it was rejected, probably because the immense labour expended on it had made it difficult to understand. It must be confessed also that the composition was a little elementary, as may be seen by our illustration on page 117.

† " Maîtres et Petits Maîtres," by Ph. Burty.

"Your trees," he said, "must hold in the ground, your branches must come forward and recede in the canvas; the spectator must, indeed, think that he could walk round your trees; *enfin,* form is the first thing to observe. In order to give this, your brush must follow the feeling of the things it paints. No single touch must be put in without meaning; every brush mark must express and explain something." He insisted always on these principles and he spoke to his pupil very little about colour. One day he said to him, "You thought perhaps that in coming to the studio of a colourist you would be able to dispense with drawing?"

At another time, when Letronne spoke of finishing a picture, Rousseau said to him, "Let us see if we understand each other in the word finished, '*fini.*' It is not the quantity of trouble which finishes a picture, but the correctness and justice of the whole together. A picture is not only limited by its frame. Whatever may be the subject there is always a principal object to which the eyes of everyone are drawn, the other objects are only the complement of it; they interest one less; after that there is nothing for your eye. This is the true limitation of the picture. This chief object must strike the spectator at once and much more than anything else. It is necessary always to go back to it, making its colour more and more strengthened and pronounced." In this connection Rousseau had Rembrandt principally in mind. He went on to say, "If, on the contrary, your picture contains throughout a high state of finish, however good and precious it may be, if it is all of equal merit, then the spectator regards it with indifference. If everything is equally interesting, then nothing actually is interesting. There will not be any limits, your picture might indeed be prolonged indefinitely; one would never come to the end; besides, the painter would never have it finished."

In this connection it is interesting to see the "Ferme dans les Landes" here illustrated. This is a picture Rousseau worked at for years; it was one of his torments, and he left it unfinished at his death. Rousseau often spoke of Rembrandt, Claude, and Hobbema. When Letronne had

copied the picture by Van Goyen, Rousseau said some words which are remarkable and well worthy of being placed prominently in all our schools of art. "At a pinch you can pass over the colours, but you never can make a picture satisfactory without harmony." In order to show the meaning of this remark that harmony was everything while colour was subordinate to it, he made a then somewhat ingenious experiment. Prefacing his remark

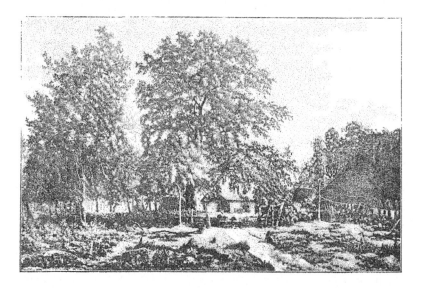

Ferme dans les Landes.
From "Etudes de Th. Rousseau." Paris: Amand-Durand and Goupil.

with the observation that a picture should be complete in the painter's brain before it appeared on the canvas, and that the process of painting is equivalent to raising the veil by stages from his ideal, he took a little picture and placed a sheet of tissue paper on it. The details of the work disappeared. He added a second, the outlines massed themselves somewhat confusedly. He laid down a third. The values of the light and shade had become less in strength but not in relation to each other. The idea of the

x

work was still visible in its strong general impression. " If I wish to complete my sketch," Rousseau said, " I should only have to reverse what I have done."

The work which Rousseau put upon his canvases was enormous, and this is the chief reason why he finally completed comparatively few pictures. He worked and painted and repainted until he forced one small portion of a picture up to a certain pitch, when he commenced to paint all the other parts up to the same strength. By the time the picture got to this pitch, then the first portion required strengthening, and so on in an almost never-ending way. "It appears to you that I am solely caressing my canvas, does it not?" he used to say, "that I am only just giving a few magnetic (*sic*) movements. A method is not of much moment when the result survives. One uses everything, even diabolical conjurings," he added laughingly, "and when necessary I have employed all the resources of colour. I have used the scratcher, the thumb, and if still necessary the handle of my brush. It is a good proof that at the end of the day I am often quite exhausted but never quite in despair." *

But his system was perhaps less complicated than he appeared to make out. Sensier states that it was only the fever of the beginning of a work that threw him into such eloquent abstraction, for nobody was more methodical to deliberate upon a picture, to prepare it and to submit it to an amount of work which was both patient and logical in its progress. His palette also was very simple, although it produced most luminous richness of forest harmonies. He did not use it as Gericault or Delacroix with the method of a strategist, who spreads all his resources under his eye. His palette was not in disorder, for it is described as shining in the sun like grey rocks covered with moss, lichen, parasite, and every infinite vegetation. Sensier often examined Rousseau's palette and says he saw there in rudimentary elements

* Sensier's " Souvenirs de Rousseau."

all that Fontainebleau conceals in treasures and in tints. The colours of his palette were grouped in three series in the following way:—*

Whites and their derivatives, the yellows.	Blanc d'Argent .	Silver White.
	Jaune de Naples.	Naples Yellow.
	Ocre Jaune. . . .	Yellow Ochre.
	Terre de Sienne.	Raw Sienna.
	Jaune Indien .	Indian Yellow.
	Laque Jaune naturelle	Yellow Lake.

Reds and their derivatives, the browns.	Brun Rouge . .	Light Red.
	Terre de Sienne brûlée	Burnt Sienna.
	Laque Rouge de Garance	Crimson Lake.
	Vermillon .	Vermilion.
	Momie.	Mummy (a bitumen).
	Laque Brune	Brown Madder.
	Terre de Cassel	Cassel Earth.

Blacks and their derivatives, the blues.	Noir d'Ivoire	Ivory Black.
	Bleu Cobalt	Cobalt Blue.
	Bleu Minérale (seldom) .	Mineral Grey.
	Bleu de Prusse (more seldom)	Prussian Blue.
	Vert Véronèse	Veronese Green.
	Vert Émeraude .	Emerald Green.

The chief points to be observed in the colours employed by Rousseau are the brilliant green pigments, Veronese green, and emerald green. These he

* In Burty's "Maîtres et Petits Maîtres" the list of Rousseau's colours in 1852 is given, and this list corresponds with that above, except that Prussian Blue, Cassel Earth, Brown Madder, and Yellow Lake are not mentioned. We learn also that he painted occasionally on polished panels of mahogany, and above all on panels of Fontainebleau oak, making use always, as a reserve, of the warm tone of the wood. He thus obtained some singular effects which no one has known how to imitate.

mixed with the browns and thus gained much of the mysterious colouring which so puzzled Diaz, who, as we tell in the story of his life, was a pupil of Rousseau, and received many lessons from him. The chief of these was Rousseau's use of emerald green. This is a colour scarcely used by British artists and not very much by French painters. It would be an interesting experiment for some intelligent admirer of the Barbizon School to take this palette of Rousseau and try to paint a scene in the Barbizon manner. With the very materials used by the master, there is no great reason why a successful work should not be produced.* All the other colours named except Yellow Lake and Cassel Earth and " Mummy," are commonly used by British painters. Mummy is, however, one of the dangerous class of bitumens, and is to be avoided by every sensible painter. Artists still use it, declaring it is quite good and will never go wrong; but this is altogether an error. It is certain to crack and run, and will ultimately damage any picture ; and anyone who buys a picture should seek to ascertain whether or not Bitumen, Mummy, or Asphaltum has been employed in its production. Many of the painters of forty years ago used it, and now few of their works remain which have not become cracked nearly all over.

In his earlier days Rousseau worked as conscientiously as he did in the full plenitude of his powers; and after the refusal at the Salon of his " Avenue de Chataigniers," he began to repaint his picture. He concentrated still more strongly its vigorous beauties, but did not resist glazing them with the transparence of bitumen combined with oil and double varnish, of which he did not then know the dangers. Very often he went over the work, caressing it as a fond father, whose pet child has been repulsed. Often, too, he sought to hide its roughness under limpid layers of oil and softened tints from his luminous palette; but he never sought, like so many artists

* The author once made a careful study, in oils, of Rousseau's " Coucher de Soleil," in the Louvre, and had no great difficulty in finding the colours necessary to imitate what was before him. Invention, of course, would have been a very different matter.

agitated by the surprise of a rejection, to soften or conciliate the antipathies of his judges.*

Frequently, when he returned in the evening to his country lodging, he would range his studies before him and consider, for a long time, those with which he was moderately well satisfied ; and, pipe in mouth, he would see in the vaporous shadows of the smoke fantastic landscapes with which he endowed his imperfect studies. When this had excited in his mind striking images he proceeded to realise them, sacrificing his preceding work. It was thus that certain romantic visions were severely criticised by *flaneurs*, as landscapes, where one could distinguish neither the sky nor the earth, and which were hung upside down. But these were only evening amusements— variations which he improvised through the smoke of his pipe and to which he only attached the importance of a fancy. He presented such sketches some- times to his unscrupulous critics, who repaid his confidence by bitter irony.*

Sensier narrates having said to him at the end of the day, " Well, Rousseau, are you content with the day?" "Ah! my friend," he would answer, " never was day long enough, never was night short enough. Have you ever thought of that coxcomb, of that impudent person called Pygmalion, who was so satisfied with his work that he came to love it? I would like to experience this presumption, it might be a crushing happiness, but I shall never attain it." When questioned as to whether he was nearly at the end of a work Rousseau would say, " You see here this corner of canvas as big as the hand—does it not appear to you much superior in intensity, in clearness, in expression to the rest of the canvas? Well, all the rest must undergo this transformation—everything around it is submitted to this luminous diapason and the *ensemble* of the picture must be as resplendent with life as this corner. Must we not unceasingly elevate ourselves, surpass ourselves in this terrible vocation of a painter?" Sensier's reply to such remark was, " But with your reasoning an artist would consume his life on a picture."

* Sensier's " Souvenirs de Rousseau."

"Well, yes," rejoined the uncompromising worker, "a man should be courageous, faithful, rich enough to produce only one grand work, so that this work should be a masterpiece and glorify man in his creation; and moreover, a great painter is famous only by a unique work—Michael Angelo by his 'Last Judgment,' Rembrandt by his 'Night Watch,' Correggio by his 'Antiope,' Rubens by his 'Descent from the Cross,' Poussin by his 'Diogenes,' Gericault by his 'Wreck of the Medusa.' Were I allowed to have a wish, it would be that I was a millionaire with nothing to do but to work upon the creation of a unique work; to devote myself to it, to suffer and enjoy it until I should be content with it, and after years of proof, I could sign it and say, There stops my strength, and there has my heart ceased to beat. The rest of my life would be passed in drawing or in painting for my amusement studies, which would be but flowers thrown on the work of which I should be satisfied."*

Rousseau's definition of what a great picture should be is of great interest, and is given at length in a letter he wrote in 1863. "It is good composition when the objects represented are not there solely as they are, but when they contain under a natural appearance the sentiments which they have stirred in our souls. If we contest that the trees have power of thought, at any rate we may allow that they can make us think; and in return for all the modesty of which they make use to elevate our thoughts and ideas, we owe them as recompense of their good qualities, not the arrogant freedom or pedantic and classic style, but the sincerity of a grateful attention in the reproduction of their being and for the powerful feelings they awake in us. They only ask us for all the thought they supply us with, that we should not disfigure them, that we should not deprive them of the air which they require so much. They also ask mercy from us in what we call modelling, which usually consists in colouring one side in a black-blue, and another in a mixture of half-tints. They only wish for relief, the one which is common to them, and which they

* Sensier's "Souvenirs de Rousseau."

borrow from the air. On this condition they will know how to support the criticism which finds them flat and cut out in examining them as isolated and separate growths, and as if one would number their profiles and accents. They will find themselves truly modelled in the air if the picture appears to be full of atmosphere. For God's sake, and in recompense for the life he has given us, let us try in our works that the manifestation of life be our first thought; let us make a man breathe, a tree really vegetate. He who knows how to make man live, is a god; but he who can only arrange with taste a few wavy outlines of lily or rose colour, manifests only enough art for a tapestry worker and a perfumer."*

Rousseau found some difficulty in the titles of his pictures, as by the continual repetition of the same words, even his own memory failed to carry a distinctive remembrance of his subjects. Sometimes even important works were renamed, and frequently with little or no connection.†

This difficulty was found so great that a list was prepared by M. Phillippe Burty in 1867 which is of great service in following up pictures and sketches by Rousseau, but this list only comprised the pictures and studies at Rousseau's command at the time, and omits many of the best-known works of the painter. Rousseau, however, was aware of what the after-value of this list would be, and in a letter dated July 4, 1867, warmly thanked M. Burty for his work.‡

Figures occupied only a very small place in the works of Rousseau. As a rule they appear in the picture only as accessories or incidents without importance, and there is seldom more than one. Rousseau sometimes painted a portrait of a relation, and in the two pictures begun for Prince Demidoff,

* Sensier's "Souvenirs de Rousseau."
† Everyone who has been at the naming of pictures knows in what haphazard way the titles are sometimes chosen. When a picture whose correct title has been forgotten is being sent to an exhibition some title must be found for the catalogue, and this may be done in such a way as may quite mislead the next owner, and the same picture may thus have several titles equally correct.
‡ It is reprinted in "Maîtres et Petits Maîtres," 1877.

there are one or two groups, but his strength did not lie in that direction. As a rule, pictures by Rousseau leave the impression of solitude. No active sensation, no excitement, nothing of even a strictly emotional tendency was usually introduced into his pictures : they were ever grave, anxious, and even sad. But this quality of severity is rather an attraction than otherwise. It is understood at once by the spectator that the painter is a great artist, one to whom it is evident others should look up, a master, in short, in the true sense of the word.

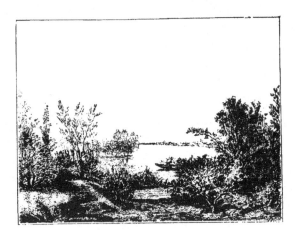

Bord de Rivière. By Rousseau. In the Louvre

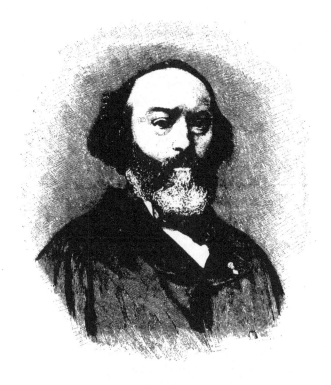

Théodore Rousseau. From a photograph from life
(Sensier's "Souvenirs de Théo. Rousseau")

THÉODORE ROUSSEAU :—CHAPTER VI.

PERSONALITY AND CHARACTER ; ANECDOTES.

THE biography of even the humblest person cannot be complete unless it
gives some idea of the personal appearance of its subject. A portrait,
as Carlyle has well shown, helps more towards this than anything else ; and
we here introduce a portrait of Rousseau from a photograph from life. He
was a stout, well-built man of somewhat uneven temper, strongly inclined to
be jealous, and rather apt to think that he was being ill-treated. There is no
doubt, of course, as the reader will have gathered, that he had much cause

for complaint in his younger days; and there can be no question that the somewhat impulsive youth was compelled to learn some severe lessons as he grew older. His twelve years of exclusion from the Salon were enough to sour a much better tempered man than Rousseau, and it is undeniable that this treatment did sour him, and caused him in his future life to be suspicious, and difficult to satisfy.

At the same time this harsh experience did not rob him of the best of his good qualities, and there is no more delightful story told of one artist's kindness to another than that of Rousseau buying one of Millet's pictures, when he could not have had much money to spare for his own expenses. His lonely and dreary existence with his wife was also a witness to his power of control over his temper, and perhaps it is true to say that to him these distressing outbreaks of his lunatic wife were far more trying than they would have been to an ordinary temperament. This would also mean that he is all the more to be commended because of his patient submission to a condition of life which most men would avoid, and which he knew well there was no legal obligation to fulfil.

When he was about thirty he was described as being a man of some personal beauty, with long brown locks and a crisp beard encircling his fresh and strongly-coloured face. The brilliancy and the intelligent questioning of his great black eyes were never forgotten by anyone who spoke to him, even up to his last days. He was *svelte* and of medium height; he would often flush all over in conversation, and he was always of a retiring and chaste disposition, living only for his art. His hands were exquisitely formed; mobile, and eloquent in expression, as only a Frenchman knows how to use them. His speech was a little wanting in clearness unless he became animated, when he spoke with great volubility; and one of his hearers said he had never heard a master who defined his doctrines and views with so much precision as Rousseau did on certain occasions.*

* P. Burly, " Maîtres et Petits Maîtres."

He was very robust and was able to stand, without fear of ill-consequences, rain and snow, hunger and thirst. He would walk for hours without apparent fatigue, and his limbs never seemed to become weary. Sometimes, in his youth, he would meet one or two others at midnight, on the Place de la Concorde, and walk into the country; not returning until the following evening after a walk of nearly fifty miles without halt.

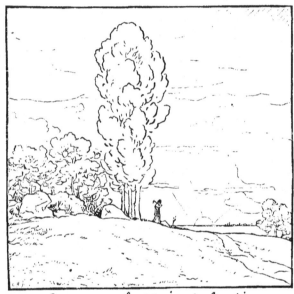

Paysage de la plaine de Barbison.

Paysage de la Plaine de Barbizon. By Rousseau, 1864.

His usual demeanour gave the impression of coldness and hauteur; but this was only on the surface, for those who knew him well knew also the strength of his affections. At the same time he was formed more as a teacher than as a colleague; and he was more disposed to give assistance than to ask it. For example he would never have so humbled himself, in his own estimation, as to write the letters of Jean-François Millet asking for

money. He kept his own troubles to himself, and did not seek to repose confidence in any one. He was careful in money matters; and, therefore, never had to undergo the anxieties of Millet; yet he, too, was often in debt, when no one would buy his pictures. But he fell into such expedients as making a forced sale of his works; and, cultivating the friendship of young *marchands de tableaux*, they afterwards repaid his esteem by assisting him to find a market for his works.

Rousseau was very little of a politician, and the assertion that it was because of his politics that he was refused at the Salon is altogether an error. He thought much more of the poetic side of the revolution of 1830 than of its practical outcome. He was sufficiently alive, however, to what was going on, to think of making a picture of the funeral of General Lamarque, one of the notabilities of the revolution, and he made a number of sketches for it.

In the text of the "Cent Chefs d'Œuvres," Albert Wolff tells that a once celebrated singer, Baroilhet, purchased the painting, "Le Givre" ("Hoar Frost") from Jules Dupré, who had undertaken to sell it. Dupré had walked about Paris all day with the picture, but no one would buy it; and at last he thought of his friend Baroilhet, the baritone of the opera, and he offered the picture to him for £20. Baroilhet hesitated at first, but he was acute enough to make the purchase, and he lived to sell the picture twenty years later for £680. We give an etching of this picture opposite page 120.

The brightest spot by far in Rousseau's connection with his fellow artists is his wonderful friendship for Millet. For Diaz, Rousseau had an affectionate regard more as between master and pupil, but for Millet he had the esteem of a man and an equal. Rousseau, being a strong-minded man, had a powerful influence over Millet and all for his good. He constantly encouraged him and was in many ways a real friend. He worked very hard to obtain for him such glimpses of momentary good fortune as he enjoyed.

He would even try to sell Millet's drawings and pictures for him in Paris, and he always introduced his own patrons to Millet. M. Hartmann, of Alsace, who was the chief patron of the Barbizon painters in later years, was presented by Rousseau to Millet at the village; and Hartmann was a good financial friend to both. Amidst their difficulties in younger life, Millet and Rousseau had been compelled to make some awkward engagements with bills which, failing to be paid in due course, recalled them to real life, and troubled them in solemn earnest.* M. Hartmann frequently interfered. He often stopped actions on the bills, he bought them up from their unrelenting creditors; and then, little by little, brought back again calmness into the life of the two friends. It was in Millet's arms that Rousseau died, depressed by disappointments and chagrins which neither friendship nor fortune had been able to dispel.

Rousseau was a long time in winning the complete friendship of Millet, but when once the shy peasant had overcome his timidity, he loved Rousseau to the fulness of his heart. They met constantly in the little village of Barbizon, where both artists found so many fine subjects. The etching given at page 144 from a picture of Barbizon by Rousseau is only one of a number he did. All Millet's outspoken troubles found a willing sympathiser in Rousseau. And perhaps at the very time when Millet was grumbling at his fate, Rousseau himself was realising how his own home had indeed become a veritable place of torment; and while he listened to and comforted poor Millet in his financial difficulties, he was probably thinking how strangely contrasted their true positions were. Millet was rich in the blessings of a loyal wife, and a large family. These brought constant troubles and vexations, no doubt, but Rousseau must have felt that he could have easily stood all the monetary worry, if he had had a wife capable of loving him, and children on whom to lavish his strong affection. Millet thought himself the poorer man because he had less money; while there is not a whisper anywhere in Sensier's

* "The Hôtel Drouot," 1881.

life of him to show that the writer could imagine that perhaps after all Millet was the wealthier of the two. Rousseau even with his little hoarded money, had a wife who was no wife, and who was never a mother, and in whom he had not any of the ordinary consolations of life. So that, taking all the circumstances into consideration, in every respect except that of gold, Jean-François Millet was infinitely richer, and had far more reason to be thankful and patient, than poor lonely Théodore Rousseau.

Rocks near Barbizon. Fac-simile of a Sketch by Rousseau.

NARCISSE VIRGILIO DIAZ.

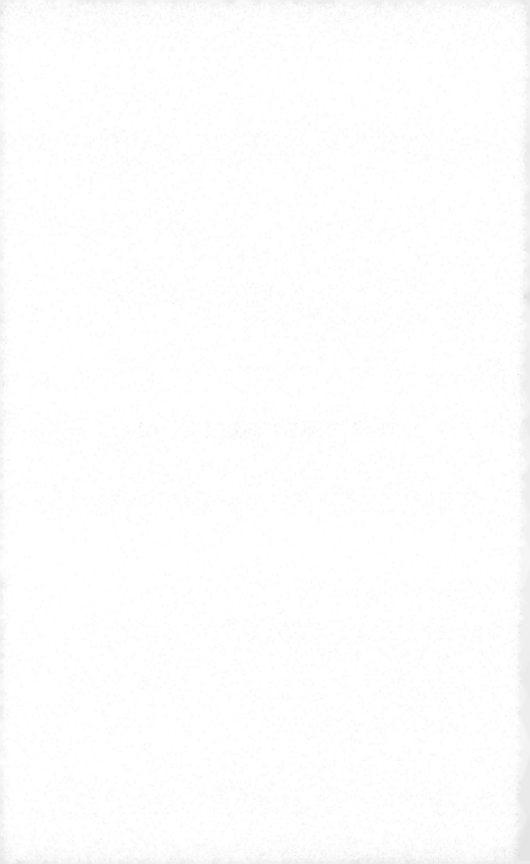

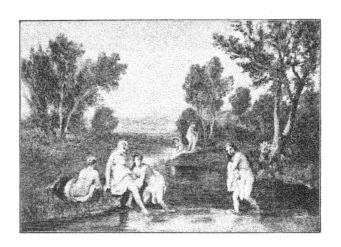

DIAZ:—INTRODUCTION.

WHILE the art of Corot charms by its cultivated treatment of pleasing compositions in which sweetness and light and general poetic gracefulness are made manifest, and while the more masculine art of Rousseau impresses by its strength and grandeur, the work of Diaz delights by its delicious and inexhaustible supremacy in colour.

Above all Diaz was a colourist. Early in life, after mastering the technical difficulties of painting on china, he produced flower pieces, rivalling in strength of tone the famous ware of Sĕvres, but superior to it in that they were executed with a quality in the brush work and a freedom of touch which put them far above the machine-like productions of the national manufactory. Diaz subsequently transferred this kind of work to canvas, gradually drifting into painting Eastern figures. After meeting Rousseau he modified his painting to follow the landscape style of that artist, while at the same time he never altogether forgot his love for figures, either nude or with flowing

draperies, and these he occasionally painted to the end of his career. Yet there can be little doubt that it is chiefly as a painter of the forest that he will live in the future. There are still those who collect his glowing Eastern figures, and his flower pieces are equally strong, but in his forest scenes alone does he reach the level of a great master.

Diaz, as we shall see, had a great deal to struggle against. His education was imperfect, his training was none of the best, and when he approached man's estate, the oats he sowed were of the wildest description. Then, when he became fashionable in art, he found no time for training. He was applauded when he ought to have been rebuked, and, generally, his career was without that curb which makes the individual agreeable and acceptable throughout life to other people.

Correggio was the master for whom Diaz had the strongest admiration · Velasquez also claimed his attention, but Correggio was his chief inspirer. He frequently went to the Louvre, where the " Antiope " was his particular study, and where, also, the works of other colourists were carefully examined by him. But it was only after he had met Rousseau and had induced that artist to show his manner of painting trees that he found what he best could accomplish. Before Diaz received lessons from Rousseau, he was afraid to paint foliage, and, in fact, he did not try. He inserted as background scenes without trees, or vague shadows indicating foliage without form or character. The skies of his pictures, early and late, were, however, always fine, and he had an advantage over both Rousseau and Daubigny in being always able to introduce figures skilfully into his composition.

Altogether, the personality of Diaz is not so interesting as that of the other great painters of the Barbizon school. He was more limited in his art, less daring in his attempts, and not so individual in his results. His figure pictures are seldom completely satisfactory, sometimes failing in composition or in drawing or in colour, though seldom in all three. His flower pieces

could never from their nature rise to the highest sphere of Art, and, as we have already said, it is only in his finest forest scenes that he reaches the highest degree, excellence, and power.

Besides such fine pictures there are existing many charming compositions by Diaz, which, although they cannot be considered great achievements, yet must be classed as thoroughly sound examples of colour, glowing with a beauty and strength unrivalled in their particular style by the works of any other contemporary painter.

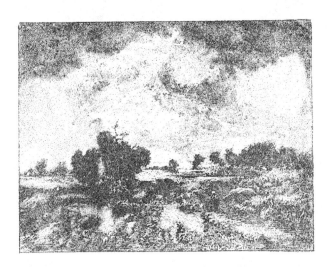

After the Storm. By Diaz. From an Etching by Chauvel.

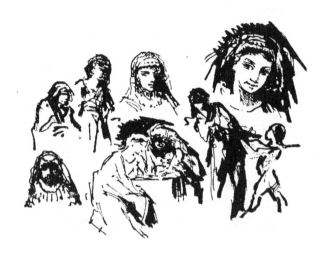

Sketches of Oriental Figures, etc By Diaz.

DIAZ:—CHAPTER I.

SPANISH PARENTAGE; ORPHAN; FOOT POISONED; EARLY WORK; 1808-1829.

ONE great difference between Diaz and the other artists of whom this work specially treats is that he was not a Frenchman by descent, while Corot, Rousseau, and Daubigny were all Parisians, and Millet was a Normandy peasant. Diaz was, it is true, born in France, and received all his training there, and though warmer southern blood, derived from Spanish parentage, made him a difficult man to argue with when he was angry, yet it also added fire and daring to his paintings, and gave him that taste for Oriental figures and gay flowers which he early developed in such an uncommon degree.

Narcisse-Virgilio Diaz was born at Bordeaux on August 25, 1808. His father, Thomas Diaz de la Peña—to give him his full title—a Spaniard of

Salamanca, had involved himself in a conspiracy against King Joseph Bonaparte, and the authorities becoming aware of the treason, he, in order to avoid arrest and probable imprisonment, was compelled to flee with his wife from his native country. The fugitives hurriedly made for French territory, but the fatigues endured in crossing the mountains were too much for Madame Diaz, his wife, in her delicate condition, and although they were on their way to England, a stoppage had to be made at Bordeaux, where their only child Narcisse was presently born. Diaz *père* went on his journey to seek a home for his wife and child, but circumstances were all against him, and after trying Norway he went to London, where he always hoped to form his own family circle. After three years' continued struggling he failed in all endeavours, and he died alone in far-off London, leaving his young wife, Maria Manuelo Belasco, and her boy in France without their natural protector.

But Madame Diaz was a woman of considerable resource, and her troubles served to bring out and strengthen her excellent character. Being able to speak Spanish and Italian, she soon obtained employment as a teacher, and after going to Montpelier and Lyons, she finally settled at Sèvres, in the suburbs of Paris, where she found occupation in teaching the children of an Englishman. Doubtless, she looked forward to the time when her growing boy would be a man, and when she could afford a little rest from her labours for him ; but fate was again cruel to the future artist, for when he was only ten years old Madame Diaz died, leaving him quite alone in the world. Fortunately, his mother had made several friends at Sévres, and Monsieur Michel Paira, a retired Protestant clergyman, living at Bellevue close to Sévres, was kind enough to promise to take charge of the orphan.

The young Spanish boy was, however, too wild for ordinary guardians, and it is certain that he had too much of his own way. He needed a stern father or mother with a strong hand, able and willing to chastise him when necessary ; but it was fated that he should ever be wayward, and the want of judicious treatment in his youth was evident to the end of his days.

This want of training was also felt in another way, such as must have cost him many an hour of sorrow and regret. His greatest pleasure was to escape from tasks and wander in the beautiful woods surrounding his home. At Sévres, Meudon, St. Cloud, and the other woodlets of that peninsula of the Seine, young Diaz was wont to roam at large. Even in these early days tree trunks and foliage had a powerful attraction for him, and all his wish was to be in the woods. One day, when he was thirteen, the unhappy accident happened which cost him so very dearly. Tired with rambling, he lay down on the grass in Meudon Wood and fell asleep. During his slumbers his foot was bitten by some venomous reptile, and when he awoke he found his leg had become greatly swollen. On reaching his home—such as it was— another misfortune overtook him. His leg was not attended to properly, and as the result of bad nursing, gangrene set in. He was carried to the hospital, "L'enfant Jesus," where amputation was resorted to in order to save the boy's life. Yet even here ill-fortune was not content to leave him; the amputation was so badly performed that a further and greater amputation had to be made, and thus nearly the whole limb was sacrificed to inattention and incapacity. From this time he walked with a wooden leg.

Diaz was fifteen by the time he was well enough to get about again, and his guardians began to think of serious employment for him. At first they thought of making him a printer, but the youth speedily found this quite unsuited to his taste, and he was apprenticed to a maker of porcelain dishes and ornaments; an occupation a little more in accordance with his liking. Madame Paira supported her adopted son in this project, as she was fond of porcelain, and living so near the manufactory at Sèvres it was natural that any one with artistic tastes should think of undertaking such work. Young Diaz did not enter the State *ateliers*, but was apprenticed to Arséne Gillet, the uncle of Jules Duprě. In the same studio were Jules Duprě, Cabat, and Raffet, all of whom achieved distinction in after years, so that Gillet's studio was a productive source of artistic merit. Diaz, like the

others, was employed in the decoration of all kinds of porcelain, and for a time at least was happy. Then the monotony of the occupation began to tell on him ; and although he remained faithfully for some years at the studio, he came to dislike it very much. Doubtless also his ill-trained will rebelled at the fixed hours, and the close and constant attention demanded by a personally superintending master. In any case he became tired of the work, and looked forward to the end of his apprenticeship as the termination of a kind of bondage.

Meantime the lad amused himself by going to the Parisian theatres, devouring Victor Hugo's works, and painting at home such subjects as he liked. He tried to introduce some individuality into porcelain decoration, but this only led to unpleasantness with his employer. Then Diaz thought he would have lessons in drawing and painting, and he commenced to attend the *atelier* of Souchon, a clever teacher, who became afterwards the director of the Ecole des Beaux-Arts at Lille. But Souchon was too methodical for Diaz, so he took to painting what he chose without any training in the composition of a picture.

Reading Victor Hugo's *Lucretia Borgia* led Diaz to make sketches of figures in robes and in processions, but usually in the desert or on a plain ; for Diaz was frightened to paint trees, and as yet he did not know he could represent foliage at all. He continued to paint Turks or the women of the harem and many Oriental scenes, so much so that he attained to a distinct reputation as a painter of Eastern scenes. To this day some persons declare he could not have painted such scenes unless he had been in the East ; but the fact is undoubted that at no time was he many hundred miles from Paris.

We now approach the more interesting period in the life of Diaz. Hitherto he had lived alone, and uncared for except by his adopted parents. Now he was to become the friend and ultimately the companion of Théodore Rousseau, whose influence over Diaz presently grew very great.

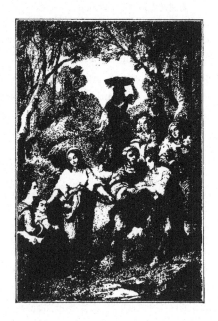

Le Descente de Bohémiens By Diaz. In the Louvre.

DIAZ:—CHAPTER II.

MEETING WITH ROUSSEAU ; THE SALON ; FONTAINEBLEAU ; ROUSSEAU ; LESSONS
IN TREE PAINTING ; PICTURES ; THE OFFICIAL DINNER ;
BARBIZON ; 1830-1855.

DIAZ was still to some extent a painter on porcelain when he first
encountered Rousseau. This was probably in 1830, but at latest in 1831,
when Rousseau, although only nineteen years of age, was already proclaimed
one of the champions of the new school of painting. In the evenings a large
company usually met at an estaminet, called " Le Cheval Blane," in the
Faubourg St. Denis, " where Decamps led the revolt against the classicists."
There Diaz met Rousseau frequently, and it is recorded that he was then
struck with the grave dignity with which Rousseau behaved, so different from

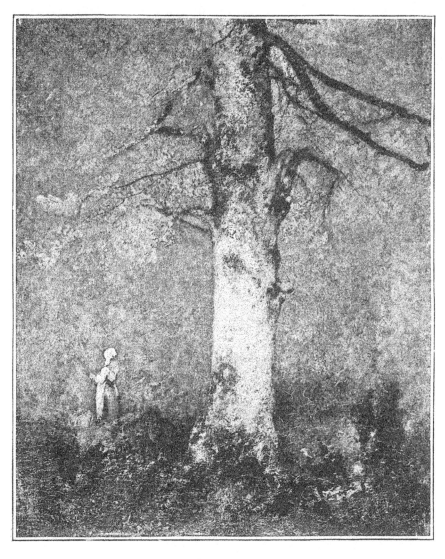

SOUS BOIS. BY DIAZ.

From the VAN GOGH collection. Now in the possession of CHARLES ROBERTS, Esq.

the usual swaggering of successful youth. Diaz from the first recognised in him the great artist, and he soon became deeply attached to him.

Up to this time Diaz had chiefly composed romantic scenes with figures, sometimes well filled up and sometimes vignetted. He also painted little bouquets of flowers on glove boxes, some of which still exist. The work on the latter has been described as timid but effective, the colours being laid on thickly, as Diaz would naturally do in his style of painting on porcelain.

In the Salon of 1831 Diaz had a picture hung, no small achievement for a man of twenty-three, with so many educational and physical disadvantages. Rousseau, the junior of Diaz by four years, had also a picture in the Salon, but he had had everything in his favour and no drawbacks. Diaz got very little money for his early works, and he was content to sell his pictures for sums varying from four to twenty-five francs. These were mostly in a low tone of colour as it was later that his palette became so very luscious, and they were of such a quality that his early patrons afterwards would say they had had better bargains for the price than they could obtain in his later works. One purchaser told the painter in after years, that he had purchased some of his early pictures " which, in my opinion, are more valuable than those you paint now." One of these early pictures is at Nantes, but on account of its low tone of colour it is difficult at first sight to believe that it is by Diaz.

The old Protestant pastor still continued to take some interest in Diaz, and on the 15th February, 1831, we find him writing a letter about one of the first large works of the artist, a picture of the Saviour, about the price of which there seems to have been some discussion, and he concludes by saying he was glad to do anything he could for the young artist, "whom I love very much, and who for a long time has had no other supporter than ourselves."

Diaz gradually became better known, and he grew more ambitious in his compositions. In 1835 he painted the " Battle of Medina," which has been nicknamed the " battle of the broken paint-pots " from its strange confusion of colours. It was a mass of clever brilliant colouring with little apparent

A A

design. In 1836 he painted the " Adoration of the Shepherds," and in 1840 the " Nymphes de Calypso," the latter, which was full of gay colours, being dubbed a "sweetmeat" picture by some of his critics. He went to Fontaine-bleau about the same time as Théodore Rousseau, and it was at this period that the works of Rousseau proved themselves a revelation to Diaz. When he saw the result obtained in the pictures of Rousseau, he at once said, " Now have I found my master." His admiration for Rousseau was, in fact, some-thing more than a conviction, it almost amounted to adoration, and even up to the day of his death he abated no atom of his esteem. Even in his older and less enthusiastic days his face would lighten and his heart would swell at the remembrance of the one whom he had been always proud to call his teacher.

The artists were not on intimate terms when they first met, and *le grand refusé* was not the kind of man to court civilities or attention. Diaz, living in the same inn at Fontainebleau with Rousseau, saw every evening the works brought in from the forest, but he dared not examine them openly. Out of the corners of his eyes he drank in the wonderful colours and rich studies which Rousseau had made during the day, but Rousseau kept him at a distance and Diaz could not find a ready means of approach. Rousseau, as usual, was suspicious of everyone, and was at all times fearful of displaying his feelings in case he should be misunderstood and repulsed.

Diaz, however, felt that, come what may, he must get at and understand the secret of Rousseau's painting. The method puzzled him, and the results obtained seemed almost impossible of achievement without magic, so he deter-mined to fathom the mystery in the best way he could.

Not daring to speak to Rousseau on the matter, he resolved to resort to stratagem. Rousseau left every morning with his *déjeuner* in his pocket, enter-ing the forest at once, where he remained often during the whole day. Diaz, providing himself in like manner, set his mind to follow Rousseau, and try, if possible, to penetrate the secret of his painting. We can picture the scene—

Rousseau diving amongst the trees with Diaz at his heels ; Rousseau resolved, if possible, to reach the forest primeval alone and be rid of humanity and all its works ; Diaz—notwithstanding his wooden leg—dodging him from tree to tree and from clump to clump with a fixed determination to be near him when he commenced to paint, yet without intruding on his privacy.

Diaz then endeavoured to imitate the method he thus tried covertly to see and he looked as much as he dared at the studies he saw at the inn in the evenings. He essayed again and again to paint trunks of trees after the style of the man he now, though still secretly, called his master. But he failed to obtain the extraordinarily rich result achieved by Rousseau, and he became despondent of ever reaching his aim. The illustration, " Sous Bois," we give opposite page 176, is from a picture such as he afterwards painted (it is in the collection of Mr. C. Roberts, of Leeds) and such as he, at the time of which we now write, envied to be able to produce like Rousseau.

At last Diaz found a favourable opportunity to speak what had so long been in his mind. The artists had gradually become more intimate, and the time arrived when Diaz could tell Rousseau plainly how sincerely he admired his works, how much he wondered at the results he obtained, and how difficult he found it to understand how they were accomplished. As Rousseau listened to the passionate words of admiration from Diaz, he felt that here at least he need have no fear, and, the ice being broken, Rousseau revealed all his methods to Diaz. On that eventful day the two artists became firm and lasting friends.

Diaz, although, as we have seen, four years older than Rousseau, always considered him as his master; and the relationship of master and pupil was pretty well maintained to the end. Diaz, in his fiery southern way, was ever loud and fervent in praise of Rousseau; in fact, he never ceased to applaud and admire him. He learned from Rousseau the secrets of his palette, and found himself in a few hours with as much insight into the methods of foliage and tree-trunk painting as Rousseau, who had spent years in finding it out.

He had to study and search for a long time before he could accomplish all he wished, and he had to practise much before the secrets revealed to him were of great service. Being without proper teaching of the various properties and qualities of colour, he knew nothing of the different devices by which painters reach their end, and all that Rousseau had to tell him about the use of emerald green,* Naples yellow and other useful colours, was worth years of laborious searching. What Rousseau had to tell was nothing much more than others could have told; but Diaz felt the inspiration of sitting at the feet of the master, seeing the actual methods he employed, and by adding his own artistic sense and taste to his new knowledge, he made remarkable and rapid progress.

This, then, was the turning point of the artistic career of Diaz Up to this time he had been more or less a simple maker of pictures, acting blindly and without teaching, and therefore uncertain in his results. But from this period he was an artist capable of the highest things.

By the mutual esteem of the two great painters, each reflected on the other his own brilliancy, and while the teachings of Rousseau did much to help Diaz, so also did the unaffected admiration of Diaz for Rousseau assist and encourage the painter who so much needed these sympathies in coming years, because of the refusal of his finest works by the Salon.

When Rousseau was in a difficulty about finding a purchaser for his "Avenue de Chataigniers" Diaz bethought himself of a connoisseur he knew, M. Paul Casimir Perier, who had just commenced to purchase pictures of the old Dutch School; and he induced this young man to visit Rousseau, with the result stated in our memoir of that artist.

It was not until 1844 that Diaz, as he is now known and admired, was revealed in his strength. Previous to this he had given occasional flashes of genius, but from this time forward his work was to be of the finest quality.

* This is a colour very little used in painting in England, although there is no chemical reason why it should not be more employed.

The prices of his pictures had risen rapidly from the years when he began to exhibit in the Salon, and he commanded good prices. About 1844 he also commenced to enlarge his figures, until he painted some nearly life-size, but none of these are entirely satisfactory, and his best works in figures are of somewhat small dimensions. About this time Millet envied Diaz the ease with which he seemed to sell his nude figures, and he also produced a few, but as we shall see later, Millet soon found that his power lay elsewhere.

In 1845 Diaz sent three portraits to the Salon, and in 1846 a number of pictures which showed the variety of his powers; there were forest scenes, nymphs, and oriental and classic pieces. In 1847 he was again very prolific and there were then ten of his pictures hung, and in the Salon of 1848 five pictures were shown exhibiting all his styles. The persistence of Diaz in sending to the Salon was not without its reward; for in 1844 he received a third class, in 1846 a second class, and in 1848 a first class medal.

Théophile Gautier was one of the earliest correctly to appreciate the art of Diaz, and in 1848, when the artist was scarcely yet completely acknowledged, Gautier spcke of his works as "pearls, brilliant as precious stones, prismatic gems and rainbow jewels." Such a picture is the "Mare à la Vallée de la Sole," of which we give an etching from the Durand-Ruel collection (page 184). In the same year the new Government wanted representations of the Republic, and opened a public competition for a design. Diaz painted a figure of a fine-looking girl, with dark hair and pale flesh, and dressed in muslin, in the style of the ancient gods. There were two children beside her, one representing Science and Literature and the other the Fine and Industrial Arts. This, however, was not accepted by the Government, and the design dropped into obscurity.

Thoré tells an anecdote about Meissonier and Diaz which is very interesting. The well-known figure and military painter saw, in 1846, a picture—an interior of a forest—in the window of M. Durand-Ruel, and he became so fond of this work by passing it frequently, that he entered the shop

and there he found another customer asking its price. "Eight hundred francs" (£32), said the merchant; but the customer thought it too dear and asked if it could not be had cheaper. Meissonier was angry to hear this attempt to cut down the small price for such a gem, and called out, "Eight hundred francs! There!—why, that is nothing. M. Durand-Ruel, I will take the picture;" and Meissonier took it away with him under his arm.

Financial matters at this time became somewhat embarrassing to Diaz, so he resolved to relieve himself by having a sale of his works. This was an unusual thing for an artist to do, but the sale was, at the time, considered fairly successful. Yet the highest prices were under 600 francs (£24) and the average was only about 200 francs (£8). These are not very large sums for works of such a master, and yet Diaz expressed himself as well content. In 1850, he exhibited in the Salon the picture called the "Descente de Bohémiens," now in the Louvre, which, as will be seen from our small illustrations, is a favourite example of that combination of figures with forest scenes which Diaz often chose for his compositions.

One of the most notable incidents which arose between Diaz and Rousseau was the famous toast of Diaz at a dinner given to the décorés of the Legion of Honour, which caused much consternation and scandal in official circles. Rousseau had by this time—1850-1—already long been acknowledged as one of the chief of the new school of painting, although his pictures in the old régime had been rejected for a dozen years. Under the republic Rousseau thought that things would at all events not be worse than under the monarchy and he was again prevailed on to send to the national exhibition. His pictures were received and hung, and in the Salon of 1850-1 he had seven pictures which brought him much into notice. Diaz also was an extensive exhibitor. At length came the time when the various honours—medals and crosses—were to be announced. Rousseau did not seem to think much of the matter, except that he felt the principles of liberty, equality, and fraternity would probably prevail; and that under these circumstances he had nothing to fear.

When the list of honours was published, great was the astonishment of everyone to find Diaz nominated Chevalier of the Legion of Honour, while Rousseau, his acknowledged master and leader of the school, was altogether omitted. Diaz was furious—far more indeed than Rousseau, who had become accustomed to be ignored, and was not so much worried and hurt by it—and he vowed by all that was sacred he would be revenged. At first he proposed to return his decoration to the ministers, but he ultimately hit on a more striking and effectual plan to bring shame to the cheeks of the haughty officials.

At this time Diaz and Rousseau were very fast friends, and the neglect of Rousseau's legitimate expectations was enough to rouse the ire of the young Spaniard. He perfectly boiled over with anger and desire for reparation. Rousseau argued with him and tried to calm him, but Diaz thought his master badly treated, and he did not hesitate to let everyone know he thought so. Naturally, the incident now to be related drew them even more closely together, for Rousseau gratefully acknowledged the ardent services of his pupil and devoted friend.

Diaz, as one of those who were to be decorated, attended the dinner given to the new officers of the Legion of Honour, and there, in presence of the officials and all the self-sufficiency which seems always inherent in administration, he rose and loudly proposed this toast to the company : " À Théodore Rousseau, notre maître oublié (To Théodore Rousseau, our master who has been forgotten)." The scene was remarkable and worthy the pencil of a great painter. No one supported Diaz, but he was strong enough not to need assistance, and he maintained and publicly expressed his opinion in this pointed neglect of Rousseau up to the end of his life.

Diaz was then living at Barbizon, and he met with many others at Rousseau's house, where he made every one laugh at his capers and his wild yet humorous exploits. About this time there was a proposition to make an illustrated volume of La Fontaine's Fables, and Diaz was to have illustrated

certain well-known fables, but the proposition was not carried out for many years.

The Paris Exhibition of 1855, which became, as stated elsewhere, such a triumph for Rousseau, was a terrible disappointment to Diaz. He had given his imagination full play and, despite of the advice of all his friends, sent a picture to the gallery entitled, "Les Larmes du Veuvage." The figures were weakly drawn, the composition was bad, and the whole work was very disappointing. Every one, friends and foes, condemned the picture, and it was only the immense strength of his previous work which saved him from falling into great discredit by showing such a painting.

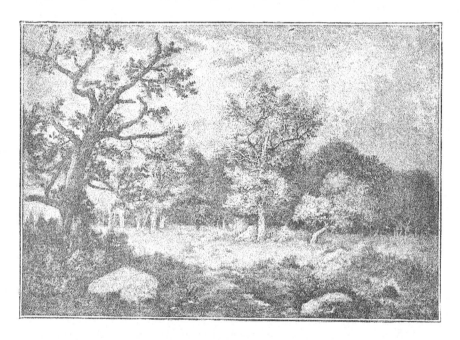

Fontainebleau From a Painting by Diaz
By permission of Messrs. Boussod, Valadon & Co.

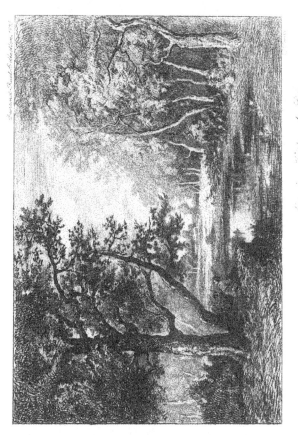

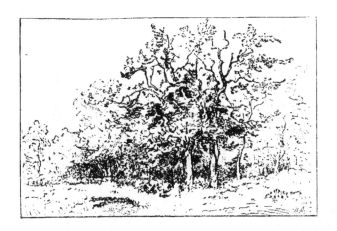

Sketch of Trees. Facsimile of a Drawing by Diaz.

DIAZ :—CHAPTER III.

AS soon as the 1855 exhibition was over with its heavy disappointment, Diaz went to the forest of Fontainebleau, and worked there for some time. Afterwards, in 1856, he built a studio in the Boulevard de Clichy, in the north of Paris, and there his friends visited him frequently, and, surrounded by all kinds of *bric-à-brac* and nicknacks from the East, Diaz, in his later years, became quite a notable character amongst the painters in Paris.

In 1857 he painted and exhibited in the Salon the picture, " La Fée aux Perles," which is now in the Louvre. This picture, which is known also as " The Necklace," " Venus and Cupid," and " The Pearl," is one of the best figure pictures painted by Diaz. It is large in size, the principal figure being

B B

nearly 22 inches high, and it is carried out in his finest manner. Our illus-

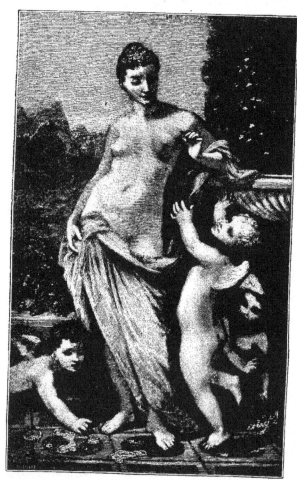

The Pearl. By Diaz. In the Louvre. From "La Galerie Contemporaine."

tration gives a good idea of the values of the picture, but, of course, its chief charm is in its colour. The draw- ing of the figures, although not per- feet, is about the best by Diaz, and it is interesting to notice that the foli- age at the back is massed in the early manner of the artist.

One of the sons of Diaz, Narcisse- Emile, who had been born at Paris twenty - five years before, died in November, 1860. He was, perhaps, more a poet than a painter, although he was both. He wrote verses which, while strongly tinged with the ideas of Victor Hugo and Musset, still possessed individuality, and he was a great favourite with artists. The other

son, Eugéne, was a musician, and composed some pieces which were well liked at the time of their publication. Emile was a painter of some power, Rousseau having taken him as a pupil, and they had become much attached to each other. Emile's early death was a severe blow to Rousseau, who looked on him as if he had been his own son.

In 1860, an attempt was made to found a Society after the model of the Art Societies of England. Rousseau was to have been president and Diaz vice-president, with Corot, Millet, Troyon, and others as members; but the project failed from the lack of someone with business capacity to carry it on. This is an instance of the difficulties artists usually find when they meddle with matters of pure commerce. An artist is a creator and not an agent, one to inspire actions for trading, but not to try to be a trader himself.

Like so many other artists, Diaz was constantly smoking, and in connection with this an anecdote is told. About 1864 he was asked to go to the Tuileries to repair some painted ceilings which he had decorated many years before, in the reign of Louis Philippe. As he was commencing work, Napoleon III. came into the room. "Monsieur Diaz," said the Emperor, smiling, " I know your taste. Do not disturb yourself. Do altogether as if you were in your own studio." Diaz, of course, was delighted, and took advantage of the permission. But an official of the palace looked in and was immensely shocked. " Hi! what are you doing—do you think a working painter may smoke in the imperial palaces? Put out your pipe immediately!" But Diaz looked at him with serenity and quietly replied, " Mon bonhomme, j'ai la permission du bourgeois."

Diaz was at Chailly in the forest of Fontainebleau in September, 1865, painting with Barye, and it was then probably that he painted the " Belle Croix," of which we give an etching opposite page 192. A couple of years later he was a constant attendant at Rousseau's house, making enquiries as to the dying painter's health, and anxious to know what he could do to relieve the last agonies of his much-beloved master and friend.

During the war of 1870, Diaz went to Brussels, being then too old to fight for his adopted country. There, in his dull room in a poor hotel looking over an unpicturesque courtyard, he painted brilliant pictures from his sketches made in the forest of Fontainebleau. The very fine specimen of his work, of which we give an etching opposite, was painted about this time. It is now in the possession of Mr. Charles Roberts, of Leeds.

When Diaz got back to Paris and affairs settled down, he obtained great prices for his works, and wealth actually flowed in on him. He then purchased a villa at Etretat, on the Channel, and there he surrounded himself with all kinds of beautiful objects, artistic and natural, wood-carvings, flowers, and other things to help him in his work. He was now at the very height of his fame, and he spent a very busy and happy life.

In 1871 there was a great assemblage of dealers and connoisseurs at Paris anxious to buy up any works that might be sold at a low price ; but the result of the presence of many purchasers made competition keen, so that prices rose enormously, and Diaz received pounds where, before, he had been content with francs. The dealers had to carry something away to pay their expenses, and Diaz was lucky enough to share in the plenitude of money from other countries.

In the winter of 1872-3, Diaz caught the illness which ultimately carried him off. In the early days of January he went to the Opera to witness the first representation of the second musical work by his own son, Eugène. This was "La Coupe du Roi de Thulé," the first having been "Le Roi Candaule." The evening was very cold, and after the close of the piece Diaz had to wait nearly twenty minutes for his carriage in the draughty passages. He took a violent shivering fit which resulted in the first touches of an attack of pleurisy. The artist soon recovered, and, to all appearances, was as well as usual; but at the age of sixty-four such attacks were bound to leave their mark, and he never really completely recovered. He was sent to Pau where the air of the Pyrenees proved very beneficial to him, so much so that he went there the two following winters.

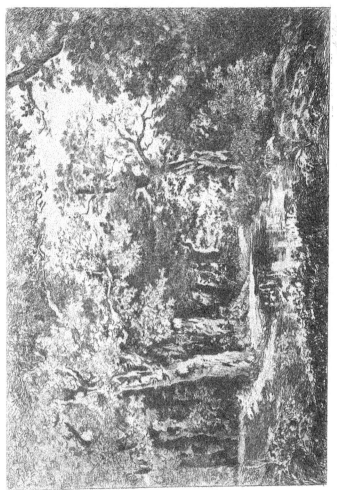

Fontainebleau

On the Jour des Morts, " Toussaint," November, 1876, Diaz went to the cemetery to pay his customary annual visit to his son's grave. The weather was so cold, however, that he was seized with bronchitis, and he was laid up in bed for a few days. Soon he got well again ; but his physicians counselled him very strongly to leave Paris for the winter and to go to Mentone, where the air of the Mediterranean would doubtless set him up once more.

Diaz started on the 9th November with his wife and servant. The evening previously he held a reunion before departing, at which he was very gay and full of spirits. " I do not understand," said he, " why the doctors should send me away as an invalid ; I have never felt better in my life. I feel as if I were only forty ; " and in order to show how agile he was, he began to pirouette on his wooden leg, and he held up one of the heavy chairs of his studio for several seconds at full arm's length.

This journey was, however, singularly unfortunate. The weather was very cold, and at Dijon it began to snow, gradually becoming worse until, by the time the travellers reached Mentone, the whole landscape was deeply covered with ice and snow. On his arrival, Diaz was put to bed at once, and if the weather had changed he might have recovered ; but the cold continued, and for the next four days snow fell continuously. The bronchitis became more acute, and even when its force was lessened, Diaz was left so weak as hardly to be able to move. For six days he lay prostrate, and then on the morning of the seventh day at ten minutes to nine, Saturday, November 18, 1876, he died quietly in the arms of his wife.

Madame Diaz had never quitted her husband for a second, and her devotedness was beyond praise. From Mentone she telegraphed, on November 18, to Monsieur Guerin, a family friend : " Mentone, 8.50 ; all hope of saving Diaz lost ; the bronchitis has become purulent." In another hour she had again to telegraph : " All is over ; Diaz has just died." He had asked to be shown the sunset the evening before, and from his death-bed in the south of France he saw the sun go down for the last time.

His body was brought home, and many people attended the church of St. Augustine, in Paris, where the funeral service took place on the 23rd November. Military honours were performed by a detachment of the 28th Regiment of the line. A part of the musical service was composed by his son Eugène, who, as has been related, had already obtained a considerable reputation. Montmartre Cemetery, where his other son had been buried sixteen years before, was the place of burial, and thither followed some of the most distinguished artists of the day. In the name of the Institute, Meissonier read a speech praising the art of the man the Institute never thought of inviting to enter its doors. But Meissonier could praise him without remorse, for he had bought his pictures. Then as the official representative of the administrator of the Beaux-Arts, M. de Chennevières, that faithful writer of eulogies for so many years, made one of his set speeches for such occasions, and returned home doubtless quite content, although his heart might have been pricked by the consciousness that Diaz, for twenty-five years, had waited for promotion from the lowest grade of the Legion of Honour, at which he died. M. de Chennevières said he thought Diaz really was an officer of the Legion, and no one could be more astonished than he himself was, so at least he averred, when he found out he was still in the first steps of the Legion. He said he had made arrangements for Diaz to be promoted the following January, but as so long a time had passed without this promotion, it is difficult to believe all that was said at the funeral oration.

Viollet le Duc, representing the Salon painters and sculptors, was, however, in his proper place to declare the loss to art by the death of Diaz, for the annual exhibition authorities were always fairly well disposed towards him and to his pictures, and many of his finest works first appeared upon its walls.

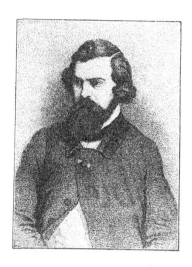

Portrait of Diaz

DIAZ:—CHAPTER IV.

CHARACTER ; WOODEN LEG ; VARIOUS STYLES OF WORK.

THE first thing that was noticed by a stranger on being introduced to Diaz was his wooden leg. Throughout his life Diaz made the misfortune of his having lost a leg one of his constant jokes. "Mon pilon (my stamper)," he always called it, and he used to say he was afraid his English admirers would walk off with it some day, leaving behind the usual "consideration," as if it were a picture.

But Diaz had such a lively spirit that he came through all his early misfortunes with little trace of bitterness left visible to those around him. Lively he was, but with a sufficiently severe temper when he wanted to use it. As a rule he was jovial and hearty. He was very active, and none of the usual exercises came amiss to him, riding and hunting, swimming, and even

dancing were undertaken, despite his wooden leg and all its drawbacks. When he was visited at his studio, the callers, after ringing the bell, could hear the noise of the painter's wooden leg stumping along as he hurried to open the door. The sound might recall to the visitor the unhappy days of the artist's youth, although it was the only thing to do so, for Diaz spoke so much and so fast that callers had little time for reflection. To his visitors Diaz was always very cordial and merry. His face brightened up as he opened the door, and he forthwith began to talk very loudly, and literally never ceased to speak until he had said good-bye.

In general appearance Diaz was not tall, but he was very robust, dark-skinned, and sunburnt like a gipsy. He had a fine head full of energy like an Andalusian, and while he was as brusque as a Castilian, he was as eloquent and voluble as an Italian. His head would not be called beautiful, but it gave the impression of remarkable power of will. His beard and moustache, turning slightly grey in his later years, were trimmed in such a way as to give him somewhat of an American appearance. His eyes were large, firm, and wonderfully expressive, and, like the colours of his own pictures, they seemed to flash and sparkle as he talked. He spoke in a voice sounding and strong as if he had been always accustomed to command; and, as we have said, he went on without ceasing, disputing, arguing, replying, and questioning in an eager quick way very difficult to keep up with. He was generous, ardent, and enthusiastic, but decidedly passionate and very reluctant to concede anything in argument; and he would never allow himself to appear beaten. He was frank in his conversation and open in his confidence, and while he often used forcible and even apparently rude language it was always easy to perceive the delicacy of his feelings.

His personal habits were also interesting. His savings-bank was quite of a primitive order, for when he did get more money than he had present need for, he often threw it into odd corners of his well-filled studio, so that when the time came, as it usually did very speedily, that he needed money, he went

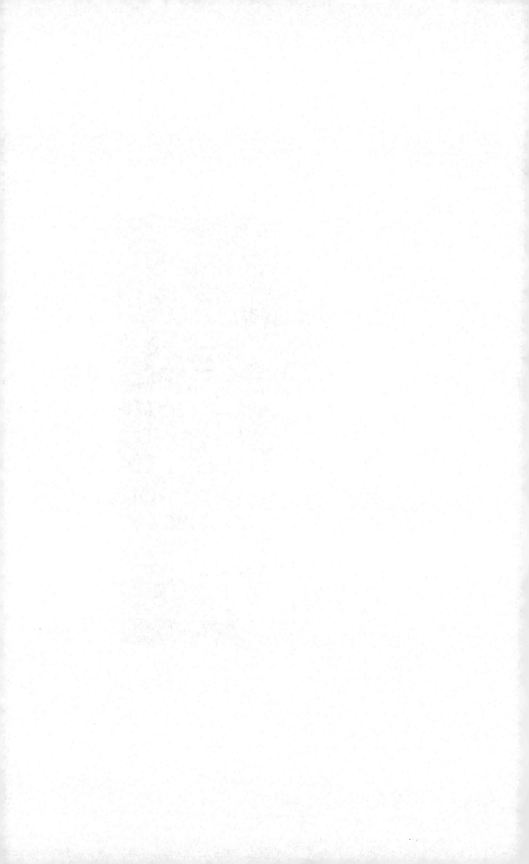

down on his hands and knees and searched until he **was** rewarded by finding a gold piece. When he sketched in the forest of Fontainebleau, he would sing and shout and thump his wooden leg on the ground, for he was always boiling over with mirth, music, or enthusiasm, except when he was crossed. One of his chief topics of argument was that the quality of good colour in a picture was far preferable to correctness of line in the drawing, and on this he would talk for hours. He would say exactly what came into his mind, and he did not change his style of language either in boudoir or in club. His laugh was always the loudest and drowned everyone else, and while he was all gaiety to those who agreed with him, he could be very much the reverse to those who contradicted him.

Diaz once had a severe discussion with Carpeaux, the once-popular sculptor (born 1827, died 1875), as to whether painting was superior as an art to sculpture. Diaz wished to prove that it was certainly possible to show an object on all its sides in a picture at one time. In order to show this he made a picture in which he represented a naked man seen behind, placed at the side of a fountain which showed by reflection the front part of the figure, a shining cuirass showed one of the sides, whilst a grand "psyché" or cheval-mirror reflected the other Carpeaux gave in, as he might have done without demonstration, for the contention of Diaz was not so very extraordinary.

Diaz, as we have seen, is chiefly known as a painter of Oriental figures, gorgeous flowers, and Fontainebleau landscapes. In these landscapes he often chose stormy effects, such as " L'Orage," which we illustrate, or setting suns in half unconscious competitions with Rousseau; and though it has to be allowed that he never achieved the grand dignity of Rousseau in his landscapes, he frequently produced pictures of extraordinary merit and quality in composition, colour, and subject.

Diaz was, however, never ashamed of the occasional similarity of his pictures to those of Rousseau. He was persuaded that the best way to paint

forest scenery was after the style of his teacher, and he frankly and openly made use of the model he thought finest. Very often we hear connoisseurs complain that a certain painter is too like his master as if it were an unpardon- able fault. Is not a painter right in taking advantage of his position and privileges? What would be the use of living at the end of the nineteenth century if we require every painter to work as if he had been in the twelfth?

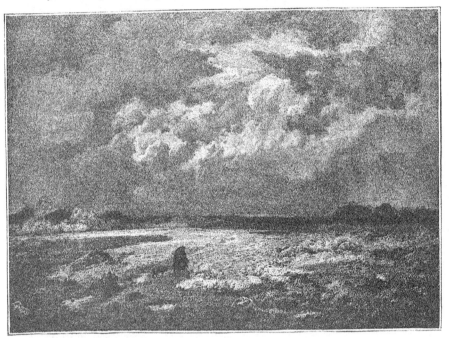

The Storm. By Diaz. From "La Galerie Contemporaine."

The small figure subjects by Diaz are often of the supremest merit in the colouring; rich, handsome, and beautiful, composed of choice harmonies of the finest quality, and produced with exquisite taste and feeling, so that he was sometimes called the Correggio of Fontainebleau. Such is the picture, "Women Bathing" (p. 169), from the Forbes collection. As has been said,

Diaz never was in the East, and his women of the Mohammedans were known to him only in imagination. Yet his pictures are admitted to be more really Eastern in effect than many other *O*riental painters before or since. He caught the correct harmonies usually revealed only to an Eastern eye, and he employed his instinct for colour in producing literally scores of these luscious little gems. He frequently painted dogs in landscapes, and one of the few in which motion is portrayed is " The Chace," in the collection of Mr. T. G. Arthur, of which we give an illustration. With his feeling for colour he naturally excelled in painting flowers, and many admirers of Diaz consider a perfect

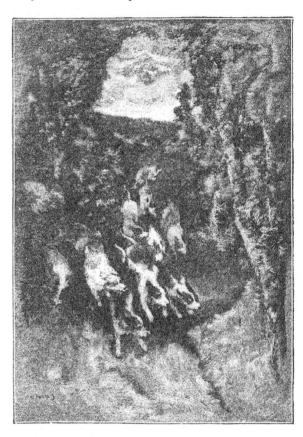

The Chace. By Diaz. In the Collection of T. G Arthur, Esq.

example of his work can be obtained only in one of his flower pieces. These have all the luxuriousness of the Oriental pictures; they are often less extravagant, while they are always grateful to the eye which

c c 2

has been trained to understand and perceive colour. No more perfect examples can be found than the exquisite groups of " Flowers " in Mr. Forbes White's and Mr. de Murrieta's collections.

Diaz was an artist to his finger-ends, very capricious and impulsive, but honestly independent and very well persuaded (like most artists and art critics) of the correctness of his own judgment. Of course, his early training, or want of training, was altogether against him during life. He had been per-mitted to have his own way in his earliest days, and the habit of expecting to have this never left him, and often appeared at very awkward times. Yet he made many warm and life-long friends, notably Rousseau and Millet. Of Rousseau we have already spoken, but we may also say that Diaz was a strong admirer of Millet. Whenever he discovered a picture in which he saw genius, his warm southern blood at once felt an inspiration to praise. When Millet exhibited in the Salon of 1844 a group of children playing, he said, " At last, here is a new man who has the knowledge which I would like to have, and movement, colour, expression, too : here is an artist ; " and when Millet was in trouble, Diaz, who was his neighbour at Barbizon, did much to help him. He made a tremendous propaganda for Millet, urging amateurs and dealers to get this artist's paintings if they could, and did not wish to stand in his eyes as blind and incapable.*

Diaz was always inclined to be generous with his gifts, and when he became better off he sent a picture to a sale which was being got up to assist a poor old dealer who had come to grief. He sent the picture with instruc-tions to have it repurchased for himself for 3,000 francs (£120), no small sum for a comparatively poor artist to give to a dealer, one of that class who are always supposed to have money, live well, and grind the genius out of the poor painter.

One day Dumas *fils* was in the studio of Diaz, and saw there a picture by Tassaert, " Une femme couchée étreignent son traversin," and Dumas wished

* Sensier's "Life of Millet."

to buy it. "How much will you take, Diaz, for your Tassaert?" asked Dumas. "It belonged to me when I was young, and when I was hard up I sold it; now I should like to have it back." "My friend," replied Diaz, "I sell Diaz and not Tassaert. That Tassaert will only leave my studio when I do." Again, at another time, Diaz noticed an elegant young lady languidly crossing the court of the house and entering the studio of one of his neighbours. "That is Sarah Bernhardt," said Diaz, "who plays the comedy of the sculptor. Elle a de talent d'ailleurs et beaucoup. Ces femmes ça fait de tout comme les singes."

Diaz was of opinion that the works of the classicist or "correct" artists, well known or otherwise, were always uninteresting; and he would laugh at Ingres, and say if he himself and Ingres were shut up together in a room without engravings, Ingres would have been incapable of doing anything, while he, Diaz, would have emerged at least with a picture, meaning that Ingres depended solely on copying what he saw before him, while Diaz was able to compose a picture from memory.

Diaz took much trouble to find titles for his pictures, but his elaborate names never stuck to his work, as witness the large figure subject from the Louvre, illustrated on page 186. "In a Wood," or "A Group of Figures," and other such titles are now the usual names for his works.

For the student, Diaz is a less desirable master than Rousseau. Flinging all restraints to the wind, he excelled in the most dangerous qualities for a beginner to try to imitate. His brilliant colours, laid on with seeming carelessness, are a pitfall for the unwary; and though easy to imitate when once produced, they are difficult enough to create and very undesirable to help to form a style.

However original an artist Diaz was in particular ways, it is certain that, like Daubigny, he was always strongly influenced by other painters. As a rule he was more impressed with the sentiment of Rousseau's pictures than any other, and all his forest scenes showed how much he owed to that master.

But, sometimes, he followed Decamps in his choice of brilliant blue skies and
sunshine; while, again, he would be like Corot, tender and beautiful in the
grey tones of his pictures, and, in his homely figures—not the Oriental groups
—he would be like Millet. Yet notwithstanding all these leanings at different
times, he was a great painter in the best sense, for, while he did not despise
the lessons of those who had gone before, in every work he added some-
thing to their achievements.

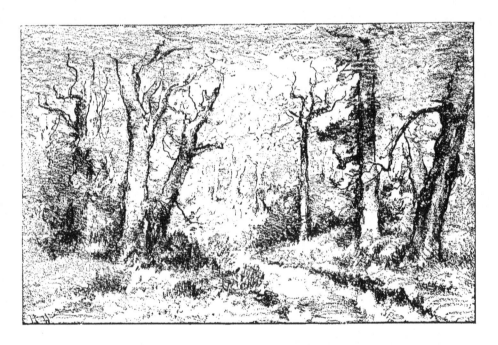

FacSimile of Forest Sketch. By Diaz. From "Peintres et Sculpteurs Contemporains," Jouaust Paris.

JEAN-FRANÇOIS MILLET.

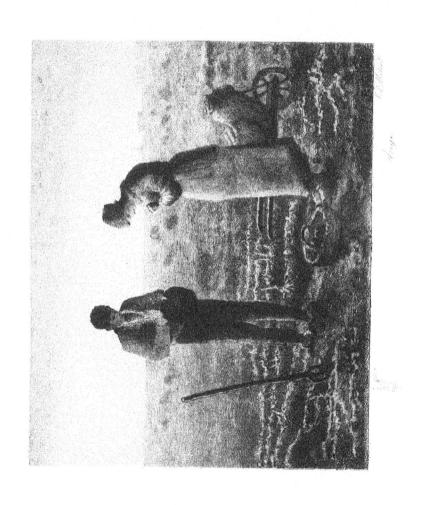

A Peasant's Sabots. By J. F. Millet *

J. F. MILLET:—INTRODUCTION.

WHILE the general characteristic of the art of Corot is poetry and light; of that of Rousseau strength and dignity; of that of Diaz colour, the best general term for the art of J. F. Millet is veracity. Absolute truthfulness to life and to nature, inner and outer, visible or hidden, was the guiding principle of Millet's career from the first; and although at one time from sheer necessity he swerved from this maxim, it was only soon to return to it with redoubled earnestness and vigour.

It has been said, with some truth, that up to the time of Millet art had been a flatterer; it had toned down the exaggerations of individual character and glossed over the deficiencies of individual expression and form, for even the most truthful of the old masters considered it right that they should pick and choose the subjects and points to be dwelt upon. There were few patrons of art like sturdy old Cromwell, who desired his portrait to be painted warts and all, with nothing left out and nothing added in.

Millet as a peasant, was born to look hard facts in the face. He had to toil in the fields until his hands became hard and horny—why should they be the less beautiful for that? he would say. He saw the cultivators of the soil stop, hot and perspiring, to lean on their hoes gasping for breath,† he had

* From "La Vie de Millet." Quantin, 1881. † See illustration, "The Man with the Hoe," page 204.

D D

seen the new-born calf brought in, in solemn yet happy procession, with the mother cow following after, and many other apparently trivial incidents of peasant life at Normandy and Barbizon. And in such incidents he found the beauty of nature and truth, and embodied them in his art.

But while the characteristic of the art of Millet was truthfulness, his characteristic as known to the general public was that he was undeservedly neglected during his lifetime. In several respects this was true, but one great misapprehension must be removed. It is popularly believed that Millet's life was, even to the end, one of extreme penury and distress; and that while his pictures after his death fetch enormous and exaggerated sums, he during life could scarcely keep his head above water. But this idea of Millet having been poverty-stricken, at least during the last twenty years of his life, is altogether inaccurate. That he did have some monetary troubles even up to his death there is no doubt, but they were latterly of the very mildest description, and were as much the outcome of want of forethought as of absolute want of cash. When Millet first settled in Barbizon, about 1849, and for perhaps the first few years thereafter, he was in some distress; but even at the worst this was not severer than many young artists have had to endure, or, as every one knows who moves amongst painters, is being endured by the unacknowledged masters even now living in our midst. But after these few years—say from 1855 onwards—that Millet or his family ever came to real starvation point is only a poetic exaggeration, which has been so often repeated that it has come to be accepted by many as a sober and prosaic fact.

Very often Millet's life at Barbizon was not very comfortable, at least, in the view of many people in these luxurious times; but it is to be remembered that Millet was born and bred a peasant, and that the necessaries of life, and these not of the finest quality, were all he actually sought for. His somewhat headstrong friend and biographer, Alfred Sensier, accustomed as he was to the lap of luxury, has taken Millet's monetary troubles too seriously. After relating, for example, the straits to which Millet found himself reduced,

quoting a doleful letter to this effect, Sensier immediately gives another letter, presumably of similar date, in which this remarkable sentence appears, "My projects for buying a house are for the moment suspended." The question is, how could a man who was said to be so much driven by debts even dream of purchasing a house? Either it is that Millet, whenever he felt low-spirited and anxious, sat down and wrote to Sensier, or he was unconsciously exaggerating his troubles to himself. It is remarkable, however, that most of these unhappy letters are written to Sensier, and though it would be unkind to say that they were courted by him, it is quite certain he had some grim pleasure in receiving them, and afterwards he did all he could to let the world know of their existence. Sensier acted as Millet's agent, receiving money, ordering frames and colours, and looking about for commissions. All this he did, be it clearly understood, without direct benefit to himself at the time, and in all probability without thinking much of the profits which were afterwards to be realised on the works of which he became the possessor; and it is quite possible he would have done what he did without hope of reward. At the same time, he is never more satisfied with himself than when he is dilating on the "malaises cruels," "inquietudes," "tortures," and difficulties of poor Millet. It was an excess of love, perhaps, for the painter that inspired this; but it cannot now be doubted that it was injudicious to publish private letters, telling of passing troubles and petty vexations which, put in print, rise from being insignificant mole-hills into the dimensions of great mountains.

That Sensier's family did eventually make profit out of their connection with Millet is undoubtedly true, for nearly all the drawings and studies acquired by the biographer have come to the market, fetching sums many times more than was actually paid for them. Also that the Sensier family were not really interested in the welfare of the Millets has been proved in another way, for at the end of 1888 Madame Millet was turned out of her old home at Barbizon, and the famous house was razed to the ground. This was

the doing of the proprietor, M. Duhamel, the husband of the only child and heir of Sensier, and whatever may be the excuses, the facts, as publicly stated, tell sorely against the father's memory. Fortunately, Madame Millet was rich enough to go to another and better house in the village, but the vandalism of destroying the famous Millet house and altering the studio is altogether unpardonable.

Generally speaking, it has been usual to consider Millet as always miserable and moody, as generally sad and toil-burdened. While not wishing to convey the idea that his life was completely the reverse, it is possible to show the brighter side of it, and also to prove that his misfortunes were not more than those of the common lot of humanity, and that he was neither miserable nor moody in his home life, nor necessarily so in his art life. In many ways he was happy and contented, in his lifetime he had many friends and admirers, and in any case he was very little worse off than other good painters of the time, and was far better placed than his less-gifted, but mayhap no less sensitive neighbours at Barbizon. In short, it may be said, that the general verdict which has hitherto been pronounced on Millet and his life, has much that is erroneous in its conclusions.

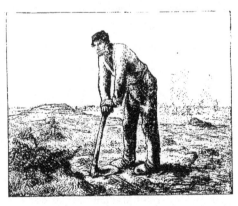

The Man with the Hoe. By J. F. Millet.

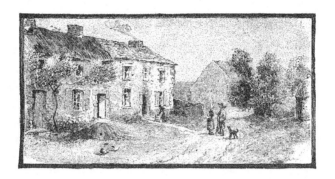

Millet's Birthplace, Gruchy.

JEAN-FRANÇOIS MILLET :—CHAPTER I.

DESCENDANT OF PEASANTS ; TRAINING ; FIRST DRAWINGS ; DEATH OF FATHER ;
RETURN TO PEASANT WORK. 1814—1835.

IT is quite appropriate that the principal peasant painter of France should have been the descendant of many generations of peasants ; and that he himself should have been brought up as a peasant, and have led a peasant's life during his youngest and most impressionable years. A true son of the soil in every sense, he may be accepted as a model of the best class of the labouring classes of France ; the kind of man on whom a nation's prosperity greatly depends, and entirely apart from the faithless and frivolous exotics of Paris who have neither reverence for the past nor hope for the future.

With little to mark Millet's family as distinctive from its neighbours, the records show that the artist came from good peasant stock, and that he originated through both parents from upright and estimable people ; the stories of whose lives, handed down by word of mouth, exercised great influence over the thought and work of their afterwards famous descendant.*

* The details of the Millet family are given fully in Sensiers' " La Vie et l'Œuvre de J. F. Millet." Quantin, Paris, 1881.

Jean-François Millet was born on October 4th, 1814, in a cottage still standing in the hamlet of Gruchy, which is in the commune of Greville, near Cherbourg, on the English Channel. At the present time Gruchy can be reached only by an old-fashioned diligence, which runs along a road by the sea through Landemer to that place.* From Landemer to Gruchy the country is wild and melancholy in appearance, and full of such combinations of cattle and landscape as remind us at every turn of the peasant-painter's work. Near the centre of this hamlet stands the house where the Millet was born, amidst a group of houses nestling behind a cliff. In the centre, on the left of the roadway which divides the village in two, there runs a little lane. This *venelle* opens abruptly into a court, and on the right is a one-storied house with the following inscription over the entrance, " Ici est né le peintre Jean-François Millet, le 4 Octobre, 1814." This house was built in 1775, of rough-hewn stones, when the Millet of the day was known for miles around as a generous-minded and charitable man.

The family of Millet *père* was in somewhat straitened circumstances, and both father and mother had to work hard in the fields all day. The care of the children was therefore left, as is customary among the peasants of Normandy, to the grandmother; and it was the teaching of this really venerable woman which sank deepest into the boy's mind and memory. Her favourite morning greeting was, " Wake up, my little François, the birds have long been singing the glory of God," and it was in this spirit, and under this kind of influence, that the artist received his first impressions of the duties of life.

Of Millet's mother we do not hear very much, her life being more than fully occupied with the cares of a large family, together with the necessity to help in earning the daily bread of the family, so that she gladly left some of the training of her children to their grandmother. But Millet's

* Up to 1888 the inn at Landemer at which the coach stopped was in the occupation of one of Millet's brothers, and the words " Maison Millet" have been left on the signboard.

mother was, nevertheless, the object of great love and reverence to her son, the artist, and he never spoke of her but in terms of great respect and affection.

Millet received his hereditary artistic instincts from his father, for Millet *père* was by feeling an artist of some sensibility, although he never exercised his talent by using a pencil. He often spoke to his son of the beauties of nature, he would pull grasses and flowers and draw his son's attention to their charms, and would often point out the varying effects of sunlight on a landscape or a group of foliage. But his talents were entirely inarticulate, though happily they descended to his eldest son. These talents, however, rendered him quickly appreciative of his son's latent powers, so that he did not oppose, but rather assisted, his son's artistic efforts from the first.

He had, in fact, often observed with interest his boy's taste for drawing, and he silently considered what was best to be done. But the family was large and their wants were many, so that François had to remain to help his younger brothers and sisters, and the father was compelled to hold his peace. The time arrived, nevertheless, when inaction could no longer prevail. When François had reached eighteen his father's attention was fascinated by the curious outline of an old man passing along which the youth had drawn, even although it is said he had never seen a picture. The little work was so clever and revealed so strongly the bent of their son's mind that the parents felt the time had come to break silence. The father took his son entirely into his confidence, and explained his position, but added the significant words, " Now that your brothers are older, I do not wish to prevent you from learning that which you are so anxious to know." So François began forthwith to prepare to go to Cherbourg, and be trained for the career of an artist.

It has been usual to consider that Millet, like other peasants, would be somewhat illiterate and dull in the understanding. But Normandy

peasants are like Scottish country folks,* for although generally poor they are frequently very well trained and deeply read. When Millet was eighteen he was able to read easily the Bible and Virgil in Latin—his favourite books throughout his life—and it is recorded that he was an eloquent and true translator of this language. His education, in fact, was equal to that of many artists; and far superior to what is considered necessary for a peasant. He was a neat and facile writer, his letters are clearly and often elegantly expressed, and had he turned his attention to literature it may be that he would have made his mark as a writer.

When he went to Cherbourg he was a well-educated man, and he was quite able to hold his own even when he reached Paris a few years later. It has, therefore, always to be borne in mind, when considering Millet's career, that although born and bred a peasant, he had received the kind of education which permits a man to progress until, as time runs on, he need not be afraid to be the associate of those whose education had been more exact and complete. It is to be noted also that Millet's talent was acknowledged from the first, and he is one of the few artists who have had no unnecessary obstacle put in the way of their earliest endeavours to prosecute awakening perceptions. Millet's father had no fear for his son, and he was the first to approve and applaud his gifts. The first drawing, as already mentioned, won instant praise, and the question of François becoming an artist was settled once and for all.

Father and son set out for Cherbourg—just as Bewick's father took him from Cherryburn to Newcastle, and as many another parent has taken his son—to search for some one to teach him the elements of his future profession. Millet was taken to Mouchel, one of the few artists of Cherbourg, and the drawings he had been carefully preparing for some time were submitted, with a little trepidation, to the local great-man. Mouchel examined them,

* At the present time, a stewardess on one of the steamers on the west coast of Scotland may be seen studying the works of Carlyle between the intervals of supplying whisky and sandwiches to passengers.

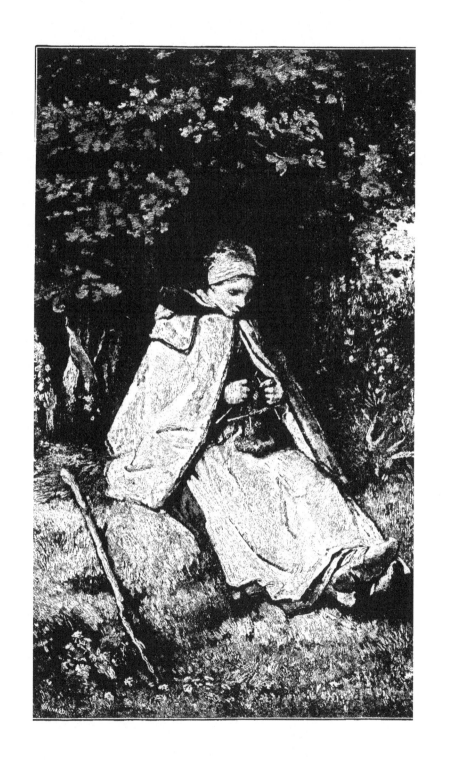

asking the question if the drawings were really the work of a beginner, and when he was assured they were, he said to the father that he was certainly to blame for keeping the youth so long away from art, "for your child has the stuff of a great painter."

This was a really remarkable prophecy for the old artist to make, and must often have brought consolation and inspiration to Millet in the difficulties through which he afterwards passed. But while man was thus propitious to Millet, the fates were combining against him. After an interval he had gone to Mouchel's studio, and had made considerable progress in drawing—copying from casts or from engravings—when he was recalled to Gruchy on account of his father's illness. Brain fever claimed him for its victim on the 29th of November, 1835, and Jean-François Millet speedily found himself at twenty-one the new head of the family, and under the necessity, according to his conscience and the custom of his country, of taking the direction of the home in hand.

To return to the labours of a land cultivator after having a foretaste of the realisation of his dreams of being an artist, was probably one of the severest trials that Millet experienced. Yet we do not hear that he grumbled, or sought an excuse to continue his studies at Cherbourg. He immediately left his drawing and painting, resigning his high thoughts and hopes, at least for the moment, and manfully set himself to do his duty. Fortunately, it was not long necessary for him thus to sacrifice his future; but the fact that he was ready to abandon his best dreams to earn daily bread for his brothers and sisters, shows plainly the grave strength of his character, and the severe yet commendable manner in which he had been educated.

Noon. By J. F. Millet. From 'La Vie de Millet.' Quantin.

JEAN-FRANCOIS MILLET.—CHAPTER II.

RETURN TO ART; PICTURES; ALLOWANCE FROM CHERBOURG; PARIS; FIRST
MARRIAGE; PRIVATIONS; DEATH OF WIFE; DESOLATION. 1836—1844.

MILLET had thus, in a stern exercise of duty, practically abandoned the
life of an artist, and had begun again the drudgery of a peasant.
But while his mother and grandmother saw with pride the steady deter-
mination of the eldest son to do his duty, and be a model to the younger
children, they soon realised that the sacrifice made by the young man
was too great, as well as quite unnecessary. Millet's brothers were growing
up, and were as capable as he was of conducting the business of the farm;
and their greatest ambition was to become cultivators. Why, therefore,
argued the womenfolk, keep François at home, and spoil his prospects, when
the work he does can be as well performed by his brothers? And after very
little persuasion, the change was accepted by all. His grandmother, who
had watched with careful eye her favourite since his babyhood, and who had
kept all the sayings about him and pondered them in her heart, was strongly

of the opinion that François should return to Cherbourg. So she reasoned to herself, and then said to François, " Thy father, my son, always said that you should be a painter, obey him then, and go back to Cherbourg."

Some of the notables in that place also exerted themselves to help the young painter, and very soon he became a pupil under, or rather with, L. T. Langlois, himself an *élève* of Gros, and considered the first artist resident in the district. Langlois quickly discovered the merit of Millet's work, and in place of putting him to tasks of drudgery, invited him to help with his pictures. In the church of the Trinity at Cherbourg there are two large sacred historical pieces in which Millet put a great deal of his own work under the general guidance of Langlois. This artist fortunately was above being jealous of Millet, sincerely trying to assist him, and on August 19th, 1836, made a formal application to the council of Cherbourg on his behalf. In this memorial Langlois drew especial attention to the work Millet had done, and spoke of his constant and rapid progress during the previous six months, concluding by recommending the council to grant an allowance to Millet in order to permit the young artist to seek renown " in a larger sphere than our own city." The letter, given in detail in Sensier's life of Millet, is powerfully written, and it had the eminently satisfactory result of making the worthy councillors promise Millet 400 francs (£16) annually; and this was supplemented—doubtless after a similar appeal by Langlois to the general council of the province—by £24 annually; so that Millet could truly say he was passing rich on forty pounds a year.

This allowance did not suffice to keep him, and it was neither punctually, nor even always fully paid, yet it is strong evidence of the early good fortune Millet met with, and of the esteem in which he was held by his fellow citizens. The simple fact of the money having been granted is sufficient to evince an appreciation flattering enough to any youth however gifted.

While these matters were under consideration, Millet was well occupied, and his reading and study ranged amongst the best writers from the time of Homer to the nineteenth century. His chief favourites after Virgil and

the Bible were Victor Hugo, Walter Scott, Goethe, Shakespeare, and Byron. He spent hours every day reading, and it is even said he read through all the books in the library at Cherbourg. Millet was apt to learn, and he mastered every work he read, so that by the time the money was given to take him to Paris he was, " a cultivated man, well-read and deep-thinking, with the Bible guiding his heart, Virgil directing his head, and both afterwards greatly controlling his heart."

In December, 1836, Millet departed for Paris, where he arrived early in 1837. Although he was twenty-three and strong of heart, he could not but bear in mind how he had left his mother and grandmother weeping and full of anxiety for his future, as they thought of the temptations of Paris. He was not in good spirits on his journey, and was only upheld by the prospect of the treasures of the Louvre and other collections of pictures, which he was so anxious to see. His own words, given in Sensier's life, are singularly well chosen and expressive.

" I got to Paris," he said, "one Saturday evening in January in the snow. The light of the street lamps, almost extinguished by the fog, the immense number of horses and waggons passing and re-passing, the narrow streets, the smell, and the air of Paris, went to my head and my heart, so that I was almost suffocated. . . . Paris seemed to me dismal and tasteless. At first I went to a little hotel, where I spent the night in a sort of nightmare, in which I saw my home full of melancholy, with my mother, grandmother, and sister spinning in the evening, weeping and thinking of me, praying that I should escape the perdition of Paris. Then the evil demon drove me on before wonderful pictures, which seemed so beautiful, so brilliant, that it appeared to me that they took fire and vanished in a heavenly cloud."

The friends to whom Millet took introductions were of little use to him. They recommended him to go to the Ecole des Beaux-Arts, but the idea of competition was repugnant to him, and he speaks of the difficulty of getting people to understand how distasteful to him was the idea of striving to excel

certain unknown people in cleverness and quickness. Another so-called friend overcharged him for his lodgings, and forcibly retained possession of his clothing. Generally his life was disquieting, but when he found his way to the Louvre—which was some time after his arrival—for he was too proud, like many country-bred people, to ask his way in Paris—he was in a new world, and no troubles of a sublunary kind had any weight with him. He revelled in the great old masters, and it is interesting to know that Michael Angelo was in his estimation the greatest master of all ; Fra Angelico soothed him, and the more modern Poussin impressed him. Watteau and Boucher he despised, Delacroix he admired ; and, very curiously, he thought the work of Lesueur strong, a painter whose work occupies a little dark room in the Louvre, but whose pictures have no attraction at the end of the nineteenth century.

After much meditation, and with some trembling, Millet entered the studio of Paul Delaroche to learn his trade, as he expressed himself, for he was quite alive to the necessity of earning his daily bread. An interesting account of his life in Delaroche's studio says : " Millet was tall and of a powerful build, his head large, and his hair thick and bushy, flowing back from his face in a manner a little wild. His face was handsome, with excellent features, and large, gentle eyes. He was proud, shy, and reserved, having but little inter-course with his fellow students, although not unfriendly when they made advances. Often they teased him by addressing him in language of exag-gerated respect, or by speaking to him in country dialect, or made jokes at his expense, which he neither resented nor noticed, unless they became insulting, in which case a threatening motion of his mighty fist brought the perpetrator quickly to order. His studio nickname was ' The Man of the Woods.' He was a diligent worker, toiling untiringly at his easel, but his achievements did not win much approval from his fellows. His pictures were often bold and expressive, but the method of treatment was unusual, and the execution apt to be rough. Most of the students regarded him as a queer

fellow with talent, but too eccentric ever to make effective use of it. From the master he received little advice and less praise, although occasionally Delaroche would point out parts of his work to the other students, to show them how they ought to do theirs. Now and then a pupil, more appreciative than the rest, would toss him a word of encouragement, as when his fellow student, Couture, afterwards famous, came up behind him the first day, and greeted him roughly with, ' Hallo, greenhorn; your drawings are good.' After getting to work in the studio he was a little less homesick; and gradually, as his shyness wore off, he made some friends. But he did not remain long with Delaroche, feeling that his own art must be of a different kind." *

At Delaroche's studio Millet really learned nothing, for the master disliked him, and dreaded his method of painting, so different from his own thin classic style; and after various rather bitter experiences he left it to go on in his own way. When his fellow-students became over troublesome, he would reply, " I don't come here to please anybody, I come because there are antiques and models to teach me, that is all." The immediate cause of his leaving the studio was that Delaroche wanted a certain pupil to get the Prix de Rome, and told Millet if he wanted to please him he must not compete. So Millet abandoned the studio where honest effort was curtailed by intrigues; but why he did not try to enter the studio of Delacroix, whom he admired strongly, has yet to be explained.

The next few years were the fullest of trouble in Millet's career. It was then that he met with his hardest experiences, and doubtless, although he knew his troubles were scarcely worse than those of not a few of his contemporaries, yet he had the consciousness that, some day, the world would acknowledge him, and be glad to do him honour. Sensible that he was misunderstood, he also felt that he should try to school himself to do what the people of his time asked from him; and one of the most curious results of

* From an article on Millet by James Parton in the *New York Ledger*, August 31st, 1889.

this unhappy combination was to have Millet, the peasant painter of France, making nude pictures in the style of Boucher, whom he loathed, and of Watteau, whose prettiness is the very antithesis of Millet's own maturer works.

Before submitting to this real degradation, he made a great effort to get people to accept his work as he liked to paint it. He took his picture of "Charity," a female figure with three children, in a sombre style, full of the feeling of Michael Angelo, and carried it round to all the likely dealers in Paris, but no one would give him anything for it, and he returned to his studio forced to the conclusion that his own work would not find a market. What must have been poor Millet's thoughts in this weary journey will not be difficult to surmise. Believing in himself, and knowing what he could do, trying to persuade unwilling, and probably discourteous, dealers to buy his little picture, sometimes thinking he would succeed, but always in the end driven out into the street with his burden under his arm; his thoughts must have been exquisite torture.

His own ideas of pictures having thus proved unmarketable, he had unwillingly to sit down and make pictures of nymphs for popular sale. One of the best examples of this kind of picture is in the collection of Mr. J. S. Forbes, at Chelsea. It is called "L'Amour Vainqueur," and is well known in England, having been lent to several important exhibitions. We give overleaf an illustration of the sketch for the girl's head, which, in the picture, is painted with much delicacy of colour and breadth of effect. The composition is pleasing and the drawing careful, but the charm lies in the powerful and masterly colouring of the figures. It is likely that this was the style of picture easiest to sell about 1840. There were not, however, a very great number of nymphs à la Boucher produced, and their rarity adds to their value.

Millet now bethought himself of that gold mine for artists when figure pictures find no market, namely, portrait painting; and to the Salon of 1840 he sent a portrait of his father, and one of Marolle, a sincere friend with

whom he lived at that time. Marolle's portrait was the better one, but with
the perversity characteristic of jurors, they chose the other portrait, which was
very sombre in tone, and not so good in colour. The portrait chosen made
no impression on the public, and Millet was none the better for having it
hung in the Salon.

At the beginning of 1841 the Town Council at Cherbourg, having heard

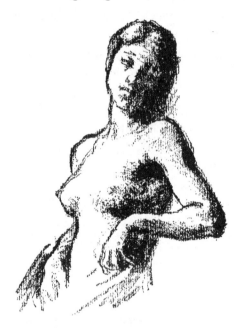

Sketch for figure in " L'Amour Vainqueur."
From " La Vie de Millet " Quantin

of his portrait painting, and
longing to see something of
the work of their protégé, gave
him a commission to paint
their recently deceased Mayor,
Javain. But this worthy died
at an advanced age, and there
was only his miniature, when
young, available. Millet had
never seen the Mayor, and this
miniature was universally de-
clared not to be like him, so
that the painter had very little
to work with. In order, how-
ever, to assist him as much as
possible, he was invited to paint
the portrait in the vestibule of
the museum, so that the coun-
cillors, and public generally,

could give criticism and hints on the likeness as it proceeded. The result was,
as might be expected under such conditions, that no one was satisfied. Every
passer-by had his own opinion and his own hint for the painter, until poor
Millet, willing enough to do what was reasonable, was lost in a maze of con-
tradiction. The climax was reached when he employed a model to sit for the

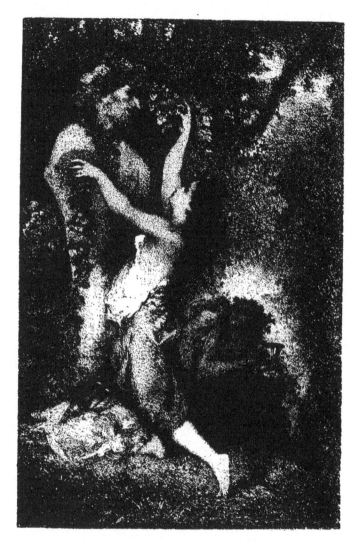

AN OFFERING TO PAN. By MILLET, 1845
From "La Vie de Millet" Paris, Quantin

hands. This model was a labouring man who used to work about the town-hall, and he had even been in prison. "Ah," said the Mrs. Grundy of the period, "if you only knew how much this portrait of Mayor Javain was the cause of humiliation to the family! Would you believe it, M. Millet the painter, in order to paint the hands that you see in this picture, and which are not the hands of Mayor Javain, has dared to paint from a garçon of the office, a workman of this mairie, who had been a servant, and had had three months in prison! What chagrin for the family and for his friends, to know that these hands of a criminal have become the hands of Mayor Javain!"* The result was that the council declined to pay for the portrait, and many of Millet's influential friends turned against him, except the younger members of the community, who took his side. He was thus not quite without defenders, but young people have no money to spend on pictures, so that Millet was compelled to paint signs for a livelihood when portraits failed him. This only made his enemies more angry, and his friends cooler. Even Langlois, his former master, abandoned him as a barbarian, for no one cared to have been the patron of a man who was reduced to painting signs for tailors, and drapers, and horse-doctors, and who was forced to be content with thirty or forty francs for his productions.

But Millet bore his troubles with remarkable equanimity, and he presently fell in love with the original of one of his portraits. The feeling was recipro-cated, and in November, 1841, he married Pauline Virginie Ono, a native of Cherbourg. Millet's mother and grandmother thought the occasion great enough to give a féte, and the parents and friends of both parties united in the jovial entertainment usual on such occasions.

Millet and his wife went to Paris in 1842. His first experiences there after marriage were unfortunate, for the portrait he sent to the Salon was not accepted, while in 1843 he had not the courage to send anything. But in 1844 he sent 'La Laitière' in oil, and 'La Leçon d'Equitation' in pastel.

* Millet painting the hands from this model might afford a theme for an historical painting some day.

F F

The pastel represented a group of children playing at horses, one mounting on top of the other. It was greatly admired by Diaz for its colour, and by Thorĕ for its harmony. This was the only bit of light in the dull sky of Millet's prospects at that time, and was of course only dimly known to the painter at the moment.

Millet's troubles grew almost more than he could bear, and were more severe then than at any future period. His wife, who had never been robust, had gradually sickened in Paris, where she died on 21st of April, 1844, after two and a half years of marriage. The year of 1844 was in fact probably the very severest of Millet's life. His wife had declined in strength at a time when he became less able to find the means of supporting her; not to mention the possibility of providing the delicacies necessary to an invalid. Few would buy his original work and pictures even à la Boucher and Watteau did not fetch over twenty francs, and often were sold for less. His portraits were not always approved, he was not old enough to have made any influential connections, and he was not a man to make friends even in his best days. In sober truth his star was very much in the descendant. But when his wife had died and he was left childless and without friends (for he had never liked his first wife's relations), with little or no money, and with scarcely any prospects of making any, his star reached its nadir, and then slowly and by small degrees it began to ascend. Sensier says that Millet's happy life altogether ended when he married again and had a family; but this was a mistake, for Millet was a joyful father of many children, and though he was occasionally altogether without money and credit, he never again felt the extreme desolation and solitude of 1844. The fame of his pastel at the Salon was the one small cheering note in all the desert of his distress, and it indicated the channel through which much of his fame was afterwards to come.

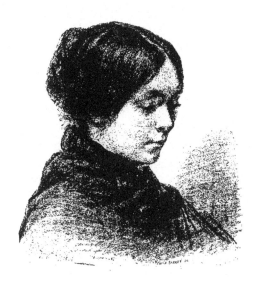

Millet's Second Wife. By Millet.*

JEAN-FRANÇOIS MILLET :—CHAPTER III.

SECOND MARRIAGE; PARIS REVOLUTION; BARBIZON; ROUSSEAU; PURCHASE
OF "THE GRAFTER"; PICTURES, 1845—1860.

FROM 1845 onwards affairs began to mend with Millet. The worst
corner was turned, and although he had his share of tribulation in later
days, it is certain that, after he had passed his thirtieth year, he met with
few extreme hardships, while he had much encouragement and real success.

Millet was a man to whom home was a word of enchantment, and his
dreariest time had been when his young wife died and he was left a widower
and alone. He had returned to Normandy at the end of 1844, and as he was
gradually getting into a reputation he was offered by the Sous-Préfet of
Cherbourg the post of drawing master in the college. But he promptly

* From Sensier's " Vie de Millet." Quantin, Paris, 1881.

F F 2

declined the honour as curtailing his liberty too much. This was, nevertheless, an incident which showed Millet that his work was not unappreciated, and in a small way it no doubt encouraged him.

His portrait painting had become more acceptable in his native province, and he soon bethought himself of getting a home together again. He dared not face the life in Paris without some place he could call his own, and he wooed and won in a very short period a maiden he had met in Cherbourg, named Catherine Lemaire. To her he was married in the autumn of 1845. This time he fortunately got a wife who could appreciate and sympathize with his talent. She bore him a large family and had sufficient domestic cares, but she never grumbled, never seems to have lost courage, and was thus an incalculable and constant source of secret strength to her husband.

Once, in later times, Millet was so closely pushed that he had no money at all, and the whole family were in a state of semi-starvation; but if we compare this even at its worst with the experience of Théodore Rousseau, "whose house was often a hell," although he was able to earn sufficient money, we can realise that Millet's lot was not the worst that has befallen a painter.

The newly-wedded couple started for Paris in November, 1845, but at Havre they spent at least a month. Here Millet met with unexpected success, and received a number of commissions for portraits, many of which, it is said, are still in the locality. He also at this time painted the "Offering to Pan," which is now in the Montpellier Museum, and is illustrated opposite page 216. This was considered a success, as were also several other mythological subjects he designed, and a small exhibition of his works was made at Havre which still further increased his popularity. He was honoured with several more commissions for portraits, and thus became quite easy in his mind respecting funds. But his prices must have been small, for he thought he had done well when he had saved 900 francs (£36). By the time he had

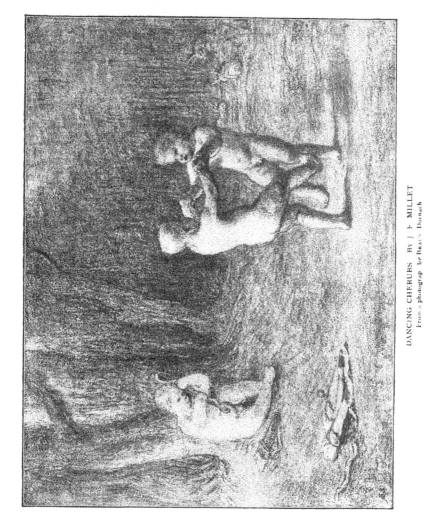

DANCING CHERUBS BY J F MILLET

From a photograp by Braun Dornach

accomplished this he and his wife started for Paris, which they reached before the New Year of 1846.

Millet took apartments in the Rue Rochechouart and settled down to live in Paris. He was gradually forming a distinct character of his own in painting —which, however, was interrupted by circumstances. His recollections of Boucher developed into rare skill in painting naked figures in such a style as to recall nothing of the insipidity of the last-century painters, and Millet was so successful in this way that he became known as a painter of the nude. This was a reputation which took some time to grow, and it was even in a flourishing condition when, in 1848, Millet heard of it incidentally. Standing before a dealer's window (Deforge), which contained his "Women Bathing," he heard himself called by a casual passer-by, who was looking at the picture, "Millet, who paints only naked women," and the whole position was revealed to him. He was hurt; he felt he had been false to himself; he knew he could do other work, and he determined to leave the nude entirely. His wife heartily supporting him, he threw himself again into the struggle.

The first work he had painted on his return to Paris, in 1846, was a "Saint Jerôme under Temptation," with a number of female figures, which was refused at the Salon; and some time afterwards, when he had formed his resolution to abandon the nude, he painted another subject over it, so that the St. Jerôme is now unknown. Working very hard, painting both in oil and pastel, although his works did not sell very rapidly, he still managed to earn a livelihood without great difficulty. He also began to gather friends around him, the best of whom was Diaz, who from the first was his warm admirer. Diaz championed his cause warmly, and went round his friends, the collectors of pictures and the chief dealers, urging them to buy from Millet, "unless they wished him to consider them blind and incapable."

On the 27th July, 1846, his eldest son François was born. This was the first child, of four sons and five daughters, all of whom except this, the eldest, who was born in Paris, were natives of Barbizon.

In 1847 Millet sent to the Salon a picture of " Œdipe taken from the Tree,"
which was again seen by the public at the Millet Exhibition at Paris in 1887,

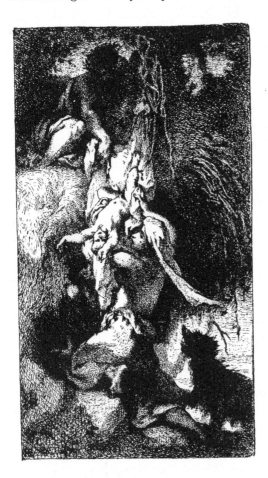

Œdipe taken from the Tree.
From " La Vie de Millet." Quantin.

and at the Exposition in
1889. The picture is now
very dark in tone, and
having unfortunately been
painted with fugitive
colours, the design is diffi-
cult to make out, but it is
indicated in the illustra-
tion herewith. Millet said
it gave him a pretext for
exercising himself in the
nude, for he did not find
it so easy to abandon this
kind of study all at once,
and in strong light and
shade. This picture was
well noticed in the Salon ;
and Théophile Gautier
wrote a lengthy critique
upon it, not praising it,
but saying that if the
painter would but leave his
ferocity of colour, he might
do well ; and adding that
it would not astonish him
if Millet had a grand future
before him. Thoré also

praised it, and spoke of the painter as one who would ere long become

famous, noting, at the same time, how like his work was in some qualities to Diaz and Decamps.

Diaz, at this time, had a better reputation than Millet, and was looked on as a fine colourist on account of the brilliancy of his groups of Eastern figures. The same year Millet made a crayon drawing of himself, which is given at page 259. This is the most famous of Millet's portraits, and is a splendid work of art, quite equal to any portrait in black and white of the century; Rajon's etching of Ouless's portrait of Darwin alone being worthy to rank with it. The original of the portrait is life-size, and is drawn with black chalk on a toned paper. The gentle, pathetic expression on the face is wonderfully fascinating, and conveys, better than any written description, the character of the painter.

He was not in very good health at this time, and early in the following year (1848) he was invalided with an attack of rheumatic fever, which suddenly became so pronounced that there were grave doubts if he could recover. For nearly a month he was severely ill, and sometimes hovered between life and death. The doctors at one time entirely gave up hope of his recovery; but his wife and friends never believed he was so ill, and in the event they were found to be right. His recovery was somewhat tedious, and was much retarded by the unfortunate condition of the artist's household, as he had not linen enough to get proper changes as well as the little luxuries so acceptable and useful in a sick chamber. Some friends, however, now unknown to fame, came to his aid, and he gradually returned to better health. He used to say that "like a wet dog" he shook himself and went back to work.

One of his most characteristic works was the first picture completed after the severe illness. This "Winnower" was finished, and went to the Salon, then held in the Louvre, and was accorded a place in the *Salon carré*, or chief room. As related on another page, the arrangements for the Salon had been greatly modified. Millet was one of those who had been treated with scant courtesy, though never so persistently and unreasonably refused as was Rous-

seau, so the change of government was as welcome to him as to the others. This picture, exhibited in the Salon of 1848, was sold by auction and went to America, where it was burned in a disastrous fire, together with Millet's "Woman watching her Child." This subject, a "Winnower," was painted by Millet at least three times. The last was probably that sold at the London Secrétan Sale in 1889, which is also the best in composition, as in the others the man's back is unduly bent over the corn. In all three the colour was good, and they were painted with Millet's usual solidity and care.

The political agitation which culminated in the Revolution of June, 1848, was the source of much discomfort to all French artists. People were too intent on making arrangements to retain their property to think of laying out money on the Fine Arts, and Millet thought himself extremely lucky because he got a commission from a midwife (!) to paint a signboard, for which he received thirty francs. For fifteen days the father, mother, and baby continued to exist on this meagre sum until the insurrectionary troubles were over, and Millet was able to barter for necessaries with drawings and portraits.

During the rising of June, Millet, like every citizen, was compelled to shoulder a musket, and at the taking of a barricade in his own district he was a witness of the death of the leader of the insurgents. As might be expected, such scenes horrified him greatly, and he hastened away from them as quickly as he could.

In the summer of 1849, Millet made the momentous change of carrying his home from Paris to Barbizon. The immediate cause of his quitting Paris was the cholera, but he had long felt that residence in a city was not for him, for he could not find a genuine countrywoman to paint, and he missed the pure air and scenery of the country. The change, therefore, would certainly have come sooner or later.

Rousseau and Diaz were then at Barbizon, and were already inhabitants

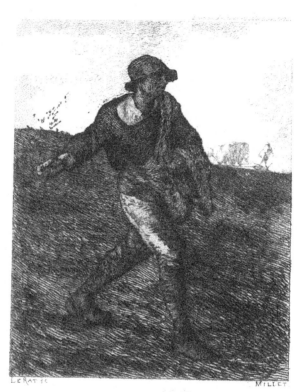

LE RAT sc MILLET

of several years' standing, but it was later that the great friendship between them flourished. Diaz knew Millet better than he did Rousseau, and it was yet to be a long time before they felt they all knew each other well.

Millet's home at Barbizon was one of much peace and pleasure. Often in the after time he was plagued with debts and troubled by uncertain prospects; but the true key to his long life near the Forest of Fontainebleau was his frequent expression, "I do not know anything more delicious than to lie on the heather and look up to the sky." In one of his letters he says, "If you could see how beautiful the forest is. It is so calm, with such a terrible grandeur, that I feel myself really afraid of it."

Millet's Studio at Barbizon (large window at left) Sensier's house beyond

His life at Barbizon was essentially that of a peasant. In the morning he attended to his garden, and in the afternoon he worked at his easel. Millet became much attached to Barbizon and never sought to leave it, although more than ever his thoughts went to his old home in Normandy. But his grandmother died in 1851, and his mother in 1853, so the farm and all the family property were divided, and there was thus very little more attraction away from Barbizon for the artist.

His house at Barbizon was a cottage on the high road, which, until 1889, still existed very much as during the life of the painter, and is shown in our

illustrations here and on the title-page. The house had but one storey, with a single window in front, and a gable covered with ivy. Inside was a long building which comprised four or five rooms. At the end of the garden was situated the studio, an old barn, likewise lighted from the street by a large window, seen towards the left of our illustrations.

This is the house which in 1889 was, as already stated, razed to the ground by the apparently grasping landlord, husband of the daughter of the writer who asked the world to believe that his friendship for Millet was altogether disinterested. Claiming the old house from the widow of the painter, and pulling it down, furnishes a sorry comment on Sensier's theatrical stories of Millet's misfortunes and well-paraded endeavours towards their mitigation.

To the Salon of 1850-51 Millet sent the first picture he painted of " The Sower," which is one of his three finest works; the other two being " The Angelus " and " The Gleaners." From our plate given opposite page 224, some idea of the grave dignity of this knight of labour may be obtained, but the best reproduction of the picture is Mr. Matthew Maris' large etching, which is almost as fine as the original. This picture, " The Sower," is more fully referred to in a later chapter, where a reproduction from the pastel of the same subject is also given.

In 1851 Millet painted the charming picture " Going to Labour," now in the collection of Mr. J. Donald, of Glasgow. This work is well known in Britain, having been hung at many exhibitions. It is entirely characteristic of Millet, and is one of the pictures of the second rank most worthy of attention. We give an illustration of it opposite.

Millet was now in his element, and for the next dozen years was painting his very best. He worked steadily from day to day and week to week, producing a large number of pictures, of many of which the names and composition are unrecorded. In 1853, when he exhibited the " Repas des Moissonneurs," or " Ruth and Boaz " as he called it at first, he was awarded a

second class medal, which gave him the right of being "exempt" for all
time coming from examination by the Salon jury.

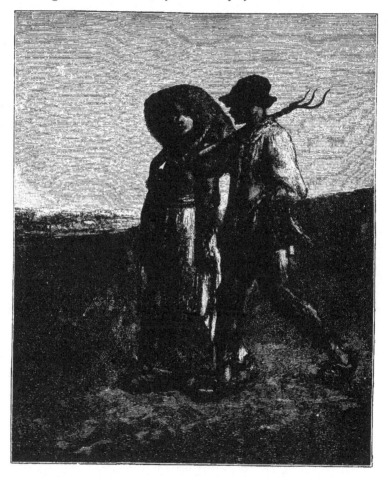

Going to Labour By J. F. Millet, 1851.

Millet was still constantly in want of money, for his family was gradually
increasing. But, except to **Sensier**, he bore up bravely before all the world,

G G 2

and no one but Sensier knew the straits to which he was apparently sometimes
reduced. But he was very happy in his wife and home. In April, 1853, his
mother died at Gruchy, and as it was necessary for the artist to go there to
arrange the affairs of the family, he went at the beginning of May to his
birthplace. But he stayed only a few days, bringing back with him the books
of his great-uncle, and the oak armoire which had been a family relic for many
generations.

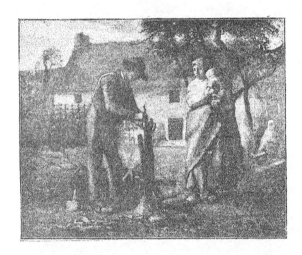

The Grafter. By Millet, 1855
From "La Vie de Millet." Quantin.

Having returned
to Barbizon he re-
mained there, work-
ing as usual, until
January, 1854, when
Rousseau sent him
a connoisseur who
made considerable
purchases, and these
kept him occupied
for several months.
In June, 1854, when
he found he had
2,000 francs, he
made up his mind
to go again to Normandy, proposing only to remain a month. As a matter
of fact he stayed four months.

For the 1855 Salon, which was opened at the same time as the Exposi-
tion Universelle, Millet prepared his fine picture of " The Grafter," his
sole contribution. In the " Souvenirs sur Théodore Rousseau " the detailed
story of this picture is given. It represents, as will be seen from our illus-
tration, a labourer grafting a tree in the enclosure close to his house, and in
the sight of his wife and children. Millet, says Sensier, always covers under

his rustic and abrupt form a touching thought. Rousseau had understood this. "Yes," said he, "Millet works for his own; he is exhausting himself like the tree that bears too much fruit, he is overworking himself for the existence of his children. He grafts the bud of a civilised branch to the robust trunk of some wild stock and thinks like Virgil: 'Insere Daphni pyros carpent tua poma nepotes.'" This picture had profoundly moved Rousseau, as it was as beautiful and grave as the existence of a father who silently overworks himself for his family. He had spoken of it enthusiastically to Théophile Gautier, and had said to Sensier, "I will find him a buyer." In fact, some time afterwards he wrote to Sensier, "Well, I have sold Millet's picture. I found an American who gave me 4,000 francs for it." Rousseau, though in rather pinched circumstances at the time, had himself given the 4,000 francs for this picture, and by a piece of rare delicacy he sought to hide it.

Millet was glad enough to have the money, as his own growing family had been augmented by his two brothers, who followed him from Normandy in order to become his pupils, and he supported them for a long time. But he was more successful than usual at this period, and did not grudge what he had to do for his brothers. Besides, he liked to be surrounded by friends, and Sensier, prone enough always to look on the dark side of Millet's life, is constrained to admit that although often sad in his letters, Millet had at this time a really delightful gaiety in his manner.

Later things became worse again, and Millet was beset by debts, but he did not let this hinder his work, and both the "Angelus" and the "Gleaners" were prepared in the midst of his troubles. In 1856 he painted the "Shepherd in the Park," a dark moonlight picture of extraordinarily fine quality, and this composition he painted again with slight variations. The small tailpiece to this chapter gives a faint echo of the charm of this picture. The "Gleaners," which is more fully referred to in Chapter VII., was first exhibited in the Salon of 1857. Millet made several repetitions of it, and

the illustration here given is taken from one of them, a crayon drawing in monochrome.

In April, 1858, Millet was again much in debt, and Rousseau is believed

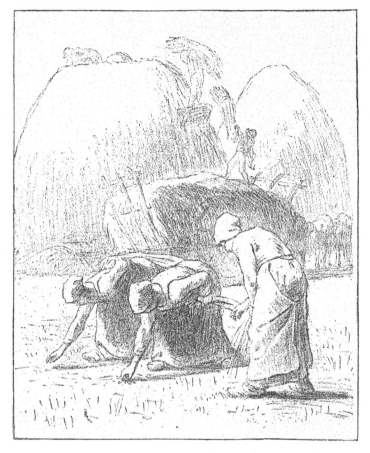

The Gleaners By Millet From "La Vie de Millet." Quantin.

to have once more helped him anonymously. He told Millet he had an order for a small " Immaculate Conception " for the Pope's railway carriage,

and Millet ultimately received a good sum for this work, of which nothing has since been heard. The "Angelus" was the chief picture of 1859, and the interesting record of this picture we give in a special chapter, devoted to its eventful career.

The picture of "Death and the Woodcutter" was also sent to the Salon of 1859, but it was rejected, as much because of the unpleasantness of the subject as because of its originality. The principal critics were altogether in favour of the picture, and a great discussion arose which brought Millet's art all the more to the front. His "Femme faisant paitre sa Vache" was hung in the Salon, and was purchased by the Government, which was a slight compensation for the rejection of the other and greater picture. This "Woman grazing her Cow" was sent to the museum of Bourg-en-Bresse and marked "Donné par L'Empereur, 1859."

Le Berger au Parc. By Millet, 1856.
From "La Vie de Millet." Quantin

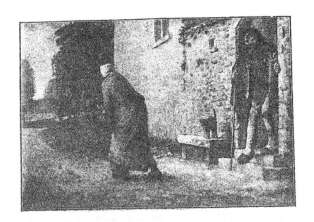

Waiting: Tobit. By Millet. Salon of 1861.
From the Picture in the Collection of G. I. Seney, Esq.

JEAN-FRANCOIS MILLET:—CHAPTER IV.

CONTRACT FOR THREE YEARS; PICTURES; THE MAN WITH THE HOE; OTHER
PICTURES; DEATH OF ROUSSEAU; TRAVELS. 1861—1869.

MILLET'S finances did not improve, notwithstanding his much better
artistic position and his growing reputation. Several of his friends
were willing to help him, and did so; but the chief event of a monetary kind
of this period was a contract into which he entered, in March, 1860, with
Arthur Stevens, a brother of Alfred Stevens, the Belgian artist. Stevens agreed
to purchase all Millet's paintings for a period of three years, on conditions
minutely set forth in a very interesting document, which was published for the
first time in *Le Temps* on 14th July, 1889. Perhaps because that **day** was a
holiday little notice was taken of the agreement, which undoubtedly is a very
remarkable one. It reveals in a small compass the businesslike way Millet
could get his affairs conducted, and it is also an undeniable evidence of the
sums paid to Millet at this period. **The** document is worthy of being pre-

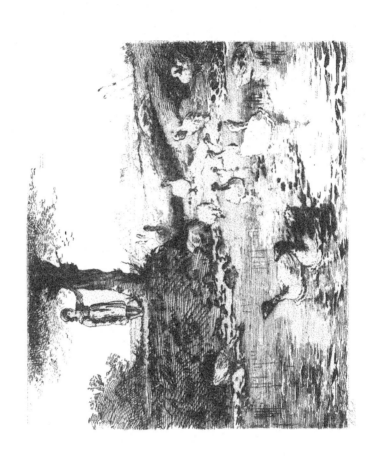

served, and the translation following gives it in the English equivalent terms.

It is agreed between the undersigned, M. J. F. Millet, painter, residing at Fontainebleau, on the one part, and M. Arthur Stevens, residing at Paris, Rue de Laval, on the other, as follows : M. J. F. Millet, wishing to assure himself of the regular return of that of which he has need, and in order to devote himself without pre-occupation to the exercise of his art, has proposed to M. Arthur Stevens to sell him all his works, without exception, during a specified time, and at prices fixed according to a tariff agreed upon beforehand. This proposition having been accepted by the said second party, the clauses and conditions of their agreement are fixed as follows :—

Article 1.—M. J. F. Millet sells to M. Stevens all the works in course of execution or not, oil-paintings and drawings, which he may make in the course of three consecutive years, the said three years to commence, not from the date of signing these presents, but from the day when M. Millet shall have delivered to M. Stevens the six pictures named on the list attached hereto. *Article* 2.—M. Arthur Stevens opens from date of signing, a current account with M. Millet, and will pay to him on the 25th of each month, to the debit of his account, the sum of 1,000 francs (£40). *Article* 3.—The pictures begun, which are at the present moment in the studio of M. Millet, form part of the present contract, according to the list hereto annexed. *Article* 4.— M. Millet binds himself to deliver, without delay, the six pictures mentioned in Article 1. *Article* 5. —M. Millet shall have power freely to select the order of his work, and to devote himself to such work as he may choose. *Article* 6.—On the delivery of each picture by M. Millet, M. Stevens shall acknowledge the same by letter, and shall credit M. Millet with the price assigned to the said picture according to the tariff agreed. *Article* 7.—Should M. Millet desire to execute a work of greater dimensions than those indicated in this contract, he will require to obtain the consent of M. Stevens. *Article* 8.—With respect to Drawings, the parties shall come to a private arrangement as to the proportion they shall bear to other works contracted for ; also as to their prices, taking for basis the usual prices of M. Millet's Drawings at the date of the signature of this contract. *Article* 9.—Should any work delivered be other than such as are specified in the annexed list, whatever augmentation or depreciation circumstances may have brought about with regard to works of art, the price shall be fixed according to the tariff agreed upon, reckoning proportionately, according to the size of the canvas or the importance of the work. *Article* 10.—Should the parties not agree on the prices as expressed in Article 9, and the prices of the Drawings named in Article 8, they shall submit them to the arbitration of M. Théodore Rousseau, friend of M. Millet, and M. Alfred Stevens, brother of M. Arthur Stevens. *Article* 11.—M. Millet, while remaining master of his initiative, engages himself on honour to take into account any requirements and recommendations M. Arthur Stevens may make in the interests of business ; and he debars himself in the most absolute manner from disposing of any works to any other person than M. Arthur Stevens, whether by sale or by gift. *Article* 12.—Six months before the expiration of the present contract, the parties shall make an inventory of the works then in the studio of M. Millet, who shall finish and deliver them before the termination of the said contract, or, in default, within the six months thereafter. *Article* 13.—At the end of the present contract the parties shall balance their accounts, and any balance due by one or other shall be paid in cash without interest by the party indebted.

H H

Article 14.—Should any disagreement arise between the parties during the existence of the contract, whatever may be their origin or object, the parties pledge themselves to appoint as arbiters M. Théodore Rousseau and Alfred Stevens, who may, if necessary, appoint a third arbiter. The inventory made up for the present contract follows. Written in duplicate at Paris, the 14th March, 1860.

Attached to the contract was an inventory showing 100 francs (£4) as the price agreed on for drawings, and 3,000 francs (£120) as the highest sum to be paid for the most important painting.

This had been a very carefully prepared document, and some of its terms are almost surprising in their severity. This contract may serve, however, to show living artists that even a great genius like Millet was ready to be bound by an ordinary business contract for his works. But notwithstanding this Stevens, unfortunately, did not immediately find this agreement very profitable. Millet was faithful to his contract, but Stevens, it is said, was considerably embarrassed with the pictures, for which at that time he could find no purchasers.

Millet, on the other hand, was not much the better, if we may judge by his condition at the end of the three years. Notwithstanding the thousand francs (£40) per month which he had regularly received from Stevens, he was at the end of the time 5,762 francs (£230) in debt to Stevens, which he had to pay off later, with other pictures. Thus instead of being able to lay by money, as he might have been expected to do during his three years in a harbour of refuge, he had spent it all, and was still in debt.

The marvel is how he spent the money. For it is to be remembered that he was a peasant born and bred, and living in a peasant's home in the country with no temptation to extravagance. It is to be feared that, extravagant or not, Millet was improvident, and that neither he nor his wife was of a severely thrifty turn of mind.

Notwithstanding all that may be said to the contrary, the first really tranquil years Millet spent were those when M. Stevens took all his works and gave him regular stated payments. During 1860-1-2 Millet painted

some of his finest works, and we hear nothing of his anxiety for daily bread, as was too frequent before. The following is a list of the principal pictures executed during the period in question:—" Man resting on his Hoe," " Waiting," or " Tobit," " The Birth of the Calf," "La Cardeuse," "La Becquée " (mother feeding her children), "Sheep-shearing," " Le Berger au parc," " The Potato Planters," " La Gardeuse d'Oies." These pictures are now all well known, and besides these Millet executed a number of which the records are less exact. The picture of " L'Attente," or Waiting, being a modernised version of the story of Tobit, was very fiercely and somewhat unfairly attacked by Théophile Gautier. But none the less is the work one into which Millet threw intense feeling of the prolonged sorrow of hope deferred. The original is in the collection of Mr. George I. Seney, of New York, the donor of several fine pictures to the Metropolitan Museum of that city.

The " Gardeuse d'Oies," of which we give opposite page 232, an etching from the Durand-Ruel collection, is a well-known subject treated in several different ways by Millet, the figure of the girl sometimes standing and sometimes sitting down. " La Becquée," now in the Lille Museum, to which it was presented in 1871, is a very charming example of this period, and is well known by Damman's recent etching. Three children are seated at a door and their mother, seated in front, gives them their mid-day meal. In the distance the father is hard at work.

To the 1861 Salon, Millet sent " La Tondeuse," Sheep-shearing, a picture of large size, which is now in Mr. Quincey Shaw's collection at Boston. This was a favourite subject with Millet, and he painted a small replica of it which has been published as a photograph. The small picture is of very fine colour, solidly and well painted, but with the defect that the sheep looks almost as if it were dead, because of the heavy hanging of the neck. Millet also did many drawings of the subject, one of which we reproduce on the next page.

In _O_ctober, 1862, Millet fell ill with a fever, which baffled the skill of the

doctors, and his health was weak for some time. In December of the same year, Sensier had seen M. Goupil, the then active head of the well-known house, and had entered into some relation with him respecting Millet's pictures. How he could be offering his pictures to this house while the contract with Stevens was still in force is somewhat obscure, unless it was for Stevens' sake that the proposal was made. In reply to Sensier's letter Millet wrote, " The result of your interview with M. Goupil seems to me very good. I know that it is an advantage to be able to exhibit my pictures at his gallery,

Fac-simile of a Sketch by Millet of
" Sheep-Shearing."

in the sense that the reputation of his house is in itself a recommendation, up to a certain point, on all which he there admits. He may be assured that my pictures will not have been seen too much at other places before he has them, and that he will have the first choice. I think the idea of an engraving excellent, in the sense that it gives to one's name a great advertisement, which if the print takes must result in a material profit." Nothing came of the project to have a contract with M. Goupil.

The " Man with the Hoe," one of Millet's most impressive pictures, was sent to the Salon of 1863. The picture was also in the Cent Chefs-d'Œuvre in 1883, the Millet exhibition of 1887, and the Paris Exhibition of 1889. The illustration on page 204 gives an idea of the composition, which is not attractive at first sight. Millet knew this himself, and only sent it to the Salon because he was " exempte," and his works went into the Salon without question.

While admitting that this picture is perhaps artistically one of the strongest of Millet's works—the realistic power displayed being quite terrible

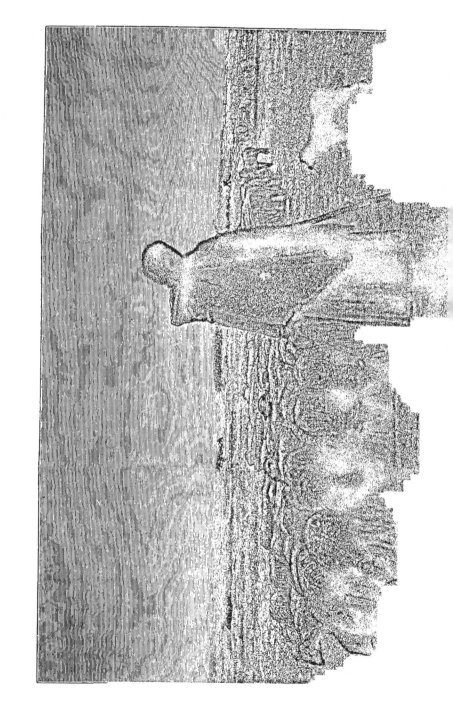

in its intensity—it can never appeal to any ordinary intelligence, which looks at a picture for its subject and not for its power and treatment. All art is meant to give pleasure of a kind, and to those who look only at the subject of the picture, the "Man with the Hoe" cannot but be non-attractive. But to those who have been trained to consider other qualities than the less important one of subject, the picture is strangely magnetic. The labourer veritably pants as he leans on his implement; he is the embodiment of hard and severe toil, and he pauses only for a moment overcome with the fatigue of his exertions. The composition is statuesque and daring, the drawing is powerful, and the colour unobjectionable. Millet, in his sternness and unbending truthfulness of representation, in his adhesion to fact, unpleasant as it may be to the delicate critic, and in his power of intense concentration in what he desires to tell, is here to the fullest extent. It is said by some that this is Millet's finest picture, and it is needless to quarrel with those whose tastes are so very uncompromising.

The exhibition of the "Man with the Hoe" created considerable discussion, most of the critics being furious against Millet; but as it was the subject they quarrelled with, and not the conception, composition, or execution, their objections have now little weight. The usual accusation against Millet was that he was a Socialist, wishing and trying to subvert the constitution, but this kind of criticism may be treated with the contempt it deserves. The best critique in the artist's opinion was that of M. Théodore Pelloquet. This writer was unknown to Millet, and never saw him, so that for somewhat similar reasons to those given in our preface, his criticisms were the more valuable. He spoke of Millet as a painter who had introduced a new element in art, as a poetic interpreter of an idea undeveloped and unexplored until then, and as one of the strongest painters of the time.

About this time Millet painted his truly grand picture of "Maternité," of which we give a reproduction opposite page 240. This is one of the most impressive of the less well-known pictures by Millet, and fully justifies

the terms in which an anonymous Scottish critic of some power wrote about it in 1887. "A young peasant mother is represented, life-size, sitting, with an infant sleeping in her lap, swaddled about the body and legs as is the custom with babes of the French and German peasantry. The mother holds her baby by the arms in such a position that its little body, all unswathed, hangs downward with a curious effect of form suggesting a cross. This is the key of the picture—the crucifix upon the wall, the unconscious sleeping babe in a pose suggesting the cross, the half-averted face of the mother. It is the face of the Woman made of our common clay, yet irradiated by divine gleams of the spirit which is the life, with hinted expression of incipient anguish, averting her gaze from the symbolised suffering of the child she has borne. Mary, the mother of the Son of Man, was none other than such as this, different in degree, perchance, but the same in kind."

At the end of 1863 Millet was chiefly engaged on a picture of a "Shep-herdess," about which, Sensier tells us, he spoke to no one. Possibly, the loud outcry of the critics and the general public against what they called the unnecessary ugliness of the "Man with the Hoe," led him to try something exactly the reverse. In any case, at this time he painted one of his most charming pictures, representing a girl seated under a tree on a warm summer day. The sun glitters over her figure through the leaves of the tree, and her face is heated and her eyes slightly drawn by the warmth and light of the sun. In the distance the labourers toil in the fields, and the whole air is filled with a sense of warmth, joy, youth, and pleasure, which is an exact opposite to the work of the earlier part of the year.*

Millet was greatly interested in the exhibition of the works of Delacroix—who had just died—held in February, 1864, and came to Paris to see it. He was at all times much delighted with this great painter's work, and at the sale

* This delightful picture belongs to Mr. Alex. Young, of Blackheath. In the same collection is the small sketch of a shepherdess knitting, illustrated on the following page.

held shortly afterwards he bought about sixty of Delacroix's drawings and sketches, which he studied very attentively. The art of the Japanese also interested him greatly at the time, and he and Rousseau often had friendly disputes whenever a good piece was offered to one of them for purchase.

To the Salon of 1865 Millet sent the "Shepherdess with her Flock," of which we give an engraving opposite page 236. It is a typical example of his work, and is very decorative in its composition. This was the picture given by Mr. John Wilson to M. Van Praet in exchange for the "Angelus."

The "Shepherdess" was so much liked that the Ministre of the Beaux-Arts wrote to Millet wishing to buy it for the Government, and offering 1,500 francs (£60),

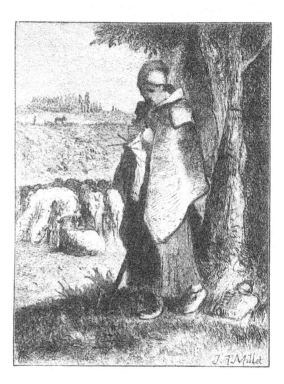

Shepherdess Knitting.
From the Picture in the Collection of Alex. Young, Esq.

but as Millet had already obtained £80 for the work, his answer was obvious.

To the same Salon Millet sent the "New-born Calf," which again brought him ridicule and severely antagonistic criticism. The usual remark was that

the figures seemed more as if they were assisting at a funeral than at a birth ; a kind of hint, perhaps, that Millet had a foresight of the new theory that it is less criminal to take life than to create it. Again Millet was awarded a medal by the Salon authorities.

During the period from 1864 to 1870, Millet made many pastels and sketches, of which examples are given throughout these pages.

In the autumn of 1864 he was commissioned by M. Thomas to paint four large panels to decorate new rooms in the Boulevard Haussman. "Autumn" was placed on the ceiling, "Spring" and "Summer" were wall pictures. These occupied Millet many months, but they have never been considered as of the highest merit, and they were sold at the Hôtel Drouot in 1875 for about £400 each.

In February, 1866, Millet went once more to his birthplace to bid farewell to his sister Emilie, who was dangerously ill. When he reached Greville, his sister was just able to recognise him, taking his hand and gasping almost with her last breath, "François." She died on the 11th of February, and the sad event greatly bore down Millet's spirits, but he soon got back to Barbizon and to his work.

Like all the art world, Millet was preparing for the Paris Exhibition of 1867, but he was interrupted by the doctor's decision that his wife's health required immediate change of air, and that as soon as possible she must be sent to Vichy. In June, 1866, therefore we find him working at Vichy amidst a country new to him, making many notes of the peasants and their ways, and delighted with the kindly disposition of the country people around. In July, he made a rapid visit to the Auvergne Mountains, which, doubtless, he was anxious to see because of the enthusiasm with which Rousseau always spoke of it as one of his favourite parts of France. The visit to Vichy and Auvergne had a profound influence on Millet's later work. He was vividly impressed with the grandeur and interest of the scenery, and from this time forth, he became as much a landscape painter as a figure painter. In

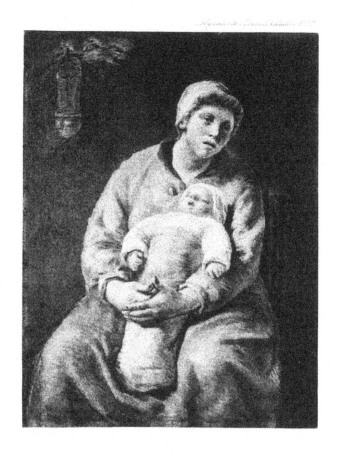

Auvergne, Rousseau found many of his greatest inspirations, and Millet, of an artistic nature nearly akin, was equally impressed with its grandeur.

To the Exposition Universelle of 1867, Millet sent "The Gleaners," "The Shepherdess and her Flock," "The Angelus," "La Tondeuse," and "Le Berger au parc" (of all of which illustrations will be found in this book), as well as "Death and the Woodcutter," "The Potato Planters," "The Potato Gatherers," and "Le Parc à Moutons." This was a magnificent contribution, and Millet was not too much honoured by his award of a first-class medal.

Fac-simile of Letter from Millet to M. Feuardent on the Death of Rousseau. From "La Vie de Millet." Quantin.

At the end of 1867 came the calamity of Rousseau's death. Ever since his return from Vichy in July, Millet believed there was serious danger for his dearest friend, and in September

Millet knew, for a certainty, that Rousseau could not recover. He was therefore well prepared for the last scene of all ; but as ever the end came as a terrible blow. Millet was greatly unnerved, he suffered severely from continual headaches, and had to take another journey to Vichy on his own account. The letter he wrote to M. Feuardent on the day of Rousseau's death is given in fac-simile on the preceding page.

In 1868, M. F. Hartmann, of Munster in Alsace, gave Millet several important commissions, and in September the artist made a journey to Alsace to see his patron, as well as for the benefit of his health. On his return, he came round by Switzerland, visiting Basle, its cathedral, and its museum with the works of Hans Holbein, also Lucerne, Berne, and Zurich. Rousseau had introduced Hartmann to Millet at Barbizon, and Hartmann frequently acted as the good genius of the two artists in saving them from relentless creditors.

A memorable incident happened in 1868, for, although Millet sent no work to the Salon of that year, he was then nominated a Chevalier of the Legion of Honour. The authorities were doubtful as to how the artists would receive such a nomination, but the friends of Millet were prepared for it. The meeting was held in the *Salon carré* of the Louvre, and when Millet's name was pronounced, the applause was so loud, prolonged, and sincere that the officials were disconcerted for a minute or two. This was observed by all present, with the effect of making the audience redouble their cheers.

Millet was now in the zenith of the fame attained in his lifetime, and it is certain he fully realised his position. Now and then his pictures came into the market and obtained prices far beyond what he would have dared to ask. He found it easier, also, to sell his pictures as they were finished, and he was sincerely appreciated by the many artists who knew and applauded him.

The Church of Greville By Millet, 1870.
From the Louvre.

JEAN-FRANÇOIS MILLET:—CHAPTER V.

ONE OF THE SALON JURY; THE WAR; CHERBOURG; ARREST AS A SPY;
PICTURES; ILL-HEALTH; COMMISSION FROM THE GOVERNMENT;
DEATH; FUNERAL. 1870—1875.

MILLET was now acknowledged to be a master; and although he could
not hope to silence his detractors or stop the mouths of the classicists,
he was respected and honoured by the bulk of the artists in Paris. The war,
which developed so disastrously for France in the latter part of 1870, was
yet in the undiscerned future, and the Salon was held as usual. To it Millet
sent his splendid landscape, "November." This simple yet sombre com-
position is probably the finest landscape—as such—that Millet painted. It is
a cool grey landscape of exceptionally firm quality, not readily liked, but full
of truth to nature, whose quietness and repose enchains the spectator. It is
a winter effect before the snow has fallen; the fields have been prepared for
the spring, and clouds of crows are in close attendance. At the same Salon
Millet exhibited a picture of a woman churning, "La Barratteuse," a fine

specimen of his later work, and of which, opposite page 248, we give an etching. The picture, "Gelée Blanche," is of this period, and from our etching opposite this page, it will be observed that it is the same field as the "Sower" strides over in the picture of that name. This etching will be found well to repay careful examination.

At the election of the jury of the Salon, Millet was voted sixth on the list, there being eighteen of a jury, and he took his seat to act in his turn as judge of the men who were to follow him—a truly difficult position for every conscientious artist.

Hardly had the Salon closed when the war-fever seized France, and the dire destruction of 1870-71 commenced. When the collapse of the defence was apparent on every hand, and the German horse-soldiers were approaching Paris, Millet packed up his household goods and the pictures he had in hand, and with all his family set off, on 27th August, for Normandy.

Painting was now carried on by Millet under considerable restraints. One of his first experiences in Cherbourg upset him completely. He had walked down to the docks on his arrival to look about him, and to sketch a little in an inoffensive way, when he was followed and denounced as a Prussian spy. He was arrested and taken before the military authorities. He felt so sore at being mistaken for a Prussian in his native country that he declined to offer any explanation of his movements, or to say who and what he was. For several hours he was detained, when he saw it would be the wisest thing to open his mouth, and the officials at the Mairie having found they had made a mistake, released him with a severe reprimand, sternly advising him not to even pretend to use a pencil so long as the Prussians were in France.

In consequence of this warning Millet worked in one of the rooms he had taken, but he did very little. His health was not good, and the political events of the time irritated and unnerved him. He could not settle down to complete a picture, but during this stay he began many important pictures, which he afterwards finished at Barbizon. Notably, he made a sketch of the

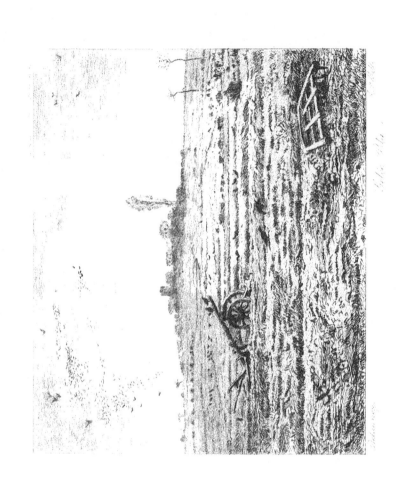

church at Greville, from which he produced the interesting picture of that title, now in the Louvre, and of which a small sketch is given as a headpiece to this chapter. The picture was one of those found in his studio after his death. He had sketched it from a window of the third story of the village inn.

On the 7th November, 1871, Millet again reached Barbizon, arriving with many ideas for future work, which he at once began to carry out. He was at no loss for models, as his peasant friends and his own grandchildren, who were beginning to grow in number, provided all he needed. One family at Barbizon frequently sat for Millet, and he painted their portraits in a group as an additional recompense for their willingness to help him. The picture represents the family standing outside the cottage door ; and, as Millet said, such a work gave the key-note to all his works ; it was " une famille de paysan." Millet made many drawings in black and white, and in tints with hard chalks, at this time ; and in this kind of art he was eminently successful. Some of his finest thoughts and compositions were first produced with the pointed pastel ; in fact, in many cases, these pastels are artistically equal to, and sometimes even better than his oil pictures. In producing pastels he frequently, if not always, drew a line round to mark the size he proposed to make the design, and filled it in accordingly.

Now that Millet had, as it were, "arrived," it was unfortunate that his health began to trouble him seriously, and frequently he had to rest from work because of his infirmities. In May, and again in November, 1872, he was confined to bed, and the headaches from which he suffered became very severe. In the following spring, and again in autumn, he was more or less unwell. Naturally these illnesses interfered greatly with the progress of his pictures, and he was often much more disposed to commence a work than to carry it through. In these last years of his life, Millet felt the difficulty of keeping to a task which had lost its novelty, and a considerable

number of works were found at his death well advanced, yet still far from being complete.

Millet had been no great favourite in court circles in Napoleon's time, so that when the power came into Republican hands, he was naturally selected to receive a commission from the government. It was decided early in 1875 that the large blank walls of the Pantheon or Church of Saint Geneviève should be decorated, and Millet was chosen as one of the artists.

In May he received a commission by letter, granting him 50,000 francs (£2,000) for designs of the Four Seasons to decorate the walls of the church. Naturally flattered by the order, he at once began charcoal sketches for the work,.but the official recognition had come too late, and he made no real progress with the compositions.

He became from this time more and more feeble, suffering much pain in the autumn of 1874. In December the fever increased, growing more violent, and leaving him often entirely prostrate. On some days, as Sensier relates, he was much calmer than on others, and during these intervals he became conscious of his approaching end. He spoke frequently of his children to his wife, and hoped they would remain an united family, and he deplored that he was coming to his death just at the time when he began to see clearly the difficult question of Nature and of Art. By the beginning of 1875 he was entirely confined to bed, and gradually losing strength he died on the 20th of January, at six o'clock in the morning.

Thus died the peasant painter of France amidst his family, gathered to his fathers with all the honour of a patriot. His life was over, the total was ready to be added up, but, even yet, it is still doubtful if the sum has been correctly interpreted. It is still doubtful if we sufficiently well understand the great artist whose results have appeared so differently to others.

Millet died, as he had lived, a Roman Catholic. Without any bigotry,

he was sincerely religious, ever since, as a child, he had assisted at mass in a red robe and white tunic in the village church. One of the ceremonies which he knew by heart was the stately mass for the dead. Needless to say he was buried with the honours paid to the faithful by the Roman Catholic Church, for this was his own earnest wish.

He was buried at Chailly, not far from Barbizon. The time of year and the distance from Paris prevented many from being present at the funeral, for the weather was very bad. The Minister of the Fine Arts sent a representative, and the artists who were near Barbizon at the time attended; also Silvestre and Burty, the critics, and a number of the picture dealers of Paris. But they did not in all number many persons. The peasants of Barbizon, however, attached themselves to the procession.

One of the visitors described the house on the funeral day in *Le Gaulois.* "Immediately on the left is the room where Millet breathed his last sigh, and there, upon two trestles, is his coffin covered with black drapery, upon which is placed a wreath of winter flowers. Four candles feebly light this dark room, of which the furniture is an arm-chair, a few chairs and a cupboard after the style of Louis XIII., the only heritage which the great painter had from his father, and with which he would never part. Opposite the bed, a Christ, of Bassier, a little further, a canvas by Théocopouli, representing a bishop in ecstasy. Here and there a few photographs of the more celebrated pictures by the master."

"At eleven o'clock," recorded *Le Figaro,* "the procession begins to move. The sons of Millet accompany the body of their father. Under the rain they cover quickly enough the two kilomètres which separate Barbizon from Chailly. Even with the curious, come from the last-named village, the small church is not half full. At one o'clock they start for the cemetery. The grave of Millet has been dug beside that of his friend Théodore Rousseau. No speech is given, and the company retire impressed but dismal."

Fulfilling one of his last desires, he was laid beside Rousseau in the church-

yard at Chailly, and Millet's bust and name have been joined with Rousseau's in the rough-hewn monument in Fontainebleau Forest. The exhibition of Millet's works, held in 1887 at Paris, had for its object the erection of a monument at Cherbourg.

Mr. Henry Wallis, the well-known artist and member of the Royal Water-Colour Society, wrote to *The Times* within a day or two of Millet's death and gave the English public a very just idea of Millet's position in Art. He concluded by suggesting that one important work of Millet's should be added to the National Gallery of England. But no notice was taken of the suggestion, and it is possible that some day the British authorities may pay ten times the present price for something which is not an important example, because they have neglected to purchase at the right time a thoroughly typical picture from Millet's brush.

Sketch by Millet of a Barbizon Beggar-girl From "La Vie de Millet.' Quantin

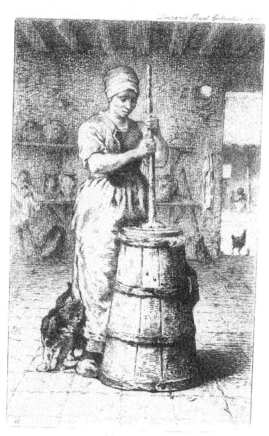

Millet's First Sketch for the "Sower."

JEAN-FRANÇOIS MILLET.—CHAPTER VI.

THE "GLEANERS;" THE "ANGELUS;" THE "SOWER."

THE Salons of 1857 and 1859 contained two pictures which, although appreciated by those who understood art, were not very greatly noticed by the ordinary public. However familiar these pictures may be to us now, and from familiarity alone the majority of people accept a picture without question, yet, thirty years ago, not one connoisseur in a dozen could sufficiently disentangle himself from the art then prevailing to be able to judge impartially of the merits of these pictures. The "Gleaners," for example, was strongly condemned by a writer, then considered a competent critic, chiefly because the figures appeared to him too large, and because the design recalled too much, in his estimation, the pictures of Michael Angelo and of Nicholas Poussin. The picture was too original to be easily understood, and this fact is the key-note to the difficulties through which, in earlier life, Millet had to struggle.

The "Gleaners" was exhibited in the Salon of 1857, and after various vicissitudes it was, in 1889, as stated in a later page, purchased in order to be bequeathed to the Louvre, and it is now in its final and proper resting-place,

the National collection of France. As the etching opposite page 252 shows, the Gleaners are seen slowly going over the reaped field, and the sense of motion which, though slight, is sufficiently well marked, is conveyed by the position of the figures. The same sense of motion is perceptible in the marbles of the Parthenon, and is produced in Millet's picture by one figure being shown in the act of stooping, while the second is nearly touching the ground, and the third is in the act of lifting the grain. This can be observed as well in the etching as in the original painting. But what black and white fails to convey is the extreme tenderness of the colour, the tones of which do so much to add to the poetry of the picture. It is a natural poem of the fields, nothing being added to make the picture pretty, and nothing hidden away from the stern truth for the same purpose.

To suggest the possibility of a defect in this picture may appear like sacrilege, for, in truth, one is disposed to pardon everything for the privilege of looking on such a supreme work. But it may be pointed out that the bright blue cap of the third gleaner is out of harmony with the rest, and those who wish to see the picture to perfection must stop out this spot of slightly crude colour. In the original sketch this blue cap was not introduced, so that the painter appears to have added it in an hour of colour weakness.

The " Gleaners " has always been reckoned amongst the finest of Millet's works, and we should not hesitate to call it his best. Although wanting in a certain sentiment evident in the "Angelus," there is no doubt the "Gleaners" is finer as a work of art. The composition, for example, is more perfect, the drawing is more correct, and the painting is better in technical quality. Moreover, it has been painted with much more care than the "Angelus," and is almost free from bituminous colour. Up to the present, it gives very little evidence of cracking, while in the "Angelus" the cracks are much more numerous than its well-wishers could desire.

In the autumn of 1889, after the disappointment because the " Angelus "

was not secured for France, Madame Veuve Pommeroy, of Rheims, purchased the "Gleaners" from M. Bischoffsheim for the sum of 300,000 francs (£12,000), and as M. Bischoffsheim sold it on the condition that it should be presented to the Louvre, he too may be considered as partly the donor. By the death of Madame Pommeroy, which took place in 1890, the picture passed to the collection in the Louvre.

In 1859 this fine picture went a-begging, and a purchaser for it was found with much difficulty. Millet's artist friends well knew its fine quality, and did their best to sell it, Jules Dupré being fortunate enough to fall in with a purchaser. Dupré, who thirty years afterwards saw the same picture change hands for 300,000 francs, urged his friend M. Binder, of the Isle-Adam, to buy it, and Millet sold it to him for 2,000 francs (£80). This was at a time when money matters were far from flourishing with Millet, and when even £80 was a much-prized reward.

The story of the "Angelus" is more romantic, and this romance is greatly the reason of the extraordinary popularity of the picture. No work of the Barbizon School has been more often written and spoken about than the "Angelus." When in the spring of 1889 it became known that the Secrétan collection (in which the picture then was) must be sold, the excitement as to the price at which the "Angelus" would be sold was very great. Everyone knew that wherever this work went that collection would be famous, and there was much counting of bank balances over the question as to who was to be the purchaser.

The "Angelus" was exhibited in the Salon of 1859, and it completes the trio of the finest pictures of Millet. The "Sower," which we place in this trio, expresses the feeling of the labourer who goes forth bearing precious seed, hoping that his return will not fail to come forth in due time. He throws the seed into the well-ploughed land. He strides across the furrows with slow, majestic pace, for he feels the importance and dignity of his task.

The "Gleaners" represents the end of the harvest, which has been plentiful enough to allow of something being left for the poor. Three women, bent to the earth, slowly cross the cut field, gathering into little sheaves the stalks which have fallen aside from the reapers. The harvest has come and will soon be past. In the distance the farmer himself superintends the stacking of his corn, and the scene, taken in connection with the earlier picture, is typical of earthly requirements fulfilled. It needs, however, the third picture to complete the story.

The "Angelus" embodies the feeling of gratitude which causes faithful labourers to give thanks at the end of their toils. Here in the fields amongst the unsophisticated French peasantry, the act of devotion is open and unconstrained. A man and a woman, simple *paysans* who have been at work until their sacks are filled, bend in humble thankfulness to their Creator, as the bell in the distant village church chimes out the hour of evening prayer. In the open fields, where the goodness of God is seen at every turn, it is not difficult to be avowedly pious, although in the crowded city, where a Supreme Being is so seldom directly felt, it is not so easy. These three pictures, based on a knowledge of the Bible, of Virgil, and of Humanity, embrace all that is best in Millet's work, in their dignity, their simplicity, and their devoutness, and it is on these and others of like character that Millet's reputation rests.

Whether we consider the "Angelus" the finest of Millet's pictures, or, as has been said several times, that the "Gleaners" and the "Sower" are really artistically better, there can be no doubt as to which is the most popular. The "Angelus" has taken hold of the public fancy very much as the "Duchess of Devonshire," by Gainsborough, did in Great Britain recently, or as Michael Angelo's "Moses" did in days gone by. There are several reasons for this. It is known that the painter got 2,500 francs or less for it, and that within twenty years of his death it was sold for 553,000 francs (£22,120) at a public auction. Then the composition is dramatic and uncommon, is easily grasped, and the picture has this estimable conversa-

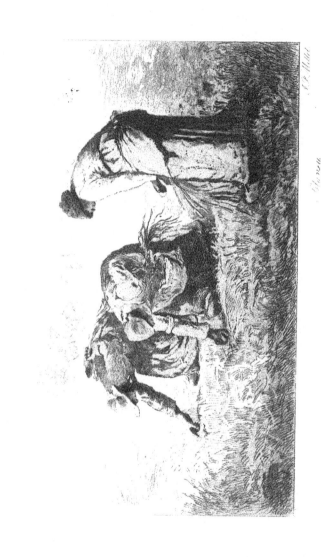

tional value that it affords plenty of room for gossip and small talk. Even before the Secrétan sale in 1889 it was a famous picture and the best known of Millet's works. Besides the question of price, for it had been sold at the Wilson sale in 1881 for £6,400, it had approached to a sentiment not wholly lost even in Republican France, by its religious expression and profound depth of feeling—qualities wherein lie the real art of the picture. The composition, however striking, may be faulty, the drawing doubtful, and the colour strained, but the pervading sentiment is so evident that it appeals to every spectator, whether learned or unlearned in art. The hour chosen is favourable to religious feeling, the idea of thankfulness is gratifying to the onlooker, and even the title, the "Angelus," is redolent with ideas of prayer and peace. Thus to the ordinary human being the picture is unusually perfect. Religious feeling does not stop to inquire if the principles of art have been carefully carried out. It sees the intention, grasps the situation, and readily seeks to join in the gratitude which prompts the peasants to render homage to the divinity.

The "Angelus" is really a small picture, measuring only 25 in. long and 21 in. high, and its subject is appropriately simple and well condensed. The etching by M. Lesigne, opposite page 200, gives the composition; at the last glimpse of daylight, a peasant and his wife incline their heads and fold their hands as they hear the Angelus sounded. Millet's wish was to make the vesper bells gently ring in the ears of the spectator, and in this he has succeeded. The picture is a pure poem on canvas, if ever there can be one. It will not attract immediately those who have little artistic or poetic sense; but when once its spirit is comprehended it will always enthral by its exquisite harmony and delicate suggestiveness. It is above all a supremely peaceful picture, one from which a very busy man can always draw refreshment, and is a most enchanting picture of the dignity of labour. It is not like the "Gleaners," for the workers have been hard at toil in the field all day digging up potatoes, a most prosaic occupation, but full of utility and

honest purpose. Then the peasants in the "Angelus," in that unaffected way that so differs from the timidity of the British at devotion, do not hesitate to bow down in the open fields; they bend in simple devotion to the God to whom they are sincerely thankful.

The "Angelus" was a recollection of Millet's earlier days, and had long occupied the painter's thoughts. In 1859 he finished his picture and sent it to the Salon. Arthur Stevens, with whom the agreement was made in 1860, tried his utmost to find a purchaser for it. He offered it to connoisseurs, to collectors, even to moneyed men simply as a speculation, but every one hesitated and nobody came forward as a purchaser. At last, M. Van Praet, the Belgian Minister, bought it, and it went to his celebrated Brussels collection. The purchase money was said to be 5,000 francs (£200), but Millet's son said in 1889 that the sum was not more than 2,000 francs (£80). Already a mystery has grown up around this matter, but in any case the price paid to Millet was very small.

After having it some years M. Van Praet became wearied of every one reiterating the catch word, which had come to be recognised as the correct thing to say when looking at the "Angelus:" "Yes; I can hear the bells ring," so he arranged with Mr. John Wilson, another famous collector, of Brussels, to exchange the "Angelus" for the "Shepherdess and her Flock," by Millet, of which we give our illustration, opposite page 236.

At the Wilson sale in 1881 the "Angelus," as already noticed, sold for £6,400, and it then fell to the united bid of M. Secrétan and M. Defoer. These collectors had agreed to draw lots for it, and the result was that the picture came to the collection of M. Secrétan.

When in July, 1889, the "Angelus" was sold at the dispersion of the Secrétan collection, one of the most exciting scenes of art sales took place. The event has been thus described by the author in another place:—*

The Art Journal, November, 1889.

"It was about half-past four o'clock when the 'Angelus' was put up, and the expert, whose quotations had been going through some severe tests, announced that £12,000 was demanded for the picture. 'Very well,' returned the auctioneer, 'we will commence at 100,000 francs (£4,000);' '125,000 francs,' called some one; '130,000,' says another, until 200,000 francs was quickly passed. '220,000,' shouted the agent of the American Art Association; '250,000' (£10,000) said M. Knoedler of New York, for the Corcoran Art Gallery. Rapidly, but excitedly, the auctioneer obtains larger and larger sums, until 400,000 francs is reached, when M. Antonin Proust steps forward and discloses the fact that, despite all rumours to the contrary, the French Government had some intention of buying the picture. By tens of thousands of francs 450,000 is soon passed, until the contest seems to lie only between one American and the French State. Half a million francs (£20,000) is named for the Louvre; 'and one thousand,' adds the American; 'and two thousand,' returns the Frenchman as the auctioneer raises his hammer. 'Cinq cent et deux mille francs,' repeats the seller. 'Allons, je vais adjuger,' and he brought down his instrument and shouted that the State had bought the 'Angelus.'

"Then began a scene which cannot often be witnessed. The American, staggered with the rapidity and extent of the bids, had simply paused a moment for reflection, when the hammer fell. It is said he even made his bid before the hammer sounded, but from personal knowledge we know this was not the case. Certain it was, however, that the adjudication had been done too rapidly, and however distasteful to French feelings, the picture had once more to be put up. But the auctioneer hesitated to do this, and meanwhile the audience shouted themselves hoarse. Every one was standing on chairs and forms, hats were being waved, sticks were raised, and everybody present was arguing with his neighbour as to whether or not the picture had been fairly knocked down. The opinion slowly gained ground that it would be fairer to put it up again, and in about ten minutes after it had been

knocked down at £20,080, the 'Angelus' was once more before the public for sale. Again the American returns to the attack, and replies manfully to the bids of the Frenchman. By sums of sometimes one thousand and sometimes ten thousand francs, the bids rise to 552,000 francs, or just £2,000 more than it had been knocked down for before. 'Five hundred and fifty-three thousand francs,' bids the Frenchman. The auctioneer asks if there is any advance on £22,120, and while waiting just long enough to be impartial, he knocks it down with a thump of his hammer which correctly expresses his feeling of joy that he has saved the 'Angelus' for France. This feeling is everywhere predominant in the room, and shouts of 'Vive la France!' rend the air, while hats and handkerchiefs are again vigorously waved.

"But the sequel is not so worthy of commendation. Through some inexplicable blunder, the sale has not been confirmed by the French Chamber of Deputies. M. Proust appears to have acted entirely without governmental authority, and when the time came for the money to be voted in the usual parliamentary way, the estimates did not include a sum for the 'Angelus.' It is said that the Chamber had not time to pass the vote, but this was evidently a paltry excuse unworthy of consideration, The secret history of the purchase of the 'Angelus' has yet to be written."

The picture having thus been repudiated by the French Government, the purchasers offered it to the previous bidder, Mr. J. Sutton, of the firm called the "American Art Association," who very luckily for them decided to complete the purchase at the sum at which it was knocked down. After being exhibited a few weeks in Paris the picture was taken to America, where it journeyed on a tour of exhibition to all the principal cities. The purchasers did not pay the duty exacted on pictures entering the United States, but took the cheaper alternative of entering into a bond that the picture would either be taken out of the country or the amount of duty, over £7,000, would be paid.

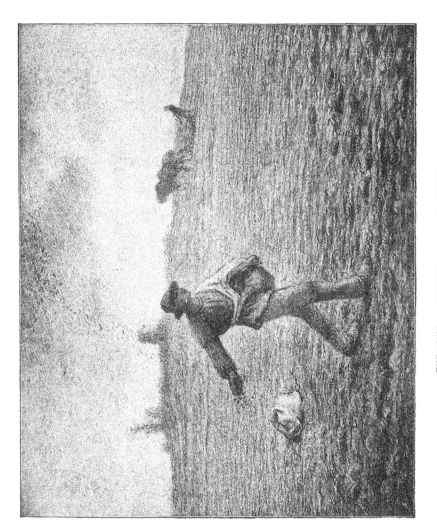

THE SOWER. FROM THE PASTEL BY F. M LLET.

The Interior of Millet's Studio at his Death.
From a Photograph by C Bodmer.

JEAN-FRANÇOIS MILLET:—CHAPTER VII.

CHARACTER; APPEARANCE; WRITER; METHOD OF WORK; RANK AS
PAINTER.

THE real character of a painter is usually sufficiently well shown in his works. An artist's outward life may be, and often, alas, has been, vastly different from what is most estimable from the moral point; but his inner life and better part of himself must be represented in his subjects and developed in his completed pictures.

François Millet's life, like that of all the Barbizon painters, was as consistent outwardly as inwardly with his pictures. He loved his wife and he loved his children, and they in turn were devoted to him. Madame Millet the second was a true wife, and her greatest delight in her widowhood is, even in 1890, to speak of the love she bore to the father of her children.

Millet fully deserved the regard of those around him, and the friendship between him and Rousseau is one of the finest passages of his life. Rousseau was more prudent in financial matters, and only spent his money

after he had earned it, and thus he was occasionally in the position of a prop to his less thrifty neighbour. But Millet was able to repay Rousseau by the strong sympathy he felt for him in that home which was unblessed with children, and presided over by one who was in later years entirely without her reason. That Rousseau's home was often, as already expressed, "like a hell," made Millet all the more enjoy his own happy family circle, while he felt pity and love for the brother artist so heavily afflicted.

In personal appearance Millet has been described as stout and sturdy, rather over the medium height, with a head like a bull, and with hands large like a peasant. His eyes were deep blue and not very bright, except when he was particularly animated. His forehead was high and intelligent, and as may be seen from his portrait, he was interesting and attractive in appearance. Yet he spoke in a hesitating way which almost amounted to a stammer, especially when he was amongst strangers. At home he was more confident in his speech, but his general character was ruled by his diffidence and modesty.

He was seldom known to express admiration of or delight in the results of his own work, and he would scarcely give an opinion on one of his own pictures. He inquired what others thought, and was very chary in telling what he himself was thinking. He was reserved, as indeed his earlier hard lot had forced on him when he so constantly found that his pictures were misunderstood and misinterpreted. Millet also disliked greatly any show of enthusiasm or unnecessary effusion, and even with his wife and children he discouraged a too great affectionate display.

But when Millet became interested in the conversation, his whole appearance changed. He lost his air of restraint, his peasant origin was forgotten, and he was able to express himself with admirable and consistent clearness. It was seldom that he trusted himself to deliver before a number of strangers what thoughts were animating his mind, and little record has been kept of his conversation, but his letters show, perhaps, more clearly the power of his intellect. The real worth of Sensier's biography lies in the many exquisite

letters given at full length. Had Millet not been a painter he would have been an attractive writer, for his descriptions are far beyond ordinary attainments.

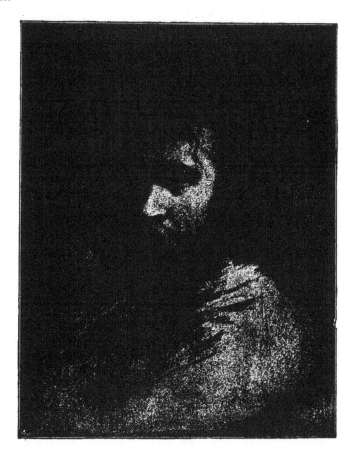

Portrait of Millet. By Himself From "La Vie de Millet." Quantin.

Some people thought Millet brusque and almost discourteous, but this was because they had dropped on him at an unfortunate moment when no

had fourteen children, of whom nine reached maturity—he was all in all to himself and his household, and he desired no intrusion. He disliked discussion on passing gossip or matters of trival interest, and it gradually came to be understood that it was useless to try to converse with him unless the visitor had something special to say. The villagers of Barbizon so well knew this that they rarely approached him, and the name they gave him, "The Patriarch," was adopted as much in fear as in reverence. Political events came and went, and he scarcely noted their existence. He was too much occupied with his art and his family to worry about outside matters of any kind, until, as in 1848 and 1870, they forced themselves upon him.

The technical means employed by Millet are interesting, especially to artists who would learn by what methods Millet achieved his purposes. The colours he used most are known in the English market as Burnt Sienna, Raw Sienna, Naples Yellow, Yellow Ochre, Burnt Umber, and "Italian Burnt Earth," while Raw Linseed Oil was his medium for mixing his colours and painting. No mention is made of the blue he used, but it was probably Prussian Blue.

That Millet employed bitumen, at all events in his earlier pictures, is undoubted, and the cracks on the "Angelus" show the harm this has done. Fortunately the "Gleaners" is almost free from cracks, and technically this may thus be considered Millet's chief work.

The technique in the "Gleaners" is not easy to be understood. The colour is laid on thickly, and therein is different from many of Millet's smaller pictures, although most of his highly finished works are thickly painted. Save in the foreground, where the plants and cut corn are touched broadly, the marks of the brush are scarcely visible. On the figures the labour of the painter has been lengthy, colour being placed above colour,

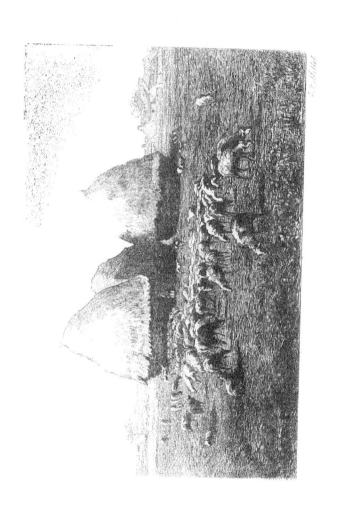

tone above tone, while the oil was still soft, and a slight scumbling work over all seems to complete the handiwork. In the flesh the under tone for the peasants' weather-stained faces is a dark ruddy tint, probably Burnt Sienna, and the lighter tones of the skin are produced by opaque colour drily painted over, a curious grey-green tint, that can be observed only by very close inspection, being employed in the half shadows. The ruddy ground, accentuated by what appears to be Rose Madder, gives excellent strength and tonality to the shadows of the flesh. The foreground has been very carefully studied, and the effect of the stubble has been added by single touches produced quickly—but after careful consideration of what was required—and all is done in a way that is as interesting as it is instructive to the student. Here, too, the effect, as usually sought by the Barbizon School when strength is desired, is produced by adding opaque and semi-opaque colours over semi-transparent browns. Rousseau also worked in this way from dark to light, and so did Diaz, and the three are the strongest in colour of the Barbizon School.

Millet was in the habit of keeping his pictures beside him a very long time, and the " Angelus " hung on the point of finish for months, until, as he said, he felt he could make the distant bell ring. With the " Sheepfold " the same happened, but for even a longer time, and when any one wanted to buy it he would say : " No, it is not complete. You cannot hear the dog bark in there yet."*

In May and June, 1887, a collection of Millet's works was formed in the large hall attached to the École des Beaux-Arts on the Quai Malaquais. This contained the " Angelus," the " Gleaners," and many other fine works, and was largely instrumental in helping forward the fame of the painter. It was organized to obtain money to assist in the erection of a statue to Millet in Cherbourg, and in this it was so successful that the statue was

* This fine picture, one of the most poetical of Millet's work, is now in the collection of Mr. Walters, of Baltimore, who also possesses the original design for the " Angelus."

commissioned from M. Chapu, and visitors to that city after 1891 may observe it in the market-place.

In the Paris Exhibition of 1889 there was again a very fine collection of Millet's works, but the "Angelus" was not there. The chief feature was the splendid gathering of pastels and coloured chalk drawings. These covered a large screen, and confirmed what had been felt before, that in pastel Millet frequently reached even a higher standard of artistic excellence than in his oil paintings. The "Sower" pastel is reproduced opposite page 256, and others are given in the volume.

The sale of Millet's sketches on 11th May, 1875, realised for his family the remarkable sum of 332,110 francs (£13,284), so that the fact of Millet's widow receiving a small pension from the State because of the genius of her husband gives a very misleading idea of her position. During the exhibition of Millet's works in Paris in 1887, nearly every newspaper spoke of the profound distress in which the artist lived; but the other side of the picture is quite as true, quite as interesting, and far more conducive to a good opinion of the common sense of Millet himself and of his patrons in his struggling years.

It may be accepted as fairly certain that if Millet had not had a severe battle in life, he would not have painted so well as he did. It was his profound knowledge of human suffering, his sympathy with human labour, and his constant devotion to what was best in art, which enabled him to develop into the artist whose pictures are becoming more and more highly appreciated every day.

He was the only one of the Barbizon group who can be called a figure painter. Diaz painted many figures and all his earlier works were of Oriental people, but his greatest achievements were in landscape. Millet, on the other hand, was perhaps greater as a figure painter than in landscape. In his later years he considered himself more a landscape than a figure painter, yet his fame rests, and is likely to continue to

rest, on his paintings of human life. He frequently made the landscape
and figures of nearly equal value, or in pictures such as "Near the
Farm," of which
we give an etching
opposite page 260, he
made the interest
general.

As a descendant
of peasants, and him-
self a peasant, he was
properly a peasant
painter, and the
dignity of labour was
never more practic-
ally or more poetically
rendered than in his
pictures. Often Millet
chose subjects which
were non-attractive
from their vivid real-
ity, but happily many
of his subjects are
quite of an opposite
quality, and nothing
can be more tender
and more truly
delightful than his

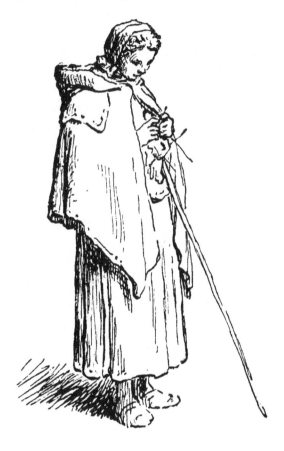

A Shepherdess. By Millet.

shepherdesses (see "La Tricoteuse," opposite page 208), and other figures
on whom the weight of life does not seem to lie too heavily.

As a figure painter Millet takes quite a different standing from the other

Barbizon artists. Figure painting, because it is an effort to realise the highest life of our globe, must embody the greatest art, and is the highest achievement to which an artist can apply himself. And however Philistine the remark may seem in its tendency, it is true that to the greater number a figure conveys an absolute impression where a landscape will fail.

Altogether it will be gathered that Millet was rather reserved to strangers, resentful of intrusion, not seeking for praise. He was difficult enough to deal with at all times, and even his friends sometimes found it better to remember that while speech is silvern, silence is golden.

But this was the necessary covering to a warm heart, bleeding underneath for the hard lot of humanity. His own career had burned into him the severity of the peasant's toils, labours, and privations, and his whole life was, therefore, spent as an exponent of the dignity of labour and the majesty of work. To the peasants within his village he might have seemed a strange incomprehensible man, less to be loved than avoided, but he was really giving forth to the world the essence of the peasant's life, and employing his highest power to add dignity to their life and self-respect to their class. He was a Republican in the sense of being thoroughly of opinion that one man was equal to another, whether he was well born and educated or not. In his eyes the peasant's life was deserving of as high honour as the statesman's, and he believed that it was wiser to demand respect for an honest labourer than to ask people to worship only that cleverness which can add guinea to guinea. Millet was the one painter who has given us the apotheosis of the peasant, and therein he has achieved what never has been done before, and which indeed will never require to be done again, as Millet's work has almost touched finality in this direction.

CHARLES-FRANÇOIS DAUBIGNY.

M M

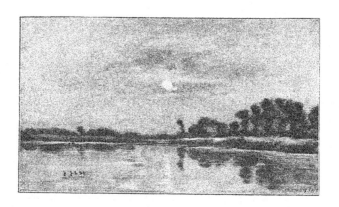

Moonlight on the Oise
From the Picture by Daubigny in the Collection of J. S. Forbes, Esq.

DAUBIGNY:—INTRODUCTION.

THE chief notes of the pictures of Daubigny may be set down as attractiveness and delicacy. They are by no means as strong in the highest qualities of art as the works of Rousseau, Diaz, and Millet, and they are not so poetic as the pictures of Corot. But the works of Daubigny, notwithstanding the criticism of Théophile Gautier, have, almost without exception, the indefinable charm of attractiveness. Not that they are pretty in an imperfect way, as a cheap modern water-colour drawing often is, but that he has given them the quality of pleasing in nearly every case, such as none of his compeers so constantly do.

Daubigny was essentially a "comfortable" artist; he never painted scenes of heavy labour like those of Millet, and hardly ever storms like those of Diaz or Corot, or solemn forest scenes like those of Rousseau. The subjects he chose were nearly always agreeable, and he seldom went to extremes. The deepest sensation he appears to have permitted himself was a moonlight with fleecy clouds racing across the sky, or a rock-bound coast in which a modicum of dirty weather was perceptible. His delight was to paint the quiet nooks of the Rivers Oise and Seine on a pleasant afternoon, with perhaps some herons quietly feeding, or a flock of geese swimming in single

file to their home. He liked the well-cultivated plain, rich and golden in colour, with a cottage in the hollow or a village on the hill-top. And he also revelled in sunsets on the river, full of glow and vigour, with a town, mayhap, in the distance, or a brilliant light from the fast-descending sun piercing through the trees and bushes.

After Corot, from whom Daubigny learned much and whose place as " the " master in the Barbizon School we cannot belittle, Daubigny is the artist most likely to retain the confidence and love of connoisseurs. The pictures of the other Barbizon men may at present be more sought after, and realise higher prices, but in the long run, and after Corot, Daubigny will be the painter whose works will probably grow more and more into public favour.

Although classed as a member of the Barbizon School, Daubigny does not strictly, or at least does not in the geographical sense, belong to the group. He was occasionally at Barbizon, and in any case he was friendly with his fellow artists living there. But he lived more on the rivers Seine and Oise, and more in the country to the north-west of Paris than in the south-east, where Barbizon and Fontainebleau are. The Oise was, in fact, his favourite painting place, and the majority of his finest pictures were produced on its borders. But in poetry and power Daubigny belongs entirely to the Barbizon School. The sentiment in his daylight pictures has much in common with that of Corot ; while his evening and moonlight effects possess qualities not very far removed from those of Millet and Rousseau.

His finest efforts are clear and luminous in colour, something near akin to the work of Corot, yet with a difference easily discernible, though difficult to describe in words. They are often stronger than Corot in colour but are never so masculine as Rousseau, occupying a place half-way between the two and yet different from both. But Daubigny is entirely individual, for any one with even a little experience can observe how clearly he differs from Corot as well as from Millet and Rousseau, while yet showing something of the feeling of all these painters.

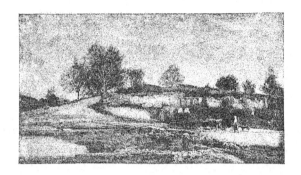

DAUBIGNY:—CHAPTER I.

BIRTH; VISIT TO ITALY; SALON PICTURES, 1817—1843.

THE story of Daubigny's life is not so interesting as those of Corot, Rousseau, and Diaz. His life was the most prosaic of the five great painters of the School, and it affords a striking contrast to the troubled life of Millet.

Little or nothing is known to the public of Daubigny's life, while Millet's "misfortunes" have been the theme of many a doleful tale. The artist, equally with the nation, is happy who has no history, and although there exists a well-written memoir of Daubigny,* from which many particulars have been culled, his life presents no startling experiences, no unhappy calamities, nor any very special incidents needful to describe in detail. Nevertheless it will be found that his life is not without its attraction.

Charles-François Daubigny was born on the 15th February, 1817, and, like Rousseau and Corot, he was a native of Paris. Why town-born people should have produced the best landscape painters might form a good text for leisurely inquiry. But Daubigny had the advantage over his colleagues

* "C. Daubigny et son Œuvre." F. Henriet : Paris, 1878.

that he was sent to the country while very young, and for several years he lived at Valmondois, on the Oise, about fifteen miles north-west of Paris. There, with nurse Bazot, the delicate child grew into boyhood, and most of his earliest impressions were of the delightful country in that neighbourhood. Naturally, too, when he had returned to Paris and was big enough to travel alone, he spent his holidays with his old nurse, and when he made money in after years, his first thought was to build a house in the vicinity. So much has it been believed that Daubigny was a native of the Oise country, that frequently pictures of fine quality representing some of the villages on it have been named by too credulous owners " The Birthplace of Daubigny." Certain it is that he often painted these villages, but equally certain it is that he was not born in any one of them.

Daubigny came from a thoroughly artistic family. His father was a landscape painter, his uncle and his aunt were miniature painters, and most of the family friends were learned in the fine arts. Little wonder then that from his earliest days Daubigny was accustomed to use the pencil, and it is the fact he could draw more or less correctly before he knew how to read. He had in fact little schooling, for his mother, who was his teacher, died when he was only twelve years old, and his education was never completed. But he had enough to carry him through life, and if he was no book-scholar, this perhaps left his ideas fresher and more natural for development as a landscape painter. In his youthful days Daubigny had to take his share in earning the daily bread of the family. His father never achieved more than artistic mediocrity, and it was with him the same in those days as now, and as it probably ever will be so long as weak artists endeavour to live by painting, there was a lack of ready cash. Daubigny as a youth knew well the value of money, and he early learned to look on both sides of his coin before parting with it. After painting for a couple of years on fancy objects, such as decorations on old-fashioned timepieces, fan, glove, and scent, and other kinds of boxes intended as presents from watering-places, he found

himself at seventeen practically independent, and ready to strike out in any new and more original way that might commend itself.

At this age he left his father's house and set up on his own account. He was, however, prudent enough to make his money before he spent it. Having heard much of Italy he came to the conclusion that in order to be a thorough artist he must study at the fountain-head of Art. Communicating his thoughts to Mignon, an equally enthusiastic and prudent painter of his own age, the two resolved to save every centime possible, and gather together enough to take them on their travels to the south. For more than a year the two young artists put their savings into a hole in the wall of their attic, a bank they devised so that they could not get their money out without knocking away the plaster. They worked hard to gain their end, painting panels for decoration of rooms, ornaments for the Palace of Versailles, or, in fact, anything that enabled them to make money, so that they might have to wait as short a time as possible for the fulfilment of their wishes. Daubigny, it is said, put away something every day, however small. At last, one day in early spring, when the air filled them with longings for the country, they decided to open their bank, and with hammers they broke into their treasury and found in it nearly 1,400 francs, or £56 sterling.

Daubigny had passed his eighteenth birthday when he started with Mignon to visit Italy. They went with bag on back and stick in hand, walking all the way. It was the summer of 1835 when they reached Italy, visiting Rome, Naples, and Florence, seeing and studying all the old masters. The landscapes of Claude and of Jan Both chiefly pleased Daubigny. In the course of his wanderings he also laid the foundation of some life-long friendships. Within a year after their departure from Paris the two comrades re-entered it: Mignon to marry and settle down to a commercial life, but Daubigny to go on in his pursuit of art. Their hoard of 1,400 francs was all spent, but Daubigny at least had laid in a stock of knowledge of far greater value than his share of the treasury.

But want of money drove him to accept any work he could get, and he received a post under the official Conservateur des Tableaux of France, as assistant picture-restorer. His business was to paint on the old masters after they had been relined, but his spirit revolted at the work. He frequently saw magnificent *chefs-d'œuvre* touched out of all reason by his chief; he expostulated and quarrelled, and very soon again found himself without means of livelihood. However, with other three artists he formed a sort of mutual aid society, which having a common purse was able to keep each member from starvation, and this rescued him from the degradation of painting "potboilers" for the dealers.

The first picture he had hung at the Salon was in 1838, when he exhibited a view of the Apse of Notre-Dame taken from the east, the same view that Meryon etched in a way so masterly and exhaustive. The community of four artists of which he was a member had agreed that each should take his turn to prepare an important work for the Salon, the others meanwhile earning the wherewithal for expenses. In 1840 Daubigny's turn came, and it is evident he had not at that time settled down to be a landscape painter, for he produced "St. Jerome in the Desert," which was exhibited at the Salon of that year. This was a curious subject for one to paint who afterwards was to become a master of landscape. But the truth is his journey to Italy had to some extent rather hurt him than helped him, and it was only by chance that he did not devote himself to historical painting, in which he probably would not have achieved fame. His studies in Italy led him away from nature, and he wanted to emulate some of the old masters whose works he could not but admire. This "St. Jerome" painted at twenty-three was considered somewhat of a success, and he entered as a competitor for the Prix de Rome, at the Ecole des Beaux-Arts. He worked in Paul Delaroche's studio for six months, and duly passed the first examination for the Prix, which is the chief aim of all young French artists. Eight students were selected, and of these Daubigny was the third, but he forgot or did not know that it was necessary to

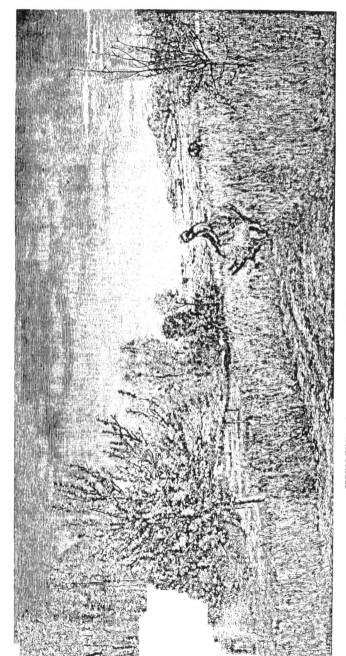

SPRING-TIME. FROM THE PICTURE BY DAUBIGNY, IN THE LOUVRE

From a photograph by BRAUN, Dornach.

attend the day before the examination to hear the subject given out. He had gone to Vincennes, a few miles off, to spend the day in order to divert his thoughts, and although a messenger was sent to the house Daubigny did not know, because of his absence, until next day that his name had been cancelled and his opportunity lost.

This accident was, however, the turning-point in his career, and was more than an ordinary blessing in disguise. He now determined to study from nature, and the first trial convinced him that his forte was landscape, and not historical painting. He saw nature with new eyes, as it were, for his sketching of the figure had taught him much in seeking for colour, and he found revealed to himself new and brilliant ideas, so that his enthusiasm soon came to boiling-point. He found the inexhaustible varieties and beauties of nature ready to his hand and very soon he abandoned figure for landscape painting.

About this time some of Daubigny's works were shown to an art critic whose name is unrevealed. This authority pronounced the paintings failures, and counselled him to leave the Fine Arts, and stick to decoration. He said that the pictures had no quality in the painting. Daubigny, however, was undaunted by this adverse criticism, much the same as when, several years later, Théophile Gautier spoke against him, and said he never properly finished his pictures.

It was natural that the first landscapes painted by Daubigny should be taken from near the house of his old nurse at the Isle Adam, Valmondois, where he had found a second home. The old lady welcomed him always, and several of his famous pictures represent "La Maison de la Mère Bazot," a modest cottage in a little village in a fertile French vale. Besides the "St. Jerome," he sent a view of the valley of d'Oisans to the Salon of 1840. In 1841 he sent another view in Isère, and a frame with six etchings. In 1843-4 he exhibited two landscapes, in 1845 more etchings, and in 1847 and all the succeeding years of his life he sent landscapes together with an occasional etching. In the latter mode of expression he greatly excelled, and a complete set of Daubigny's etchings is a veritable treasure-house.

As yet, however, Daubigny was not looked on with more than ordinary favour. He gave promise of excellence, but although he was not so long in developing as Corot, yet he was slower in reaching artistic maturity than Rousseau, and the pictures upon which his reputation depends were not executed until after 1860, although, during previous years, he had produced several excellent landscapes.

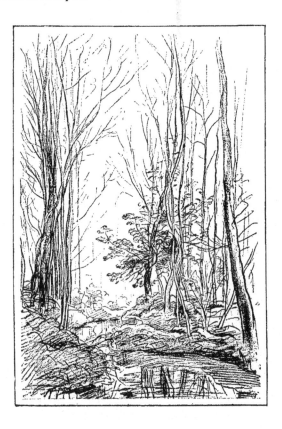

Fac-simile of Sketch of Trees by Daubigny. From Jouaust's "Peintres Contemporains"

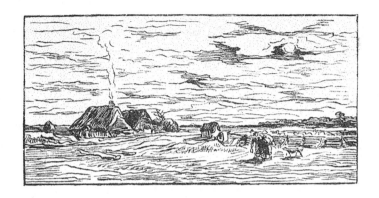

Moonlight.
Fac-simile of Drawing by Daubigny of his Picture in the Salon, 1865, and Royal Academy, 1866

DAUBIGNY:—CHAPTER II.

BOOK ILLUSTRATIONS; PRIX DE ROME; SUCCESS IN LANDSCAPE; SALON
PICTURES; VISITS TO LONDON. 1843—1874.

DAUBIGNY still was searching for his *métier*, and although he seemed early in the forties to be excelling as a painter of landscape, he had at this time to work very hard for daily bread.

His sister's husband, Louis Trimolet, a well-known book illustrator, died in 1843, and Daubigny had to provide for his family as well as for his own. He married about this time, and his son Carl was born in 1846. After painting all day, he drew on wood and on stone at night, and he produced many illustrations which are now somewhat sought after. He had worked a good deal in black and white, his *beau-frère*, Trimolet, having shown him the methods of the technique.

In 1848 Daubigny began to show distinct signs of genius, and for his five delightful landscapes sent to the Salon of that year he was awarded a second-class medal, a notable event even in those days for a man of thirty-one. His circumstances gradually improved, and a very acceptable legacy

having been left to him he was able to take longer and more distant travels. He had a boat made for voyaging on the Oise and Seine, and very early in the mornings he started off, mostly alone until his son Carl was old enough to accompany him. The boat was allowed to drift until it took him to some new position and effect suitable for painting, when he would cast anchor and soon produce the scene on his canvas. The boat contained everything necessary for lengthy journeys, for he sometimes went nearly to Rouen, and as there was always plenty to eat and drink on board as well as provision for cooking, though he worked hard he lived well. From the ownership of this boat he delighted in receiving the title of " Captain " from his friends.

Daubigny's reputation rapidly grew, and several of his pictures were purchased by the State and presented to provincial museums. In 1852 the Minister of Justice hung his fine picture " La Moisson " in his bureau, and in 1853, when Daubigny was awarded a first-class medal, the Emperor bought his " Etang de Gylieu," near Optevoz, which was then the patronage of the highest grade, so that, officially, he was now in the height of his fame. To the Exposition of 1855 he sent four pictures, one of which, a " Lock in the Valley of Optevoz " (see illustration, page 269), was purchased for the Luxembourg, and has now been transferred to the Louvre.

To the Salon of 1857 Daubigny sent his " Springtime," now also in the Louvre, and of which we give a large wood engraving, opposite page 272. This picture shows the highest finish in detail that Daubigny produced, and although to the artistically educated mind this detail is not by any means a recommendation, to the ordinary public it is a great attraction. In 1877, it may be remarked in passing, Daubigny painted a picture of his garden with the figures of his son and daughter-in-law as lovers, which has many qualities similar to the " Springtime " of 1857. In 1859 Daubigny was made a Chevalier of the Legion of Honour, and in 1874 he was made an Officer, while at the Exhibition of 1867 he obtained a first-class medal in the keen competition of the Exposition Universelle.

Daubigny was very simple in his life in the country, and amused himself with the humblest pursuits. A friend visiting him was asked to go with him, as he was painting his boat. The friend naturally thought it was a picture the artist was engaged at, but he found it was a veritable coat of colour for the boat itself that his host was working at.

In 1860 he took a country house at Auvers, one of the most charming places within easy reach of Paris. There he painted many pictures, now known only as "Bords de l'Oise." There Daubigny, about 1864, built a house, which became almost a museum of art decorated by himself and his brother artists. In the loggia, giving access to the studio, there were three upright and three oblong compartments or panels, and those were painted by Corot, who always took a lively interest in Daubigny. Indeed, like many other painters, Daubigny looked on Corot as a father, went to him in his troubles, confided in him, and, what was more uncommon, acted on his advice. Again, in 1872, Corot, then an old man and not able to mount the ladders, directed the further decoration of Daubigny's studio, which were carried out by Daubigny, *père* and *fils* and Oudinot, Daubigny's pupil. Corot was said to be entirely satisfied with the result, and only expressed regret he could not himself ascend to complete the work.

In 1864 Daubigny sent to the Salon "Les Bords de la Cure, Morvan," a large picture showing a stream running across the view, with cows standing in the water. A wonderfully luminous colour of autumn pervades this picture, which is in the collection of Mr. Alexander Young, and which was afterwards painted on by Daubigny, as it is now dated 1867.

To the same Salon, that of 1864, Daubigny sent his "Villerville-sur-Mer," now in Heer Mesdag's collection at the Hague, and of the numerous pictures of this locality painted by the artist this one is the largest. We give a reduction of a drawing by Daubigny of this picture on page 279. In 1865 he exhibited his view of St. Cloud, which had been commissioned by the Emperor Napoleon, and which is now in the Museum of Chalons-sur-Marne.

time a considerable number of admirers. Even as early as 1854, an English artist, Mr. G. P. Boyce, had found him out and had purchased a small specimen of his work. This little picture in oils represents a hillside near Villerville, where Daubigny always liked to go. The sweetness of tone and the artist's exquisite knowledge of values in painting are well exemplified in this little sketch. This was almost certainly the first Daubigny bought by an Englishman, and the purchase was only possible by an artist of the keen artistic insight of the buyer.

Twelve years later Daubigny was invited by certain English painters, Sir Frederick Leighton being the chief, to come to London, and in the summer of 1866 he landed in England for the first time. Earlier in the year he had sent a large picture to the exhibition of the Royal Academy, then held in the building now entirely occupied by the National Gallery. This picture was unfortunately rather shabbily treated, being placed, to the dismay of all the artist's friends, at the top of the east room. This picture, called " Moonlight," is one of Daubigny's finest canvases, and had been in the Salon of 1865. We give at page 275 a fac-simile of Daubigny's original drawing of the subject.

When the opening day of the Royal Academy came the artists who knew Daubigny were perplexed about the bad position assigned to the picture, and there was some feeling expressed that a protest should be made. But a more effectual action than simple protest was made by Mr. H. T. Wells, then recently admitted to the Royal Academy, who, ascertaining that the price asked by Daubigny was quite moderate, purchased it there and then. It was a bold stroke of business for a comparatively young artist to buy a master piece by a fellow-painter, and no one can grudge the good bargain Mr. Wells doubtless made.

A little later Daubigny came with his son Carl on his long-promised visit to London, and soon found his way to the Royal Academy. It took all the

consolation of a far-seeing artist having bought his picture to tide over his natural disappointment in the hanging of his work, but the attention shown by the group of artists who were his special admirers soon made him forget the discourtesy.

During the Franco-German War in 1870-1 Daubigny again spent some time in England as well as in Holland. He made many sketches in the Netherlands, and his fine compositions of windmills were favourite subjects all during the succeeding year. As soon as things quieted down in France he returned there, for he felt that his strength lay more—as witness the " Lever de Lune" of 1872, which is reproduced opposite page 280, and the " Moonlight on the Oise," on page 267—in the poetic treatment of his bright native rivers, rather than in the realisation of the somewhat prosaic Thames and Scheldt.

Daubigny had now achieved a wide fame, and he had no further anxiety in regard to his pictures. He was accepted as a master, and his works were being placed in the most exclusive collections. His pictures dated between 1864 and 1874 are of his best period, and all his works of this time are good. Occasionally, between 1874 and his death four years later, he executed some

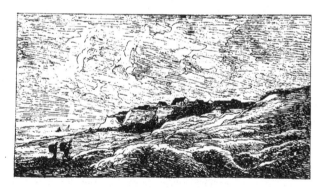

Villerville-sur-Mer. Fac-simile of Drawing by Daubigny of his Salon Picture of 1864.

thoroughly satisfactory pictures, and these will be mentioned in the following chapter.

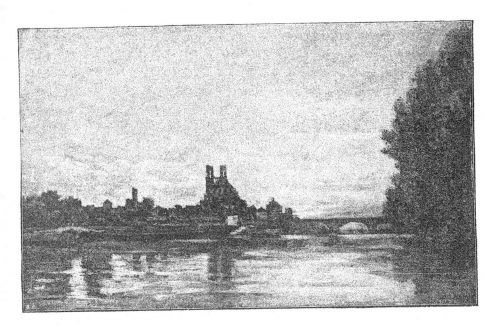

Nantes. By Daubigny. From the Picture in the Collection of Alex. Young. Esq.

DAUBIGNY:—CHAPTER III.

LAST PICTURES; ILLNESS; DEATH; FUNERAL. 1874—1878.

ON his return from Holland Daubigny found it desirable, though very much against his own wish, to have a show studio in Paris in the orthodox fashion. English painters are still able to keep their studios fairly private, and many artists decline to receive visitors during painting hours, unless actual or expected purchasers, but in Paris it had then become frequent— now it has grown to be almost compulsory—to open the show studio to every one. A number of artists do as Ary Scheffer did, and have two studios, one for work and the other for exhibiting their completed pictures, but this is a tax only the most successful can maintain.

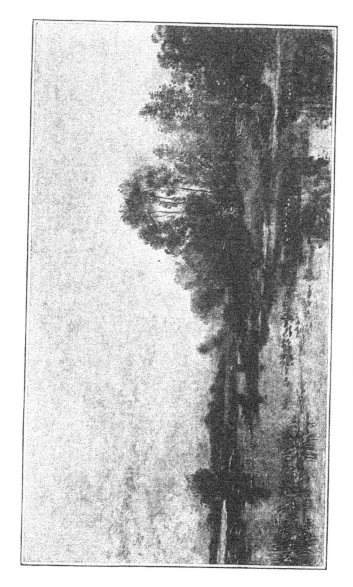

LEVER DE LUNE. BY DAUBIGNY. 872.

From the VAN GOGH collection

In 1874 Daubigny worked on the Seine, and he then painted his very strong picture of " Mantes," with the bridge and the cathedral strong against the sky. We give an illustration of the picture opposite, remarking that it is seldom that Daubigny painted anything so pronouncedly black and white. He also exhibited his large picture of " La Maison de la Mère Bazot," a work of the finest quality in its exquisite sky and sense of peaceful, unbroken repose.

Henriet gives a humorous description of Daubigny in Paris the day he had been made an Officer of the Legion of Honour, in July, 1874. " What are you doing in Paris in this heat?" asked Vollon, the painter, whom he met. " A duty ; one that is rather a bore, but I am off again to-morrow." " Are you then alone?" asked Vollon. " Yes," replied Daubigny. "Come then and dine with me." " Willingly;" and the two set off arm in arm to Vollon's house. "Oh! but I have just remembered," suddenly said Vollon as they walked along: "I am alone also; my wife is in the country, and it will be necessary to buy the dinner and be my own housewife." So the two artists went to the baker, the wine merchant, the grocer, and the cook-shop. Daubigny soon appeared again, carrying the bread in one hand, the bottles in the other, with the two ordinary long-shaped packets of salt and of pepper sticking out from his waistcoat pockets. As for Vollon, in order to preserve the broadcloth of his comrade, he had taken charge of the turkey and the sausage, which formed the chief portion of the impromptu feast.*

Towards the end of 1874 rheumatics and gout, which had more or less troubled Daubigny for some years, became more acute, and from that time up to his death, four years later, he never was free from pain. The rheumatic gout tried him greatly, as it occasionally affected his hands, and prevented him from working. He persevered, however, whenever possible, and continued to paint up to within a very short period of his death.

He remained faithful to the Salon, although in 1875 he was too ill to send anything. He exhibited in 1876 and in 1877, and at his death he left a work

* Henriet's "Daubigny." Paris, 1878.

which was doubtless intended for the Salon of 1878. This picture, of which we give a reproduction opposite page 284, was the last great work painted by Daubigny, and is called the "Return of the Flock—Moonlight." The intense stillness of the evening, when the moon's rays are just beginning to be felt, the gentle patter of the sheep with the slightly hurried movement of the dog pressing on the flock from behind, the mists commencing to rise over the long plain, the wonderful never-ending depth of atmosphere, are all sources of continual pleasure and interest. This picture was part of the celebrated Secrétan Collection, and is now in the possession of Mr. G. A. Drummond, Montreal.

The beginning of 1878 found Daubigny in very poor health, yet his friends had no serious apprehensions for him. The end was, in fact, rather sudden and almost unexpected. His illness quickly developed and became very severe, and finally, on the morning of the 19th of February, 1878, Daubigny died of hypertrophy, or enlargement of the heart.

The closing scene of his life was marked by an expression which showed the deep admiration and devotion he had for Corot. The appreciation was mutual, for Corot had a fine specimen of Daubigny's work in his little collection of pictures. The thoughts of Daubigny on his deathbed turned towards his companion, and almost his final words to those around him were: "Adieu. I am going to see above if friend Corot has found me any *motifs* for landscapes." In this spirit, on the 19th February, 1878, Daubigny died. He was buried in presence of a large concourse of friends, in Père Lachaise, where a monument with a bust has since been erected to his memory

The funeral service was practically open to all, and it is estimated that about 1,500 people attended the ceremony, which took place on the 21st February, in Notre-Dame de Lorette, the procession to the cemetery going by the Faubourg Montmartre and the boulevards. At the grave there were the usual speeches, and the officials of the Salon, as in duty bound, said some complimentary things, for Daubigny had always sent his finest pictures to the Salon, and supported it in every way he could.

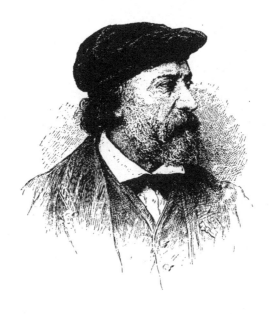

Portrait of Daubigny. From Jouaust's " Peintres Contemporains "

DAUBIGNY:—CHAPTER IV.

PERSONAL APPEARANCE ; RANK AS A PAINTER ; CHARACTER ; STUDIO.

IN personal appearance Daubigny was robust and jovial-looking (like the "captain " he was often jokingly called), with loosely trimmed beard and moustache. In youth he was considered rather good-looking, and even when his beard became grey and his face covered with furrows, the result of rheumatism contracted by his frequent journeys in his boat, he was still, though sailor-like and rustic in appearance, an interesting-looking man.

There is a story told of a poor young man, afflicted with consumption to the last degree, who, coming suddenly before a grand work of Daubigny, exclaimed, "Ah, I can breathe better now." Who can explain why the invalid felt the fresh air blowing on his face, felt the clear atmosphere which

O O 2

the painter had made perceptible more to the mind than actually visible to the eyes. The artist had as it were mixed the very ether with his pigments, and the consumptive felt refreshed as he inhaled their vigour.

That Daubigny is not quite so strong and individual an artist as Corot or Rousseau is proved from his frequent impressibility by the work of other painters. For example, a good picture by Corot in his best period stands by itself, entirely independent in ideas, and free from resemblance to works of other masters. Daubigny, on the other hand, showed how he could be influenced by the resemblance his pictures had at one time to Corot—with whom he frequently painted—at another time to Rousseau, and in still other pictures to Millet. In his earliest pictures his work resembled the old Dutch masters, and the way he introduced and painted figures showed a decided inclination towards the school of Holland—Van Goyen, perhaps, chiefly.

Like most painters, Daubigny became much less precise in his painting as he progressed. His first pictures are well defined and carefully finished, not quite so hard as the earliest studies by Corot, but still very definite in treatment. About 1860 he began to leave this style of work, and up to 1877, the year before his death, he very gradually became freer and bolder, and therefore more admirable. Like Corot, he did not always finish his pictures at one time, but laid them aside often for years, and then took them up again, although he did not keep them about him so long as the older painter.

The character of Daubigny was less marked than those of his colleagues. He appears to have kept very closely to painting during his whole life, and seldom or never mixed in public matters, either artistic or political. He was essentially a quiet man, and prudent in his affairs; very glad to welcome visitors, but not specially courting them ; beloved by those who knew him, but not a man to arouse enthusiasm in his daily life. His chief wish seems to have been to be let alone with his absorbing passion for painting. Personally he did not have influence equal to any of the other Barbizon painters, and his pictures partake a little of the same character, although his artistic merit was in his own walk almost unequalled.

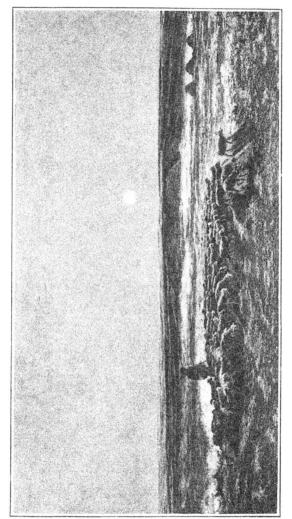

RETURN OF THE FLOCK—MOONLIGHT By DAUBIGNY
From the Picture in the Collection of G. A. Drummond, Esq.

The chief qualities of **Daubigny's** pictures have been noted as regards their relation to the other artists in the Barbizon group, but it may be added that Daubigny was entirely a landscape painter and etcher. Figures he never painted of large size, his greatest works being landscapes. They showed most frequently a river or some water in the front plane. He also often painted pictures with well-wooded banks and a flock of geese ascending, and sometimes with a village at the top showing a church spire, trees, and houses against the sky. There were two great effects upon which Daubigny usually relied. One, that of comfort and cheerfulness, as shown in the well-planted landscape and river, lively, liquid and glowing, suggestive of the busy activity of life, such as the " Springtime" in the Louvre ; the other full of a feeling of repose like the " Mantes," the sun setting in golden clouds, magnificent in its quietness and wonderfully solemn in its silence.

Daubigny was a productive etcher, and over one hundred plates were etched by him. Nearly the whole of these are of small size and used only for book illustrations, but about half-a-dozen were over twelve inches long and about double that number were small, but large enough to be framed as separate proofs. He also drew a considerable number of designs on wood for engraving, especially in his earlier years, and many of them contained figures of minute dimensions. He also employed a process of etching on glass, but this has never been successfully worked, as the difficulty in printing impressions is so great.

Daubigny's Paris studio was, in 1870 and later, at No. 44, Rue Notre-Dame de Lorette, in the north of the city, and there during the season he was to be found on certain days, ready to show his pictures to his patrons and friends. It was a little house, built probably at the beginning of the century, and had in front a small court separated by a railing from the street. A little gate, it is said,* opened on the left, leading to a narrow staircase which in its turn led to the studio, which was of fair proportions. This was literally

* " Peintres et Sculpteurs Contemporains." J. Claretie, 1882.

filled with sketches, studies, and unfinished pictures, of which a great number were sold at the sale held soon after his decease. When unsigned these were marked " Vente Daubigny " in red letters. The house has been rebuilt, and no vestige remains of the studio where Daubigny painted. But the studio where he really did his best works was at Auvers, where, as has been described, he worked in the midst of the scenery best adapted to his brush and palette.

M. Albert Wolff tells that Daubigny often became tired of his visitors, and that he was irritable on the visitors' days when the *monde* passed by his finest work in silence, and praised him only when he produced an effect with which they were familiar or which reminded them of something they had seen before. One day he is said to have gone so far under the petty annoyance of visitors, who would not spare a few minutes' thought even to try to understand the artist, that he said, loud enough for every one to hear, " Laissez moi donc tranquille ; the best pictures are those which do not sell." Let the reader ask any painter he may meet how much this phrase means to the real artist, and he will ascertain how true it is. The painter's best pictures do not sell mainly because they are too individual in themselves, too different from what has already been done and accepted as masterpieces ; and also because, as they follow no acknowledged style, they are not recognised at once to be good works of art.

This, as will have been seen by the preceding pages, is characteristic of the whole class of pictures produced by the Barbizon School. It is the same as in music and poetry, where the familiar is admired because of its association, as well as because of its intrinsic value, while the art which is new has everything settled and conventional against it, and frequently cannot be admired but at the sacrifice of at least a portion of some previously accepted and probably long-cherished tradition.

A Garden at Barbizon. Fac-simile of a Drawing by Rousseau.
From "Etudes de Th. Rousseau." Paris; Amand-Durand & Goupil.

OTHER PAINTERS OF BARBIZON.

BESIDES the five artists whose careers have been considered in some detail in the foregoing pages, there are, as may readily be believed, many others who were in active sympathy with them. Without exaggeration it may be said that the great majority of French artists, as well as many from other countries, have, for longer or shorter periods, been residents at Barbizon. Many of them are unknown to fame, while some have reached the highest pinnacle of success. Amongst these we have selected the following painters as those whose works are in closest affinity to the five artists treated—Constant Troyon, Charles Jacque, and Jules Dupré. Of these Troyon is by far the greatest artist, whilst Jules Dupré is placed lowest in the trio.

CONSTANT TROYON.

Outside the group of five great artists, Troyon was the chief painter who had strong sympathy with the Barbizon School. As an artist adding the interest of cattle to a landscape he has never been excelled ; and although

we may willingly give honour to the famous Paul Potter, our praise is tempered with the thought that the work produced by this artist is chiefly wonderful in consideration of the period at which it was executed, while in examining the works of Troyon no such reservation is needful. He painted his animals from the life, not making them stand like a still-life object, but to run, walk, or ruminate, while also they live and breathe. But however excellent may be Troyon's cattle or horses, they are, in all his greatest works, subordinate to the scheme of landscape which constitutes the picture. Troyon is a landscape painter who studied animals, and usually added them to his compositions, but in order to understand his art completely it is necessary to remember that his landscapes independent of his animals show the greatest side of his art.

He was born at Sèvres on the 28th August, 1810, and, like Diaz and Dupré, his earliest artistic training was in connection with the decoration of porcelain. His first teacher, now perfectly unknown, was Riocreux, and later, Roqueplan, the deservedly famous landscape and figure painter, was also one of his masters. Unfortunately Troyon absorbed more of the practices of porcelain painters than was good for him, and for at least ten years afterwards he was occupied much in ridding himself of those influences or in getting together such knowledge as was afterwards to be really useful to him. He had a hard time, and his earliest works are now scarcely recognisable as from his brush. He was nearly forty before he acquired the power that has since made him famous, and all his good pictures were produced in the last fifteen years of his life—that is between 1850 and 1865.

It is said to have been Paul Potter's "Bull" at the Hague which inspired Troyon, during a journey about 1846, to introduce animals into his pictures. In any case this influence led him to study form and colour more closely, and in this way it helped him greatly forward.

Troyon was a frequent exhibitor at the Salon, and the Emperor Napoleon III. was his friend and patron. He obtained a number of medals and

This artist lived for many years at Barbizon, and was well known and much esteemed by Millet and Rousseau. Born at Paris in 1813, he tried several walks of life before he settled down as an illustrator of books by wood engraving and etching. He began painting about 1845, and at that time he was constantly associated with Rousseau and Millet. Since then he devoted himself more entirely to painting, and has not been without successes. In 1867 he was awarded the cross of the Legion of Honour, and on three occasions he obtained third-class medals.

Charles Jacque excels in pleasantly composed, peaceful, and well harmonized pastoral scenes. His shepherds and shepherdesses and sheep reclining under a huge oak-tree are always delightful, and in this special characteristic he stands nearly alone. He is less suggestive than Millet, and more prosaic than Corot or Daubigny. He is perhaps more nearly allied to Rousseau than to any of the other painters of the school; and while it cannot be denied that he fell far short of the masterfulness of that artist, he has a well-defined dignity of his own. He composes his subjects carefully, draws with knowledge and ability, and colours strongly, though not always richly. His small studies of farm-yards are frequently delightful, and the colour is some-times altogether satisfactory; but his power lies in pastoral scenes with heavy foliage, and in stable interiors with animals, and in subjects like these he is always a thoroughly admirable artist.

JULES DUPRÉ.

Jules Dupré became a famous painter as much because he was associated with and was the bosom friend for some time of Rousseau and Millet, as

because his works are always of high merit. This does not mean that Dupré was really an inferior painter, but that he cannot properly be placed in the highest rank, however often he may have been accorded such a position. Dupré lived until October, 1889, and he, therefore, was a witness of the triumphs of *le grand refusé*, Rousseau, and of Millet, whose pictures are now well known in every quarter of the globe.

Dupré, like Millet, was a countryman, having been born at Nantes in 1811, where he commenced life by painting on china. Afterwards he lived at Sèvres with his uncle, and still later he took to painting independently of the porcelain. When he was twenty-two he was awarded a second-class medal at the Salon. He was always remarkably well treated by the Academy and the Salon, and jealousy of his having been awarded the Legion of Honour in 1849 was the cause of Rousseau's separation from him at that date.* In 1867 Dupré was again awarded a second-class medal. This was greatly to Rousseau's private disappointment, as he had hoped his old friend would have been more fully recognised. Yet it is certain that the Jury were more impartial judges than Rousseau, and that in rewarding Dupré with a second-class medal they were placing him in his proper rank.

The art of Dupré was too conventional to be of the first quality. He painted the same or similar effects frequently, and his style once known, his pictures are always easily recognised. He was too fond of the "brown tree" in his pictures, while his knowledge or power of representing aërial perspective was by no means perfect. At the same time some of Dupré's landscapes and sea-pieces are very fine, and when he avoided conventional foliage and too "painty" horizons, he occasionally touched the highest phase of landscape art.

* This and many other details of Dupré's relations with Rousseau and Millet will be found in the biographies of these artists. *See* Index.

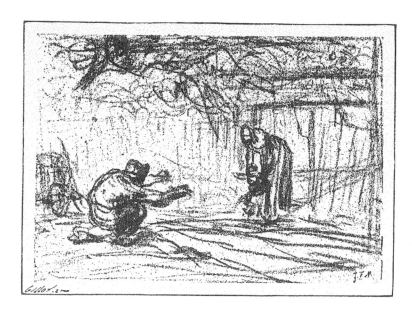

Sketch by Millet First Steps From "La Vie de Millet." Quantin

GENERAL INDEX.

ERRATA.—Page 16, heading of chapter, *to read* First Journey to Italy.

Page 22, heading of chapter, *to read* Second and Third Journeys to Italy.

Page 28, line 11, *for* better *read* little.

Page 34, in heading of chapter, *for* 1841 *read* 1848.

Page 56, line 19, *for* Sennagon *read* Sennegon.

Page 251, lines 1 and 5, *for* Pommeroy *read* Pommery.

Made in the USA
Columbia, SC
20 May 2021